for Leah

CONTENTS

ACKNOWLEDGEMENTS

What appears here is the product of many year's labor and analysis that began while I was living in Philadelphia and continued in Miami Beach. The ideas in this theory of visual music took shape in talks about the role and potentials for synchronized sound in motion pictures with my friend and fellow artist, Charles Recher. It is the product of discussions with too many people to adequately list or thank all of them here, although I wish I could.

visual music

visuals produced as an analogue to musical form
—i. e. as a visualization of an audible equivalent;

thus, a variant of representation,
and so tied to realism in art.

o

glitch

an unexpected or aberrant product of machine function
—a failure in an otherwise operational system;

thus, a means to consider the operation
of the system, apart from its products.

CHROMATIC - VALUE FORM OPPOSITION
DESIGNATING ORIENTATION, MOTION FOR
TRANSFORMATION DYNAMICS.
USE TO PRODUCE <u>PRIMA MATERIA</u>

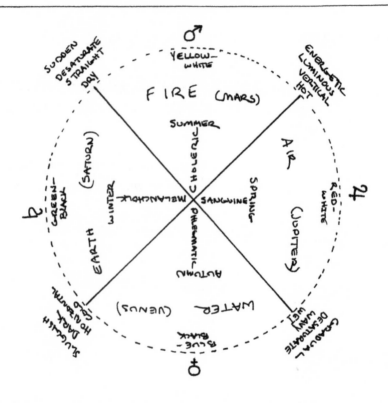

conjunction of opposites
(male-female) produces ∝ ⚡ movement follows pattern of
beginning of sequence opposites

⟨CONJUNCTION → MULTIPLICATION → PURIFICATION → RESURRECTION⟩

Script–diagram for *Prima Materia* (2005).

INTRODUCTION
A BROKEN HISTORY

This book presents a chronological survey of artistic research into, around, and with digital motion pictures, slightly revised for internal consistency and clarity. The result unveils a theory of both visual music and abstraction, one that is directly connected to a critical engagement with the socio–cultural meaning of "visionary art."

Digital Materiality

"Materiality" for digital art and technology is complex: it describes an ambivalent relationship between two distinct, but overlapping, understandings of "materialism." The first is familiar from art history and criticism: the literal substance of the digital—the electronic signals that encode binary data. This digital code is what enables computer operations and is the substance of all electronic files. Artistic and aesthetic engagements with the materiality of the digital are addressed to the technological and semiotic functioning of encoded files and the use of computer languages. In manipulating these features of digital technology, artists (and critics) are addressing the materiality of that technology and its active role evident in even the most banal or prosaic uses of computer and digital technologies. This first meaning for "materiality" has an extensive use in the discussion and analysis of technological and computer art, and is apparent from the recurring emphasis on computer programming in the evaluation of digital art. The materialist engagement with the technology itself is a precursor to the differentiation between art addressed to the machine, and art that addresses what the machine can make. This understanding of digital materiality transforms computer software and hardware ("computer art") into an analogue for the same formal relations from other artistic media such as "painting"—it recreates a conception where the manipulation of software/paint on the hardware/canvas brings

the realm of digital art into a coherent parallel to older, established media, allowing the transfer of the art historical conceptions of materiality to apply to the discussion and analysis of the digital.

The second understanding of digital materiality tangentially overlaps with this art critical understanding, but moves away from the direct engagement with the software/hardware configuration to examine the political and economic factors that instantiate the digital; this other conception of "materiality" aligns with Marxist critiques where the social relationships in the political economy for production—the network of supports and infrastructure that enables the digital to exist—are the "materiality" of the digital: the ambivalence of these two uses arises in the duplicity of this Marxist critique. In understanding digital materiality as a collection of resources consumed, labor expended, and machineries constructed, the second variant of "materiality" necessarily includes the software/hardware dualism, but conceives of it in different terms. Digital technology is integrated into the material of the political economy—it is simply one aspect of how capitalism arranges and marshals production. This understanding always potentially effaces the particulars of digital technology, focusing instead on the flows and lacunae of capital and its expenditure/crystallization. These different foci for the same, singular term are not mutually exclusive; they are a revelation of ambivalence.

Digital materiality is metastable, a shifting set of relationships where the concerns at one level of interpretation shape and direct the engagements at another: the descriptive materiality of art criticism is neither less accurate, nor more precise than the contextual materiality described by Marxist critiques. This pair identify the same concept, but at different levels within the same analytic engagement. Their ambivalence arises from their interrelationship—the linked association of technology and the productive systems that support and sustain its activity. The difficulty arises with "digital materiality" from how these levels diverge in their scope of address, creating misconceptions about which should take priority and how the immaterialism of the digital should be understood in relation to this materiality: as (a) political "false consciousness" that hides the costs and labor involved in its production, or as (b) denial of the physicality of digital code and technology (software/hardware)—in both cases, the materiality is elided, but what is being erased differs in both

particulars and significance. The political "false consciousness" requires a neglect of the economic and productive *apparati* that make the digital an effective instrumentality of production and automation; in denying the physicality of software/hardware, the digital becomes a transcendent technology, one that magically escapes form the constraints of the physical world—and these fantasies are not mutually exclusive.

As a potential revelation of materiality, the digital is thus only one part of what the digital glitch might present: the other part is the utter dependence of all these technologies on the human social realm. The particular form of a digital work when rendered for human viewing/encounter makes the purpose of that particular data stream apparent, whether it is a movie, a piece of music, a text or anything else, the data itself is encoded for human purposes. The automatic nature of the digital device is of a different character than the autonomy of agency. The illusion that our devices function without our input, without responding to our desires and demands is a reflection of their design, and the functions these machines are constructed to achieve—the superficially mysterious, perfect nature of the digitally manufactured, its magical aura, work to obscure the underlying physical reality of the digital and its subservience to human choices and agency. These foundations are all hidden within the aura of the digital, most especially the dependent relationship between the functioning of the digital technology and the demands made by the desires of human society (and provides its formal basis).

The social realm of human desires and needs are of an entirely different order than their instrumentalities. The connections are implicit, rather than explicit, and so require a jump of interpretation to move from one level of this construction to another: the structure as a whole is necessarily interrelated to the political economy and social organization of the human society that produced it. Without a social function—given and directed by the human agency that puts these devices into action—the digital, however active the device itself may be, has no function. This most basic fact of digital technology: that it is designed for and functions in service to particular human demands is lost when the auratic powers of these technologies dominate: not only do we forget their physical basis as devices, we also forget their dependence on human desires and demands. Like all machines,

digital software and hardware are constructed to meet specific human–originating goals, and these goals are the 'reality' of the device, not the instrumentality itself.

The insistence on the human dimensions of interpretation make this human–centeredness emerge as a contingent value: often absent from consideration, the human use (interpretation) of digital work is simultaneously essential to that work, and at the same time its unacknowledged constraint. The "media" generated from digital files—whether glitched or otherwise—are ordered precisely to create forms that are recognizable and comprehensible to humans. This human element becomes contingent with digital machine–rendered "media" precisely because the work is not based in an analogical relationship to its source. The digital is a language–based translation between electrical signals and their interpretation by the computer when then renders them into a new form entirely presented to the human audience. This performance of the work is entirely inhuman, yet for a human spectator; thus, the contingency of this audience as the source file is not intelligible. Focusing on the "unintelligible" to humans aspects of this digital signal entails a basic mistake—when the digital machine produces anomalous results, they are still evidence of normative function (even if truncated by glitches), since a true breakdown would produce nothing.

The heritage of earlier Modernist aesthetics, whose avoidance of physicality arises as an explicit "realism born of the mind" that is neither concerned with nor engaged in a verifiable link to observation but is realized in abstraction, still shapes contemporary thinking. Art critic Roger Fry made this connection between abstraction and transcendence in his review of avant–garde paintings by Henri Matisse, Pablo Picasso, André Derain, Auguste Herbin, Jean Marchand and André L'Hote on exhibit in 1912:

> [These artists] do not seek to imitate form, but to
> create form; not to imitate life, but to find and
> equivalent to life. By that I mean that they wish to
> make images which by the clearness of their logical
> structure, and by their closely–knit unity of texture,
> shall appeal to our disinterested and contemplative
> imagination with something of the same vividness as
> the things of actual life appeal to our practical
> activities. In fact, they aim not at illusion but at reality.

The logical extreme of such a method would
undoubtedly be the attempt to give up all resemblance
to natural form, and to create a purely abstract
language of form—a visual music.[1]

Fry's focus on the physically apparent form of the art—its purely visual aspects such as compositional elements (color, line, shape and texture)—directs attention to these visual features as aspects of an immaterial, otherwise unseen order, hidden from everyday senses. These abstract artists, in their "aim not at illusion but at reality" are engaged in a movement away from literal depiction to a transcendent presentation of a "deeper" mental reality. The aesthetic distinctions between a realism of everyday appearances and a realism of thought connects the aura of the digital to explicitly aesthetic concerns of art while remaining concerned with digital technology and production in a dramatization of the role of culture in mediating our engagements with the world around us. The connections of technological, scientific, and cultural domains to the political economy are expected, revelatory facets of the same social and political activity; however, the ways that this framework obfuscates the relationship between digital technology and materiality makes its critical examination and consideration significant for any critical engagement with the particular materiality of digital capitalism and how it is systematically denied.

Employing "digital materiality" in a critical construction requires acknowledging the ways that it is connected to the same Modernist ideology that informs other aspects of digital capitalism, apparent in how the aura of the digital internalizes the erasure of context particular to Modernist aesthetics. Separating the specific presentation of a digital work from the consideration of the work in itself—that the digital file is not the same as its presentation on a screen, in a print–out, or other physical presentation—literally inscribes the Modernist desire to isolate the art work from the context that produces it into our consciousness and our interpretation of the digital (art) object. In apprehending the digital, the sanitized, clean white gallery space to eliminate external context from the interpretations of art, (erasing the specifics of location, presentation, context) becomes instead an internal elision in the mind of the spectator. This disavowal of the physical context and form of the work

instantiates the same Modernist desire for transcendence common to abstraction and abstract art generally as a "natural" feature of the digital work, one that derives from its peculiar form—inaccessible, coded instructions that require an electronic apparatus to render them visible. This attempt to escape from the physical repressions the material world has its historical foundations in the factories and enforced labor of industrial capitalism: a transference of the alienation of capitalist social valorization into a rejection and alienation from the physicality that accompanies that alienation.

This erasure of the physical world from consideration is not uniquely a feature of capitalism nor of the digital, but is shared with transcendental thought generally—in the cases of digital/ capitalism, the internalization of this impulse is at the same time a reaction to their omnipresent dominance. The aura of the digital internalizes the effacement of physicality common to critiques of capitalism, returning it as a fantasy of freedom from material restrictions—an appeal to an immaterial realm accessed (or even realized) in/through the digital computer. Traditional, religious paradigms (immediately recognizable in the fantasy::reality dynamic that rejects empirical science, from the assertions of a "flat earth," to suspicions about vaccination causing disease, to denials of evolution), the desire for transcendence of the physical world is simultaneously a rejection of the material world arising with the duality of mind::body in European philosophy that separates the immaterial mind from the 'mere matter' of the body. In denying physicality, this superstructure avoids those challenges originating with empirical observation. For digital capitalism, this same framework authorizes the varied and relativist impacts of agnotology and "alternative facts." They are aspects of the *same* cultural desire to transcend a "limited" physicality.

o

Technical failures, what are commonly called "glitches," have played an essential, *material* role in my media work in one way or another since 1990. I am not sure when I first specifically called this kind of work "glitch," but the concept and the work it produced have been continuous features of my work since 1989. I know I was using the term by 2001, and I did a bit of writing with it in 2003 for the *Miami Art Exchange* when it was the

On Television, still image showing *VideoToaster* glitch (1990)

only publication concerned with Miami–based art on a regular basis (this was before Art Basel Miami Beach). The deployment of accident (chance) within carefully prescribed frameworks enabled the uncontrolled, chaotic features of glitched imagery to develop organically from my technical process, focused by using the looping methods of video feedback as a protocol for making *all* my work: *iteration, revision, recursion.*

My first works with glitches were in video, done in 1990, 1991 and 1992 with the digital freak–out that would happen when breaks in time code ran past the digital frame buffer of the *NewTek Video Toaster* on the *Amiga 1000* systems available at Temple University. I used these failures in several videos; my movie *On Television* was the first of them, produced in 1990. These glitches were recorded to VHS tape and provided a reference point for my future movies. Experimenting with video feedback produced other interesting results, as did the inconsistencies that arose between digitally processed video and its transfer onto 16mm film.

Other glitches, made using the types of manipulation now familiar as "databending," became an on–going (if low key) area of interest following a catastrophic hard drive failure while working with *Adobe Photoshop* in 1993 that destroyed much of my data, and

The Gunz (1996)

added "junk" to what image files I could recover. My experiments with these broken files elicited no positive responses from the few people I showed them to: puzzlement and the statement that my file was broken were typical, especially when I posted them on-line in 1996. I worked with these for several years after 1993, never really satisfied with the results. Sometimes the glitched file was the focus; other times, it provided source materials for more manipulation. The first round of broken pictures that "worked" emerged starting in 1995 and early 1996; posted on–line that year and then (almost immediately) removed: while the graphics were not *actually* broken, their glitched form resulted in visitors emailing me with slightly concerned, brief messages to say my graphics were broken. That the page stated that the "broken" appearance was how these pictures were supposed to look made no difference to these responses. So, this idea sat on my hard drive while I worked on other things. If you can't show it to an audience, it's hard to be motivated to do more work.

"Broken pictures" and "deranged" video files (compression–based glitches) became an increasingly common part of TV and being on–line in the late 1990s, frequently encountered during

Malfunction, video still (2000)

the final days of dial–up connections and long download times (I was poor, and DSL was *so* expensive in those days). These fractured downloads, coupled with the problematics of CableTV in Miami, Florida (cable theft was rampant, and even if you paid, your neighbors would steal your signal, seriously degrading it) made video glitches a common part of my media landscape. This was the same period that glitch music started to make inroads into the electronic (and experimental) music scene in Miami, so it seemed like the idea was just *"in the air."* I experimented with various ways to capture and manipulate these failings, using them as both subject/material and models for making my own work. Charles Recher would have me help him with the background to his 2001 piece *TV* because of these experiments.

The kinds of video glitches and glitching I was working with in this time focused and revolved around the incorporation of feedback and technical failures, largely based in defective compression and the shuffling between formats, analog–digital media and rephotography all of which would then be polished down into something seamlessly, bright, colorful—yet originating with these technical failures. *Malfunction* (2000) is one of them, created by swapping the MPEG video codec for a defective version, and transcoding the results into AVI formatted video.

These early engagements with digital files all emerged out of my engagement with the experimental film/video and electronica music scenes in Miami that paralleled each other, but rarely ever actually intersected. Few of the film or video art people I knew had these interests in either digital technology, or its failures, but it was of active concern in both music scenes at the end of the 1990s. Much of this early DV work was made as experiments and trials that were only shown to a small circle of friends. When I would try to arrange shows of these videos I would usually either get rejected or a panicked email/phone call about how my media was "broken." The idea of working with and showing im/pure failures just wasn't around at the time. The dynamic interplay between obviously glitched and less–obviously glitched was a 'feature' of my movie *Year* (2003). The *"September 11"* section makes these associations obvious. A still from this movie was included in the *Glitch: Designing Imperfection* book, published in 2009.

A series of works begin in 2010—and continuing with my movies *Dancing Glitch* (2013), *The Kodak Moment* (2013) and *Going Somewhere* (2015–2018)—are engaged with an examination of the affect of digital glitches, specifically with their normative functions within a particular work both (*a*) in the immediate encounter and (*b*) over time across the duration of the movie itself. This pair provides an opportunity to examine the relationship between those distortions effected by digital video encoding glitches and the perceived imagery presented on screen: what is under consideration in these two related experiments is the role that the recognizable figure has in the stabilization and normalization of these technical failures within the work itself. This concern is not simply a formal issue. The interpreted status of the depiction as glitched (as unintentional/autonomous technical failure) or as a coherent not–glitched visual form (i. e. interpretable as an intentional construction) has an impact on the avenues of interpretation available to considerations of the work since an identification as unintentional technical failure renders the formal dimensions of the work moot, thus their impact in shaping any interpretation is negligible—it is often "noise" to ignore, rather than "signal" to consider.

o

Year, still from "September 11" section (2003)

So does this international history mean "glitch art" is a movement? The problem with calling the amorphous collection of artists making "glitch art" a movement is precisely its shapelessness: the things being done and called glitch art have been around and in use by artists since the late 1970s and first started to become prominent during the 1990s, but emerged more–or–less independently in places as diverse as London, Chicago, Oslo and Miami—all places also associated with the use of glitches in electronic and avant–garde music. This plurality of origins makes any suggestion of a "movement" highly questionable: there were no manifestos, no proclamations that circulated across all these origin–sites. Instead, the use and embrace of glitches appears to have happened more or less simultaneously, as a result of the faults and failures of digital technology in the 1990s, especially the vagaries and interruptions common to dial–up internet access and the slow speeds of download that would often result in partial and damaged files. The embrace of glitch by these initial artists (whose work from 2003 and earlier was collected in the *Glitch: Designing Imperfection* book) was highly dispersed internationally and aesthetically, even while they shared formal similarities because of the technologies involved.

In these early years, before social media and easy photosharing, the people working with glitch tended to be isolated, often in spite

Still from *Going Somewhere* (2016).

of the communications possibilities of the internet. The highly–
European focus of *Glitch: Designing Imperfection*, for example,
demonstrates the advantages of geography—while there was a
great deal of experiment and "play" with glitches in Miami, there
was not much visibility outside Miami for the works being made
there (this was before Art Basel arrived, bringing the art world
along). This early isolation was true for other places as well. The
Oslo, Norway conference organized by Motherboard in 2002
was, in part, an attempt to overcome that isolation; those of us
in Miami heard about it after it was over. These same limitations
have restricted the availability and writing of histories around
"glitch art." The disappearance, and generally poor visibility
of works made during or even before "web 1. 0" fosters the
mistaken belief that "glitch art" didn't emerge until after 2005
due to photosharing sites such as *Flickr*.

Movements tend to emerge around new aesthetics, either
prompted by new technologies (as with *video art* and *computer
art* in the 1960s/70s, or *net. art* in the 1990s) or the embrace of
theories that result in radically new conceptions of the work (for
example, the historical avant–gardes—Cubism, Futurism and
Surrealism being obvious instances—all have a strong connection
to new theories of vision, motion, and mind respectively).
Even Impressionism is partially a response and exploit of new
technology (paint in tubes). With this historical framework in
mind, the strongest case for being a "movement" would then be

the artists responding to web 1. 0 or even the early days of web 2. 0—those artists working between circa 1995 and circa 2006. But the problem then arises: they are a disparate, motley group whose organization into a movement would necessarily be a post hoc description, not in itself unusual for art history. It is a misleading grouping, one whose visual focus ignores the overlaps of ideation with experimental music, electronica (techno) and the innovative graphic design work of record labels such as Warp Records in the UK during this same period.

In the case of glitch art, perhaps a better understanding is to see it as a specific and recurring engagement with technology, rather than as a movement. With the lack of manifestos during its formative years, it is better identified as a shared tendency or collection of concerns driven by common experiences, and part of a general engagement with then–new technology during the transition from analog media to digital media. Understood in these terms, "glitch art" retains its historical foundations and gains context as a continuation of artist–engagements with the possibilities of new technology beginning in the nineteenth century. In a history of technology–art, "glitch art" would come at the transition between one kind of media and another, comparable to the changes developing out of photography a century earlier.

What this means for the question of a "glitch art movement" is that there wasn't one. Much like the invention of abstraction, glitch art may be best understood as a transition between one conception of art–technology and another, a symptom rather than a cause. The historiographic issues of artists and movements are best left for later, more disinterested analysis: it is likely that there is not one "movement" but potentially several, separated by the geography and spatial distance that the idealism of the early years of Internet connectivity hoped to erase but didn't.

written, Summer, 2017

REFERENCES

1 Fry, R. "The French Post–Impressionists" (preface to catalog for the *Second Post–Impressionist* exhibition, 1912), *Vision and Design*, (London: Pelican Books, 1937) pp. 195–196.

IMHO, a column – 009: Welcome to Cyberia

published in
Miami Art Exchange
September 19, 2003

WELCOME TO CYBERIA

There is a set of engineering issues that are common to all technological arts in the digital age: sampling, fragmentation and reassembly, data compression and expansion . . . and the glitch. We like the glitch, not because it formalistically reminds us what we are seeing is an artifact (it does), but because in our encounter and by developing our relationship to the glitch, we can enter into a dialogue with our technology on its own terms, negotiating for points of contact between what we–as–audience will accept and what we reject as technological failure, as an interruption to our fantasies of dominance, power, mastery.

The digital pretends to allow us access to abilities beyond our competence because it is so technically perfect. In searching out the glitch we find ourselves in cyberia, encountering the artifacts left–over from our technological abstraction. This experience has the potential to become a dominant paradigm for our encounters with mediated reality. When we encounter the glitch the limits of our technology become apparent to us. It causes a manifestation of the interpretative limits to our technology and our ability to prevent that technology from degrading over time. What we call a glitch is a variety of entropy revealing the secret language of digital technology.

Glitch

In its perfection, the digital introduced new kinds of signal–to–noise degradation. This decay was unexpected, a reminder of the connections between the virtual and the physical that digital media seeks to hide. By exploring these realms we can discover the limits of our technical competence; the points where our technology impedes us rather than enables functionality. While in principle digital "objects" are infinitely reproducible, the reality is these "objects" exist as real–word electrical signals subject to

physical effects. One copy may be exactly the same as another, but only so long as nothing interferes with that copy to degrade it.

The glitch shows us the paradox beneath the claim of perfect replication, exact copying, infinite availability. While the digital does allow complete, perfect replication, it also offers possibilities for complete loss, total system crash. The glitch is the transient failing, the momentary lapse that allows us to see underneath the mask at the reality hidden inside the digital representation: How much data has been lost to faulty storage, poor transmission, or obsolete technology? How much more will we lose in the future? These are the questions of cyberia that make us aware of the glitch. We find at the heart of the digital a paradox unresolved— the illusion of infinite reproducibility, perpetual reproduction and replication—forces us to confront the glitch as the inevitable limit to our extended reach.

> Glitch is technology talking back to our fantasies of the infinite.

Once we discover the glitch, like addicts, we want more. For technojunkies, the glitch is endlessly fascinating, the final aspect of the real playing into the virtual realities we're told to desire. It is the latest Gnostic moment, for hatred of the physical body runs deep, a desire to place "mind and spirit" above the corporeal, ignoring the intimate connections all our virtualities have to mundane physicality. (Cyberspace was born a fantasy from its start in *Neuromancer*.) The glitch brings us back into reality from cyberia. The desert of virtuality grows only vacuum flowers, glowing and effervescent, side–effects of other processes. We only become aware of this link to the real when the glitch interrupts our fantasy with a 404 Error—blue screen of death—pixelization: the digital medium impinging upon our transparent reveries before the screen. The glitch shows us the screen, not our fantasy displayed upon it. Broadband, DSL, T–1 each only serve to mask the technological window into cyberia, bringing things faster, so we see less of the medium, and more media. We set the digital in motion and it generates itself on our command.

Rip, Mix, Burn

The extension of virtual media will eventually change the marketplace as we know it, leaving behind only fetish objects

whose actual contents are infinitely available: the lessons of mp3 music swapping are already readily visible. It provides suggestions about what the future may be like when media such as music is free, (the songs available now, here . . . everywhere, legal or not), the only reason to purchase the album is to own an object, singular and special in itself as a thing independent of the music it might contain. Physical recordings begin to take on the same quaint quality we reserve for hand–blown glass, traditional carvings, paintings. Commercial CDs become specialty products, luxuries for enthusiasts, the same way that vinyl records are now a minority interest item, important only to specific subcultures (the DJ and scratch subcultures are the most obvious examples). The music and digital "content" are secondary to our purchase. In a triumph of form over content, we buy not for its contents, but for the package. Design culture triumphs. This paradigm is a potential (nascent) future for all digital media. In this future, the glitch plays a prominent role in our technological encounters.

Cyberia

When the glitch comes, we have fully entered into cyberia. It is a state without a direct physicality (in the way groves cut in vinyl are physical)—everything we encounter in digital media is a second–order (re)presentation given to us by ingenious devices that speak their own digital language inaccessible to humanity, but wholly dependent on us for its existence. This is a machine world built to service us even as we find new uses for it. It is one where the glitch reigns supreme, the final ruler of cyberia, because to destroy a thing is to control it. The glitch that arises from machine failure reminds us of our powerlessness before the technology we have built.

Neither celebration nor fear are appropriate responses to this development. It is the side–effect, the afterburn, of our technology reaching a kind of maturity. It gives us the potential to remake portions of our civilization in different terms, much the same way the printing press enabled a basic change in European civilization that has produced, ultimately, the digital. The movement towards abstraction is implicit in this development; the glitch is always an abstraction—it is the eruption of digital representations into the realm of human encounter: the ways the digital interprets its data enables our meeting in cyberia.

As artists we can choose to engage this glitch preemptively, before its dominance becomes immediately apparent. Art may provide a means to understand and frame our phenomenal relationship to the glitch in terms other than as–interruption in the seamless transparency of cyberia. We need encounters with the glitch that are independent of its hijacking of our experiences, a terrorist that destroys our encounter with digital media.

A formalist answer to this problem neglects the human angle. The glitch is a way to see what our technology typically hides from us: the actual functioning of its processes, events that come into motion only because we have set them into motion. Formalism makes machines that exclude the human, while these machines exist only to extend our human capabilities. We are already cyborgs whose cyberspace is a vast, unexplored, mechanized wasteland that stands apart from human experience. Cyberia is a place we can only see through the glitch.

As our civilization becomes increasingly a resident of cyberia we create new names for our experiences."Art" should be one of those names. It offers us a way of reaching an understanding of our technology and our relationship to it.

instaglitch#16908426_260348597753145_8598616421712265216_n.jpg
glitch made with *iPhone* panorama software, Miami Beach (2017)

Barbara Wilson Memorial Lecture

University of Nebraska—Omaha
February 23, 2006

VISUAL MUSIC AND THE BIRTH OF ABSTRACT ART

Visual music[1] plays a central role in the early development of abstract painting and informs the entire history of abstract film. These histories are more than simply parallel evolutions—visual music, abstract painting and film intersect, overlap and share artists. There has been a consistent movement between these forms. As film historian William Moritz has noted, the history of abstract film is a culmination of cultural tendencies that begin with Louis–Bertrand Castel's attempt to create "visual (color) music" in the eighteenth century:

> Indeed, visual music has a history that parallels that of cinema itself. For centuries artists and philosophers theorized that there should be a visual art form as subtle, supple, and dynamic as auditory music—an abstract art form, since auditory music is basically an art of abstract sounds. As early as 1730, the Jesuit priest Father Louis–Bertrand Castel invented an Ocular Harpsichord, which linked each note on the keyboard with a corresponding flash of colored light. Many other mechanical light–projection inventions followed, but none could capture the nuanced fluidity of auditory music, since light cannot be modulated as easily as "air." The best instrument for modulating light took the form of the motion picture projector.[2]

Using visual music to construct a conceptual framework for "thinking" abstraction as a result of synaesthesia[3] suggests abstract film should have a central role in the history of twentieth century art. The history of visual music implied by Moritz is one where a desire to create a synaesthetic art motivates the invention of visual music instruments, and the eventual dominance of abstract film. As this relationship suggests, the history of visual music on film may be identical to the history of abstract film. The

invention of abstract art may be symptomatic of earlier interest in synaesthetic art forms, a relationship that is indebted to visual music. A theoretical framework for a history of abstraction focusing on the role of visual music shifts our understanding of twentieth century abstraction away from concerns with "purity."

The need to translate abstract form into motion is apparent in the interdisciplinary nature of synaesthetic abstraction in particular (and abstract art in general) in the early decades of the twentieth century: the number of artists working with one form of abstraction, only to later produce visual music and/or abstract film is striking. Even a cursory listing of artists cuts across the boundaries between avant–garde movements, different media and decades of time to reveal a consistent interplay: as early as 1910, painter–theorist Vassily Kandinski experimented with visual music, leading to his play, *Der Gelbe Klang*,[4] and his ideas about color, art and spirituality in *Concerning the Spiritual in Art*[5]; the Futurists Bruno Corra and Arnolda Ginna began as painters, abandoned painting to make abstract films, and then abandoned film to invent a color organ.[6] In Germany, developments in abstract film by Walther Ruttmann, Oskar Fischinger, Hans Richter and Viking Eggeling drew their forms and approaches from painterly abstraction. These films are the earliest surviving abstract motion pictures, dating to the early 1920s.[7] Fischinger continued making abstract films through the end of the 1940s, ultimately becoming an abstract painter. He also built a color organ called the *Lumigraph* in 1950 which he superstitiously stopped using after 1954.[8]

Danish–American Thomas Wilfred, who worked primarily as a visual musician giving *Lumia* concerts, also produced gallery versions of his *Lumia* compositions in the early 1930s that closely resemble contemporary video installations where a projector throws abstract imagery onto a screen inside the "white cube" of the gallery.[9] He also constructed *"Lumia boxes"* that presented his visual music as abstract paintings–in–motion. *Vertical Sequence, Opus 137,* was bought for the Museum of Modern Art in 1942 by Alfred Barr, Jr. Wilfred was also included in MoMA's 1952 exhibition *15 Americans,* along side Abstract Expressionists such as Jackson Pollock and Mark Rothko.[10] Wilfred is notable because he does not embrace film,[11] instead choosing to build devices whose presentation in non–theatrical settings is very much like

both film and video installations. His ideas on *Lumia* exert an influence on later artists working with visual music.[12]

The experimental filmmakers John and James Whitney worked with analog, then later digital computers from the 1940s through the '90s to create abstract films designed to correspond to musical forms,[13] and meant to suggest spiritual states of consciousness.[14] All these artists' work implies the existence and development of an alternative abstract tradition whose origins lie in visual music and synaesthesia, but whose aesthetic and formal development was primarily in technologically–produced art such as motion pictures and color organs, rather than traditional media such as painting or sculpture.

While this history could be characterized as "kinetic abstraction," as artist and founding editor of *Leonardo* magazine Frank J. Malina does,[15] the description "synaesthetic abstraction" is preferable since historically the emphasis in the form and meaning of these works is on synaesthesia and visual music, not movement. Some aspects of this history are well known and described elsewhere, most notably in the history of abstract film; however, the network of connections between abstraction, visual music, synaesthesia, and how these forms continued to develop in abstract film has not been proposed as an extant historical tradition that challenges the reductive view of Modernist abstraction.[16] Where *Modernist abstraction* proposes a continuous reduction, *synaesthetic abstraction* works towards hybridity, consistently rejecting physical materials for immaterial projected light.[17] However, to be more than an intellectual exercise in "what–if," an "alternate" history of abstraction built around visual music must provide an account of how and why it diverges from the generally recognized history of abstraction. It should also illuminate the established history in ways current understanding does not.

In the essay/manifesto "Modernist Painting," the theoretical history of how abstraction developed proposed by critic Clement Greenberg, there is no place for abstract film or visual music—he does not mention either of them—and the concerns with synaesthetic, hybrid responses and consciousness appear anachronistic at best, a vestigial Romanticism to be rejected at worst. While stating that Greenberg's account of abstract art sees it as "purifying" itself of all extraneous content derived from other arts *is* an oversimplification, it does capture an essential quality

of his argument. His "purity" comes from a Kantian withdrawal of each art into the contemplation of its own materials:

> The essence of Modernism, as I see it, lies in the use of characteristic methods of a discipline to criticize the discipline itself, not in order to subvert it but in order to entrench it more firmly in its area of competence. Kant used logic to establish the limits of logic, and while he withdrew much from its old jurisdiction, logic was left all the more secure in what there remained to it.[18]

The result of this Kantian "purity" is the movement of painting into considerations of the flat pictorial surface and the physical materiality of paint without reference either to other arts, or to illusionistic depictions of the visible world. The only content left for such work is related to the physical materiality of the art object itself. Greenberg argues that since the mid–nineteenth century art (by "art" Greenberg means mainly "painting") had been steadily divesting itself of any references beyond art, with abstraction being the final evolution of this withdrawal into a solipsistic contemplation of its materiality. This dramatic narrative reaches its climax with the American artists variously grouped as the "New York School" or as "Abstract Expressionism." This dominant conception of abstraction is primarily a painterly practice that disrupts naturalism in the name of autonomy for Art.[19] Greenberg's "pure" art does not accommodate the impurities that, by definition, synaesthesia and synaesthetic art represent and require. "Visual music" is conceptually foreign to the materialist idea of abstraction; (hybrid) motivation deriving from synaesthesia is forbidden.

Moving abstract film/video to a prominent role in the history of abstraction implicitly argues that visual music is more important to the long–term historical development of abstract art than the emphasis on reduction evident in Greenberg. By placing the foundations of abstract art in the ideas of visual music and synaesthesia, the "birth" abstract art appears at least as early as Louis–Bertrand Castel's ideas about visual music that lead to his *ocular harpsichord* in 1734, if not earlier since Castel refers to earlier sources for his ideas.

Castel's ideas are often mistakenly identified as originating with Isaac Newton's *Opticks*,[20] when in fact Castel was critical

of Newton's claims about color as historian Maarten Franssen has shown.[21] Instead it is a series of observational analogies between sound and light, first noted by sixteenth century natural philosopher Athanasius Kircher in his study of music, *Musurgia*, that informed Castel's proposal of a visual instrument that could project and modulate light in the same way musical instruments modulate notes: "they are both reflected by plane surface as, both can penetrate into denser media and are refracted in the process; and both can be concentrated in a focus by a hollow mirror."[22] It is this analogy between light and sound that leads to Castel's proposition of visual music, not Newton's arrangement of the spectrum following a comparison to the European musical octave.

Aesthetic interest and adoption of the physical phenomenon of synaesthesia—the actual commingling of two senses—as a spiritual metaphor is a logically a potential interpretation of this phenomena in the absence of a scientific account, *if* following the implications of Kircher's observed similarities, sound and light were only to be regarded as distinct phenomena due to the differentiation between the senses. Within this framework *synaesthesia* becomes a more primal approach to reality—a view promulgated by Romanticism[23]—giving the poetic and aesthetic understandings of synaesthesia a pre–scientific foundation recognizably akin to alchemy. This Romantic idealization of synaesthesia is crucial to the birth of abstraction.

Maarten Franssen has noted Castel's initial discussion of his instrument recognized the relationship between visual music and painting.[24] Although Castel lapsed into obscurity following his death, his ideas about visual music may have indirectly survived through the Romantic interest in synaesthesia, a proposal Franssen discusses at length in his extensive history of Castel's *Ocular Harpsichord*. Franssen observes about past considerations of the potential link between Castel's ideas and Romantic interests in synaesthesia that:

> The instrument has mostly been treated as the isolated
> invention of a crank. Only very rarely has it been
> recognized that, during the greater part of the
> eighteenth century following its announcement, the
> idea occupied the minds of many more people than
> just its inventor. An early and not very well know
> example is the work of the historian of literature Von

> Erhardt–Siebold, whose extensive study of the sudden
> emergence of synaesthetic imagery in early Romantic
> English poetry lead her to surmise a wide diffusion of
> Castel's ideas on color harmony. Although she had
> not read any of Castel's own writings, she stated: "I
> see the ocular harpsichord as the direct stimulus of
> the use of synaesthetic imagery in literature."[25]

While this hypothesis is difficult to prove, nevertheless the potential is very suggestive; Franssen presents several possible lines of direct influence at the beginning of the nineteenth century that include some of the first Romantic artists to use synaesthetic imagery in their work—German poets Wilhelm Heinse, Ludwig Tieck, and a variety of later composers such as Mendelssohn.[26] The possibility that Romantic interest in synaesthesia could be related to the development of later "visual music" implies the presence of an unacknowledged history whose earliest stages are not well documented or clear, but that only emerges in visual art at the start of the twentieth century. The movement from abstract imagery into visual music produced with both motion pictures and the construction of "color organ" devices can be recognized as an explicit "goal" of these interests that begin with Castel.

Even a cursory sampling of the known *color organs* demonstrates an astonishing consistency to their design, even though their individual color–sound relationships have an arbitrary character.[27] Devices produced over a two hundred year period by Louis–Bertrand Castel (1734), Johan Gotleib Krüger (1743),[28] Bainbridge Bishop (1876), A. Wallace Rimington (1895), Alexander Hector (1922), A. B. Klein (1922), and E. O. Munsell (1923)[29] all employ a keyboard where pressing a key causes a window (or light) to project a flash of color. Most of them either termed their systems "color music," or invented their own name. It is likely that many of these inventors believed their invention was unprecedented, a fact that the painter A. Wallace Rimington noted in his 1912 discussion of his own invention. [30] (Only Krüger was definitely influenced by Castel's color organ designs. [31]) Their consistency and common belief in the total novelty of their creation lends support to the idea that visual/color music is an underlying concern for European art, one that has not received wide recognition or consideration as a tradition.

If Castel's ideas are carried through the nineteenth century by Romanticism, by the end of the nineteenth century Romanticism

provides the connections between synaesthesia and the religious /
spiritual interpretations of synaesthetic perception as a "pure
view of reality"[32] that are implicit in the observational analogies
made by Kircher. The historical evolution of this alternate
conception of abstraction suggests a foundation different than
Greenberg's "historical materialism," one that influences the
reception of Abstract Expressionism. This line of development
is apparent in the ascription of spiritual meanings to Abstract
Expressionist Mark Rothko's color field paintings. Within the
materialist view of abstraction, Rothko's sublime meanings
are in conflict with the reductions of materialist abstraction.
The connection of spirituality to abstract form derives from the
synaesthetic analogy. For Rothko's paintings (or any Abstract
Expressionist work) to be sublime, they need the connection
to synaesthesia and its religious connotations, otherwise their
transcendent meanings appear as a vestigial Romantic content
within an otherwise reductive Modernist art work implicitly
rejecting Romanticism.

Kevin Dann's history of synaesthesia suggests the
transcendent claims for abstraction are a direct heritage of
the analogy between imagery and music. Dann explains that
synaesthetic abstraction evolved from an earlier Romantic
interest in synaesthesia as a merging of "subjective" and
"objective" views of the world.

What is crucial in Dann's history is the critical aspect
conveyed by this subjective::objective merging. Those cultural
groups interested in synaesthesia were also disenchanted
with the rigorous, rational world of normative scientific and
psychological theory.[33] The embrace of synaesthesia at the
end of the nineteenth century leads to abstract painting, to
visual music, and to abstract film. Both synaesthetic art and
the physiological phenomenon of synaesthesia were viewed
as escapes from the predetermined, mechanical world being
described by the empirical methods and rational procedures of
materialist science. Romanticism viewed behaviorist psychology
as reducing humans to predictable, machine–like entities, and
understood the fusion of the senses in synaesthesia as a counter
to this predictability. Synaesthesia offered a way to present an
elemental "purity" superior to the "fallen" state of discrete
sense perceptions—synaesthesia was a recovery of primal
experiences, thus a more "accurate" depiction of reality. These

beliefs imbued abstraction with the spirituality that is apparent in the interpretations of Mark Rothko's painting.

Early abstract art also had a specifically critical dimension deriving from the 'universal' claims made about abstraction. Within this critical framework, the "universal" nature of abstraction is typical of the historical avant–gardes criticism of rationality. It is comparable to Alfred Jarry's *pataphysics* that parodies scientific procedures, Marcel Duchamp's *chance operations* where the only "chance" element is human interpretation of mechanistic result,[34] and Surrealism's transformation of psychology generally.

Clearly the "purity" of synaesthesia is antithetical to the formal "purity" described by Greenberg. Synaesthesia's "purity" (and thus synaesthetic abstraction) stems from its *failure* to be separate and independent. Instead of the "purity" of Greenberg's arts irrevocably separate from each other, this is the primal "purity" alluded to by concepts such as Ricard Wagner's *gesamtkunstwerk* where all the arts fuse into a singular, total art. Greenberg's "purity" is much closer to the object of the early abstraction's critique—materialist science.

In spite of the obvious differences between Greenbergian abstraction and synaesthetic abstraction, it is Greenberg's description that has had a significant impact on contemporary understandings of abstraction's origins. Historian Jeffrey T. Schnapp has discussed the ways Greenberg's reframing of abstraction confuses later examinations of its initial meanings. The early history and meaning is obfuscated by the mid–century revisions and redefinitions of what was meant by "abstract." Schnapp explains that in the 1910s and '20s:

> "abstraction" rarely meant abstract in any pure,
> rigorously formal, non–referential, and non–
> representational visual sense, accommodating instead
> a wide array of hybrid formulations. [. . .] At once
> pictorial, poetic, and philosophical, it is embedded
> within a genre whose history can be traced back to
> romanticism, but whose moment of triumph comes at
> the end of the nineteenth century in the context of
> symbolism, decadentism and the avant–gardes: the
> interior landscape. [. . .] As initially employed in
> twentieth–century cultural debates, "abstraction"
> signifies less a distinctive pictorial practice that
> disrupts naturalism in the name of autonomy of art

than a mode of unfettered exploration of the world—
hence the referential trace embedded in the word
"landscape"—closely allied with visionary states:
meditation, dreaming, delirium, hallucination. [. . .]
So understood, "abstraction" opens up the prospect of
an art that, following in the footsteps of pure
philosophical inquiry, symphonic music and certain
expressions of spirituality, finds in geometry not only
the new vernacular of the era of industry but also the
secret language of the psyche or of the world, or of the
psyche as world; an art that is "abstract" inasmuch as
it has withdrawn from the realm of appearances in the
pursuit of something anticipating the noumenal.[35]

The historical convergence of abstraction, spirituality and a
musical analogy for visual art describes a cultural context that
includes Romanticism and Symbolism as active influences and
direct heritage. Left unstated, but implicit in his description, is the
concept of "synaesthesia." The initial meaning of "abstraction" as
a, or perhaps, *the* mode of "unfettered exploration of the world"
originates in the synaesthetic visions understood as unbiased
encounters with actuality, as Dann has shown.

William Moritz has suggested that abstract film can be
understood to be the direct inheritor of the aesthetic and formal
innovations of early synaesthetic abstraction. Thus it comes as no
surprise that the history of abstract film embraces Greenberg's
kind of "purity" relatively late—not until the mid–1970s—and
then most prominently by artists such as Takahiko iimura whose
work draws on Japanese aesthetic traditions.[36] This lateness may
be explained by the historical isolation and insularity of avant-
garde film in relation to the American art world, and the minor
position abstract film has within that marginalized tradition.
This double marginalization allowed abstract film to develop
independently of Greenbergian abstraction. The heritage of
synaesthesia can be seen in how abstract films are interpreted
and in the specific form those films have taken.[37] Abstract film
(and perhaps avant–garde film as a whole) can be understood as
further developments of ideas expressed in early abstraction—
film maker Stan Brakhage makes this heritage explicit in his
theoretical text *Metaphors on Vision* (1961):

> The hand painting was always in a direct relationship
> to the particular kind of "closed eye vision" that

comes only in dreams. The commonest type of "closed eye vision" is what we get when we close our eyes in daylight and watch the moving shapes and forms through the red pattern of the eyelid. [...] Painting was the closest approximation to it; so I painted, throwing down patterns and controlling them in various ways. Shapes emerge out of that kind of eye–nerve action and reaction.[38]

The point that Brakhage makes is that 'abnormal vision' coexists as a liminal perception within 'normal' vision.[39] With careful observation, these unseen aspects of sight become visible. The 'unfettered exploration of the world' of synaesthetic abstraction is Brakhage's self–evident focus. By adopting the visual forms of synaesthesia, abstract film presents a transcendent reality located only in irrational states of consciousness and perception. The spiritual meanings assigned to these abstract films by historian William Wees evokes the description of early abstraction proposed by Schnapp:

Similarly, one may call inner imagery "abstract,"but the perception of it can be as concrete as the perception of the outer world. In matters of visual perception, it is best to avoid making hard and fast distinctions between inner and outer, abstract and concrete—and for that matter, East and West, except in the sense that the West has been more inclined to insist on these distinctions than the East has been. By collapsing these distinctions, one can begin to understand how inner vision can be a literal and communicable "increased ability to see." In addition to the physical light of the exterior world, there is a perceived light produced by the central nervous system. Equivalences of the colors, forms, and movements of this inner light appear in many kinds of visual art. Therefore, there is no reason they could not be translated into the art of light moving in time.[40]

The hallucinatory visions that characterize synaesthesia and the spirituality ascribed to those forms combine in Wees' evocation of abstraction as presenter of "inner visions." His construction is typical of discussions of meaning connected to synaesthetic abstraction, even though he arguing for these meanings in abstract film. Both historian William Wees' interpretations of

abstract film and filmmaker–theorist Stan Brakhage's insistence on "closed–eye vision" link abstract film and earlier abstract painting at the theoretical level of praxis, and in the interpretation of resulting abstract work. Their religious and "spiritual" claims about reaching "higher planes," evident in the interpretation of abstract film, originate with the abstract art initially derived from synaesthesia.[41] Abstraction and visual music present this "spiritual" reality through the visual forms of abstraction.[42] Spiritual meanings connected to abstract form emerge from the relationship between abstraction and the Romantic conception of synaesthesia.[43] This relationship implies more than just similar goals, it demonstrates the continued existence of synaesthetic abstraction beginning with early twentieth century abstraction and continuing through the history of abstract film/video into the present; it constitutes a vigorous, thoroughly established tradition in abstract film.

The lost, primal state of innocence and purity proposed by synaesthetic abstraction also projects an inevitable *Spenglerian* view of a degenerate present and future, as Dann observes about Adrien Bernard Klein's comments on color music:

> A. B. Klein, a painter whose early work aimed at abstraction and who had designed a color projector in 1921, was in 1925 still rhapsodic about the possibilities of color music: "Can one image anything in the arts which would surpass the visible rendering of sound, which would enable the eyes to partake of all the pleasures which music gives to the ears?" Noting Western civilization's disillusionment about its own future, Klein ranked the dream of a color music with religious and political utopias: "For the singularly few who enjoy loveliness, it might snatch one or two more gems from the chaos before the end."[44]

The dualism of Dann's observations about Klein are typical of the utopian proposition of synaesthetic abstraction. The Spenglerian vision of inevitable cultural decay and collapse mirrors the "fall" evident in the differentiation of primal sensation into sight, hearing, touch, taste, smell, etc. Synaesthetic abstraction, as Klein suggests, appears heroic in this framework as a means to slow the decline: this is the meaning of the spiritualism contained by early abstraction, and implicated

in the meaning of abstract film. It is the Romantic rejection of rationality, materialist science, and behaviorist psychology that Dann identifies with those groups attracted to synaesthesia and is the clearest difference between this tradition and the materialist formalism proposed by Greenberg.

o

In drawing together the network of relationships between abstraction, synaesthesia, and visual music already noted in a variety of historical studies, this paper has tried to show more than just a set of congruencies; it has suggested this network is, in fact, a tradition that has continued unacknowledged through the twentieth century and into the twenty–first. The theory of abstract art this tradition suggests is grounded in the specific context that produced synaesthetic abstraction in the 1910s and that informs the history of visual music. Within this history, the divergence is in the theoretical understanding of abstraction proposed by art criticism; the separation of abstract film from the understanding of abstraction in the art world follows logically from the critical and theoretical gulf that separated the two at mid–century. Abstract film proceeded independently of abstract painting even though in the 1920s the two were intimately linked.

The temporal element is essential to synaesthesia,[45] and makes the movement between static painting, visual music and abstract motion pictures not only logical but also inevitable. Clearly the appearance of abstraction may have been less a matter of historical necessity than a potential implicit in the ideas of synaesthesia and visual music from the beginning. Placing the "birth" of abstraction in a pre–Modernist period is therefore warranted; this paper has suggested a development whose origins lie at least as early as the seventeenth and eighteenth centuries.

The potential continuity of visual music, synaesthesia, and abstract art proposes a different understanding of the development and meaning of abstraction in the twentieth century. By changing the emphasis in abstraction away from Greenbergian "purity" and materialist reduction towards the hybrid forms of synaesthetic art and visual music, it is possible to recognize a distinct historical development and continuity between contemporary abstract film / video and Castel's proposal

of the *ocular harpsichord* based on Kircher's observations about sound and light. In doing so, this theoretical development of abstraction illuminates the spiritual meanings assigned to abstract art, and shows the anti–rational aspects of abstraction are not accidental, but are actually the influence of this synaesthetic tradition originating in Romanticism.

Early abstract art was deeply connected to synaesthesia and visual music. This connection consistently recurs in discussions of abstract film because the ideas that motivate the invention of visual music instruments also animate the abstract film. Where Modernist abstraction theorized by Greenberg would imply synaesthetic abstraction is anachronistic, the historical origins for abstraction outlined in this paper suggest otherwise. The approach this history suggests invites a reinterpretation of mid–century abstraction via the synaesthetic tradition as a way of understanding the transcendental and sublime aspects of Abstract Expressionism that cannot be approached coherently by a reductive materialist theory.

Thus, synaesthetic abstraction can be understood as an alternate, continuing tradition for abstraction. New media art by artists such as Leo Villareal, who constructs computer–controlled environments and sculptures of color and sound, or Golan Levin, whose audio–visual works employ computers to produce synaesthetic works based on interaction driven by computers belong to a synaesthetic approach to abstraction. The ability to contextualize both historical art and current developments within a longer chronology is the most useful aspect of such a conceptual framework for thinking about the development of abstraction.

REFERENCES

1 "Visual Music" will be used throughout this paper to refer to a pair of tendencies that are closely linked, but whose clear distinction can be confusing: "visual music" that involves the projection of imagery, and "color music" that is the projection of pure colored light without particular form. This definition is the one used by Hallock–Greenewalt and Rimington. The lack of form is significant for both artists, and is the specific defining feature of their work. While "visual music" can subsume "color music," the reverse is not the case; thus the choice of terminology.

2 Moritz, W. "Visual Music and Film–as–an–Art Before 1950" *On the Edge of America: California Modernist Art, 1900–1950*, Paul J. Karlstrom, ed. (Berkeley: University of California Press, 1996), p. 224.

3 There is an ambiguity of usage to the term "synaesthesia" considerations of the arts: one use specifically describes the neurological phenomenon of cross–modal sensation, as experienced by synaesthetes; the other describes, typically audio–visual, art works inspired by the idea of cross–modal functioning, rather than the actual functioning itself. Synaesthesia in the arts often employs the term to mean both, even though this usage may be inappropriate from a neuro–physiological understanding of the term. The use in this paper follows the observations of Bulat Galeyev, "Open Letter on Synaesthesia" *Leonardo*, vol. 34, no. 4, 2001, pp. 362–363.

4 Originally published in *Der Blaue Reiter*, 1912. Held in The Thomas de Hartman Papers, Irving S. Gilmore Music Library, Yale University, Series II. A. 1, folders 22/192, 22/193, 22/195.

5 Kandinski, V. *Concerning the Spiritual in Art* (New York: Dover, 1977).

6 Corra, B. "Abstract Cinema——Chromatic Music" *Futurist Manifestos* ed. Umbro Apollonio, trans. Robert Brain (Boston: MFA Publications, 1970) pp. 66–69.

7 Le Grice, M. *Abstract Film and Beyond*, (Cambridge: MIT Press, 1981) pp. 19–31.

8 Moritz, W. *Optical Poetry: The Life and Work of Oskar Fischinger*, (Bloomington: Indiana University Press, 2004).

9 Eskilson, S. "Thomas Wilfred and Intermedia: Seeking a Framework for *Lumia*" *Leonardo*, Vol. 36, No. 1, 2003, pp. 65–68.

10 Peacock, K. "Instruments to Perform Color–Music: Two Centuries of Technological Experimentation" *Leonardo*, Vol. 21, No. 4, pp. 404–405.

11 Wilfred, T. "Correspondence with Edwin M. Blake" *Thomas Wilfred's Clavilux* ed. Michael Betancourt, (Washington: Borgo Press, 2006) pp. 23–38.

12 Collopy, F. "Color, Form and Motion; Dimensions of a Musical art of Light" *Leonardo*, Vol. 33, No. 5, 2000 pp. 355–360.

13 Goodman, C. *Digital Visions: Computers and Art*, (New York: Abrams, 1987) pp. 156–158.

14 Wees, W. *Light Moving in Time: Studies in the Visual Aesthetics of Avant–Garde Film*, (Berkeley: University of California Press, 1992) pp. 137–146.

15 Malina, F. *Kinetic Art*, (New York: Dover, 1974).

16 The exhibition *Aux origines de l'abstraction: 1800–1914* at the Musée d'Orsay, Paris suggested a earlier historical origin for abstraction, and recognized a similar range of connections as this paper.

17 This tendency is apparent at the theoretical level in the work several of the artists proposing various forms of visual music, including the pianist Mary Hallock–Greenewalt, *Nourathar: The Art of Light–Color Playing*, (Philadelphia: Westbrook Publishing Co., 1946) and painter Willard Huntington Wright, *The Future of Painting*, (New York: B. W. Huebsch, Inc., 1923) pp. 47–50.

18 Greenberg, C. "Modernist Painting" *The Collected Essays and Criticism: Vol. 4*, (Chicago: University of Chicago Press, 1955) p. 85.

19 Greenberg, C. "After Abstract Expressionism" *The Collected Essays and Criticism: Vol. 4*, (Chicago: University of Chicago Press, 1955) p. 131.

20 This confusion may result from a pamphlet published in English in 1757 in England by an unidentified associate of Castel's who adopted Newton's color–sound associations in place of Castel's arrangement, as noted by Franssen, *Op. cit.*, p. 37; the pamphlet is located in the British Library, shelf nr. 1041. h. 4. (1.).

21 Franssen, M. "The Ocular Harpsichord of Louis–Bertrand Castel: The science and aesthetics of an eighteenth–century *cause celebre*" *Tractrix: Yearbook for the History of Science, Medicine, Technology and Mathematics 3*, 1991, p. 28.

22 Franssen, M. "The Ocular Harpsichord of Louis–Bertrand Castel: The science and aesthetics of an eighteenth–century *cause celebre*" *Tractrix: Yearbook for the History of Science, Medicine, Technology and Mathematics 3*, 1991, pp. 17–21; 39.

23 Dann, K. *Bright Colors Falsely Seen* (New Haven: Yale, 1998) pp. 94–95.

24 Franssen, M. "The Ocular Harpsichord of Louis–Bertrand Castel: The science and aesthetics of an eighteenth–century *cause celebre*" *Tractrix: Yearbook for the History of Science, Medicine, Technology and Mathematics 3*, 1991, pp. 21–22.

25 Franssen, M. "The Ocular Harpsichord of Louis–Bertrand Castel: The science and aesthetics of an eighteenth–century *cause celebre*" *Tractrix: Yearbook for the History of Science, Medicine, Technology and Mathematics 3*, 1991, pp. 15–16.

26 Franssen, M. "The Ocular Harpsichord of Louis–Bertrand Castel: The science and aesthetics of an eighteenth–century *cause celebre*" *Tractrix: Yearbook for the History of Science, Medicine, Technology and Mathematics 3*, 1991, p. 52–67.

27 Von Helmholtz, Hermann. *Treatise on Physiological Optics, Volume 2: The Sensations of Vision*, ed. James P. C. Southall (Optical Society of America: 1942; Electronic Edition: The University of Pennsylvania, 2001) pp. 114–118."At any rate, it is clear that in the so–called color–harmony no such absolutely definite relations are to be expected as are characteristic of music intervals." (p. 118).

28 Franssen, M. "The Ocular Harpsichord of Louis–Bertrand Castel: The science and aesthetics of an eighteenth–century *cause celebre*" *Tractrix: Yearbook for the History of Science, Medicine, Technology and Mathematics 3*, 1991, p. 34.

29 Betancourt, Michael. *Visual Music Instrument Patents Vol. 1*, (Holicong: Borgo Press, 2004).

30 Rimington, A. A. *Wallace Rimington's Colour–Music*, (Holicong: Wildside Press, 2004) pp. 57–58.

31 Franssen, M. "The Ocular Harpsichord of Louis–Bertrand Castel: The science and aesthetics of an eighteenth–century *cause celebre*" *Tractrix: Yearbook for the History of Science, Medicine, Technology and Mathematics 3*, 1991, pp. 33–39.

32 Dann, K. *Bright Colors Falsely Seen* (New Haven: Yale, 1998) pp. 94–95.

33 Dann, K. *Bright Colors Falsely Seen* (New Haven: Yale, 1998) pp. 94–95.

34 Betancourt, M. "Chance Operations / Limiting Frameworks: Sensitive Dependence on Initial Conditions" *Tout–Fait* Vol. 2, No. 4, 2002.

35 Schnapp, J. "Bad Dada (Evola)" *The Dada Seminars*, ed. Leah Dickerman with Matthew S. Witkowski (Washington DC: National Gallery of Art/ DAP: 2005) pp. 50–51.

36 Möller, O. "Eiga No Kojiki: Fat Man Rising (Notes on iimura Takahiko and Ono Yoko)" *Retrospective of Japanese Short Film 1955–1991/International Kurtzfilmtage Oberhausen 1994*, translated from the German by Sabine Niewalda (Oberhausen: Germany, 1994) pp. 70–80. While it is true that the "Structural Film" is reductive to a degree, films by artists such as Tony Conrad on Paul Sharits in the US, or Malcolm LeGrice and Peter Gidal in the UK still worked with images and produced spatial illusionistic effects through their use of flicker effects, while iimura's films of the mid–1970s were focused on the duration of the theatrical experience.

37 Wees, W. *Light Moving in Time: Studies in the Visual Aesthetics of Avant–Garde Film*, (Berkeley: University of California Press, 1992) pp. 124–152.

38 Sitney, P. "Introduction" *Metaphors on Vision*, by Stan Brakhage (New York; Film Culture, 1963) np.

39 This is an observation that Heinrich Klüver's psychological studies of hallucinatory states supports.

40 Wees, W. *Light Moving in Time: Studies in the Visual Aesthetics of Avant–Garde Film*, (Berkeley: University of California Press, 1992) p. 130.

41 Dann, K. *Bright Colors Falsely Seen* (New Haven: Yale, 1998) pp. 94–119.

42 Moritz, W. "Jordan Belson: Last of the Great Masters" *Animation Journal*, vol. 7, no. 2, pp. 4–16.

43 Some of these spiritual claims were codified in religious terms by theosophists Annie Besant and C. W. Leadbeater in *Thought–Forms*, (Wheaton: Quest, 1925).

44 Dann, K. *Bright Colors Falsely Seen* (New Haven: Yale, 1998) p. 91.

45 Klüver, H. *Mescal and Mechanisms of Hallucination* (Chicago: University of Chicago Press, 1966),p. 43.

Perform. Media Symposium **paper**

September 30, 2006
9:00–10:30 AM
Performing the Audio–Visual
Radio–TV Building, Studio 5

FROM COLOR MUSIC
TO VISUAL MUSIC
AN HISTORICAL EXAMINATION OF ORIGINS AND DEVELOPMENT

By arguing for a narrow definition of "color music" based on the creation of chromatic scales that directly link specific colors to specific notes, where the particular color–tone relationships are justified by the artist claiming the connection is an absolute, empirical relationship reflecting facts about the nature of light and sound, rather than an arbitrary aesthetic decision, it is possible to distinguish color music from both visual music and from other discussions of color and sound relationships.[1] The color music systems described by this definition would then be examples of what was considered a scientific truth about physical reality—their inventors believed they were demonstrating valid scientific principles about the nature of light and sound both resulting from vibrations in "aether": **the harmonic ratios of the diatonic scale applied to the color spectrum (light) creates** *color music*.[2] Thus, "color organs" (a.k.a. "color music") belong to a class of devices and instruments initially invented to be scientific tools or demonstrations, a group that includes the telescope, photography, motion pictures, and the pianoforte.[3]

Color music's interpretation of observational similarities between light and sound has consistently been considered a demonstration of an underlying "harmonic" order[4] that is ultimately theological in origin.[5] The use of observational similarities between sound and light is a common feature of artists who claim an absolute relationship between color and sound. Louis–Bertrand Castel, A. Wallace Rimington, and Adrian Bernard Klein all believed their color music *proved* pseudo-scientific beliefs about an underlying similarity between light and sound. This "harmonic order" has its origins with Aristotelian philosophy and theories of color that were codified into Christian dogma during the mediaeval period.[6] By this definition, we can

recognize that "color music" was meant to serve both a scientific purpose and an aesthetic one.

The "scientific" claims made about color in defense of this harmonic order have had a lasting influence on how we understand color–sound relationships in an "intuitive" way. Extending this scientism backwards in time, it is possible to understand why writers such as William Moritz would argue that "Ancient Greek philosophers, like Aristotle and Pythagoras, speculated that there must be a correlation between the musical scale and the rainbow spectrum of hues. That idea fascinated several Renaissance artists including Leonardo da Vinci (who produced elaborate spectacles for court festivals), Athanasius Kircher (the popularizer of the *Lanterna Magica* projection apparatus) and Arcimboldo who (in addition to his eerie optical–illusion portraits composed of hundreds of small symbolic objects) produced entertainments for the Holy Roman Emperors in Prague."[7]

However, even a cursory familiarity with the range of artists mentioned here would suggest Moritz's backwards–extension may not be appropriate. His implicit definition of "color music" cannot distinguish metaphor from correspondence; similarity from actuality. (It is like a definition of "lightning" that cannot distinguish the electrical discharge from the "lightning bug.") Unlike Moritz's broad–ranging proposal, by focusing on a narrowly–defined conception, "color music" is demonstrated by the existence of specific, absolute chromatic scales, regardless of whether any instruments were built. Such a definition enables us to trace a lineage of ideas about "color music" to the early modern period. It allows us to recognize the basic difference between "color music" and other considerations of color and music such as comments on this subject made by Aristotle or by Athanasius Kircher: "color music" originates with an empirical claim about demonstrating the nature of reality; "visual music" does not.

o

Aristotle's comments on color and music may be misleading. He proposed what would become the "modification theory of color" in his book *Parva Naturalia,* in the chapter called *De Sensu.* In it, Aristotle discusses the five senses, in particular sight, then explains the nature of color in *Part Three.*

His ideas were elevated in importance during the middle ages to the point that challenges to his claims were problematic for later thinkers. [8] "Mediaeval scholars explained the apparent colors of the rainbow and the prism by elaborating upon Aristotle's explanation of the rainbow, according to which color arises from a weakening or darkening of visual or light rays; that is, it is some modification of pure, uniform sunlight. In these theories, colors do not exist independently prior to some modification."[9] This elevation is the reason Aristotle's color theory is essential to understanding both why color music does not appear in earlier systems of thought, and why his modification theory is crucial to the later invention of the absolute chromatic scale proposed by Louis–Bertrand Castel's *color music.*

Aristotle's color theory focuses on luminosity (luster)—a white:black opposition—rather than hue. His spectrum is arranged according to brightness: **white—yellow—red—violet—green—blue—black**,[10] where white and black are the primary colors and all the other intervening ones are derived from their combination:

> It is conceivable that the White and the Black should be juxtaposed in quantities so minute that [a particle of] either separately would be invisible, though the joint product [of two particles, a black and a white] would be visible; and that they should thus have the other colors for resultants. Their product could, at all events, appear neither white nor black; and, as it must have some color, and can have neither of these, this color must be of a mixed character– in fact, a species of color different from either. Such, then, is a possible way of conceiving the existence of a plurality of colors besides the White and Black; and we may suppose that [of this 'plurality'] many are the result of a [numerical] ratio; for the blacks and whites may be juxtaposed in the ratio of 3 to 2 or of 3 to 4, or in ratios expressible by other numbers; [. . .] Or it may be that, while all colors whatever [except black and white] are based on numbers, some are regular in this respect, others irregular; and that the latter [though now supposed to be all based on numbers], whenever they are not pure, owe this character to a corresponding impurity in [the arrangement of] their numerical ratios.[11]

These ratios describe how the mixture of white and black create color. It is the harmonic character of this combination that produces hue, and even though it mirrors the ratios of music, is not the same as a musical division. The ratios themselves are what is significant, not that they are used to create music or color; their repetition in/as color and music is simply a manifestation of an underlying, universal harmonic principle. His explanation of color is part of a much larger system of order where relative value and importance depends on mathematical regularity expressed in/as these ratios. Their simultaneous appearance in color and music is something other than a "color music."

In addition, as classicist Maurice Platnauer's discussion of color in classical Greek has shown, what was of interest about color to Aristotle and other Greeks was *not* hue. By examining their use of color descriptors, Platnauer has shown they were focused on the surface effects of light. The color terminology of classical Greek suggests an *achromatic* understanding of color based on the relative luminosity and visual characteristics such as shininess or dullness. Aristotle's modification theory of color is implicit in Platnauer's discussion:

> That what seems to have caught the eye and arrested
> the attention of the Greeks is not so much the
> qualitative as the quantitative difference between
> colors. Black and white are 'colors,' and colors are
> accounted as shades between these extremes. It
> follows from this that no real distinction is made
> between chromatic and achromatic; for it is luster and
> superficial effect that struck the Greeks and not what
> we would call color or tint.[12]

Platnauer suggests that Aristotle's understanding of color is typical of his culture and time. Within such a linguistic context, his construction of color along a luminosity scale becomes intelligible and logical. This conceptual framework lacks the foundations for color music for two reasons: (*a*) as expression of a principle of universal harmony, what mediaeval scholars would adapt as the *"harmonia mundi,"* and (*b*) via their conception of color—the *"modification theory."* Color music is unlikely to arise in either of these frameworks. The classical understanding of musical ratios themselves also argue against the establishment of the chromatic scale essential for color music.

The Aristotelian paradigm of light and color remained largely unquestioned for centuries because mediaeval artists did not mix pigments. They tended to use pure hues, and when color mixing occurred, it was through glazes and washes or pointillist stippling techniques.[13] Historian Alan Shapiro has noted that painting did not commonly engage in mixing pigments until oil paint was invented; the painter's palette was only introduced at around 1400.[14] The modification theory of color was challenged only when, (starting in the early Renaissance), the use of mixed pigments in oil painting lead many painters (and natural philosophers) to question modification theory of color's foundations. These challenges culminate in the establishment of the subtractive primaries **red—yellow—blue** as the foundation of painterly color mixing in the early 1600s.[15]

The earliest known "color music" was proposed sometime before 1590 by Mannerist painter Guiseppe Arcimboldo, who followed the dictates of modification theory of color in proposing a series of absolute color–tone relationships.[16] Given his interest in transforming rhetorical and metaphoric language into imagery, his creation of color music is logical. Arcimboldo's color music is only documented by Gregorio Comanini's discussion in *Il Figino, overo del fine della pittura* (1590)—no examples of it or other records are known to survive.

Arcimboldo produced two linked systems: a scale of light–to–dark related to musical notes, a luminosity scale, and a second, chromatic scale where notes were linked to colors. Crucial to the recognition of Arcimboldo's work as color music is the difference between hue and luminosity that Comanini notes in the translation of Arcimboldo's luminosity scale into a chromatic one. His color scale is derived from the luminosity scale and not only changes hue, it grows darker as it becomes higher in pitch: **yellow—green—blue—gray—brown.** Art historian Austin Caswell reconstructed his system[17] and suggested that as Arcimboldo's color music is divided into specific voices,[18] it reflects the form of sixteenth century musical composition and performance. However, the full details of performing with Arcimboldo's chromatic scale and the precise structure of the color music that would result remain unknown.

Approximately sixty years after Arcimboldo's invention, Jesuit Athanasius Kircher's book on music, *Musurgia Universalis* (1650), includes a lengthy section detailing sound, color and their

relative places within a system of celestial harmony—what he calls the *harmonia mundi*. His conception of universal order is derived from Aristotelian theories evident in musical rations and the modification theory of color. *Musurgia Universalis* extends the musical analogy as a demonstration of the harmonic organization of the universe. His comments introducing the section of *Volume Two* titled *"Sound and Light are Similar"* seem to claim a direct linkage between color and music:

> This premise, for sound to be similar to light, sound must be like light in all ways, it must spread out because it has the same source. [. . .] Just as the light from a fire spreads different colored bodies in different directions around itself, so is sound spread through the air by moving bodies that carry its qualities. [. . .] When a musical instrument sounds, if someone were to perceive the finest movements of the air, they would see nothing but a painting with an extraordinary variety of colors.[19]

Kircher's explanation is literary; his starting premise that sound and light travel through the air in a similar fashion, clearly frames his later description of viewing sound as if it were painting, in a metaphor illustrating the idea that sound and light have a similar nature. His statement that "it must spread out because it has the same source" is not to be taken literally in a physical sense—the "source" is not a physical cause, but a metaphysical one: *God,* as revealed through the *harmonia mundi* Kircher describes.

Thus, even though Kircher presents a systematic relationship between color and musical intervals, his system does not propose a color music; Kircher's systematic connection is derived from Aristotle and is not limited to color—it includes precious and common types of stone, the known planets, all the various animals and plants, the various orders of angels, and God—to construct an entire hierarchy of the world visible in physical things that parallels the heavenly order.[20] The conceptual paradigm implicit in Kircher's discussion of music and sound is one where "experiment" is an afterthought, meant as a demonstration of explained theory.[21] This understanding of "physical demonstration" will reappear in/from the debate over light and color as "color music."

o

Isaac Newton assigned specific notes to colors using the Dorian scale in his initial discussion of the prismatic spectrum in 1695, a relationship he maintains in the longer study *Opticks* published in 1704. While his discussion suggests the possibility of color music, nevertheless, his chromatic scale is a vestigial remainder stripped of its metaphysical referents and is not meant as a system for performance.[22] Newton's separation of the color and tone linkage from Kircher's *harmonia mundi* may be the conceptual shift needed to make color music possible.

Newton's work on color initiated a larger debate over the nature of light. His experiments with a prism and his interpretation of the spectrum as the true nature of light, where white light is composed from the mixture of the individual colors visible in the spectrum resulted in a debate over the nature of light lasting 200 years. His divergence from modification theory of color and Aristotelian theories of color depends on his interpretation of the nature of the spectrum; what is at stake in the debate is the underlying physical nature of light itself—whether the theologically–supported Aristotelian theory is correct or not. It is a debate over the relationship between science and religion; the idea of color music was introduced as part of this argument. It was meant to be a refutation of Newton's experiments.

When the Jesuit Louis–Bertrand Castel proposed his *ocular harpsichord* and "color music," he identified the source for the idea as Kircher's discussion of sound and light.[23] Castel's arguments are in support of a *vibratory* theory of light, one where light (like sound) is a vibration in the "aether," Aristotle's fifth element. Historian Maarten Franssen has observed that while Castel may find the suggestion of color music in Kircher, the model for this invention lies elsewhere—in Newton's chromatic scale. "Apart from Kircher, Castel mentioned a second authority for his cherished analogy [between sound and light] in the *Opticks* of Newton, the French translation of which he had recently reviewed for the *Mémoirs de Trévoux*."[24] Franssen's connection of Newton and Kircher reveals a reification of Aristotelian theory as *literalized* metaphor: the analogy of sound and light (and by extension, the modification theory of color) becomes a direct linkage of musical ratios to the visible spectrum, resulting in the idea of performing pure colored light in the same way as

music: *color music.* Given the rejection of the theistic paradigm that Newton's work presents, and Castel's familiarity with it, it is possible to say that a misreading of Kircher's discussion is responsible for Castel's invention of color music.

The argument over light began in earnest with the break between the empirical paradigm of Newton, and the older theistic paradigm when, in the 1730s, the Jesuit order rejected Newton and the new empirically scientific approach because it rejected Aristotelian doctrine.[25] Castel's ideas parallel his order's rejection of Newton's views of color and light. The Jesuits' opposition to Newton was part of a reversion to Aristotle, and the theological paradigm apparent in Kircher's *harmonia mundi.* Castel's proposal of color music in the 1730s was part of an attempt to disprove the Newtonian view of light as composed from discrete colors, and support the Aristotelian modification theory of color. This debate shows that Newton's connection of color to sound was a vestigial remnant, fundamentally incompatible with the rest of Newtonian theory; Castel's critique of Newtonian color is at the same time a justification of his own color music.[26]

For his ocular harpsichord to be of *scientific* value, Castel's chromatic scale must be an accurate depiction of the *empirical* relations between light and sound; the linkage of notes to colors cannot be arbitrary. The desire to make his instrument be a demonstration of scientific principle repeats the scientific origins for the *pianoforte* proposed[27] by Eleanor Selfridge–Field: the instrument realizes Newtonian laws of motion—action and reaction; Castel's *Ocular Harpsichord* "demonstrates" an abstract principle of universal harmony—Kircher's *harmonia mundi*—found in Church dogma.

Castel's system established the parameters that later color music inventions would (unconsciously) repeat: the synchronization between specific notes and particular colors; that color music could be performed with or without audible accompaniment; and that it represented an absolute system of correspondence between sound and color where the colors "illustrate" particular notes revealing the underlying harmonic nature of the world: color and music as equivalent phenomena.

Thus, any instrument, whatever its technical design, that retains an *absolute* chromatic scale is *color music.* It implicitly recreates Castel's "demonstration" of the *harmonia mundi.* This is the case with A. Wallace Rimington's invention, the

Colour–Organ. It has a similar construction to Castel's ocular harpsichord: a network of lighted windows present flashes of color synchronized to the controls of a traditional organ keyboard; his *Colour–Organ* closely resembles a traditional pipe organ. Rimington's *Colour–Music* explicitly used the same theory that was Castel's justification—that both sound and light are different types of vibrations—linking his absolute correspondence between sound and color to the same debate over light.[28] The lack of projected shapes and forms in his *Colour–Music* is a logical consequence of this foundation. The idea of light as vibration is the influence of a vestigial Aristotelian theory, just as the color–tone correspondence was in Newton's *Opticks.*

However, the debate over light as a vibratory phenomenon continued in the nineteenth century, and was ultimately rejected by Albert Einstein who demonstrated that "aether" did not exist, thereby ending debate in the Newtonian approaches' favor. The idea of an absolute chromatic scale was also in question, and was specifically rejected by psychologist Hermann von Helmholtz who studied the question of color–tone correspondence, and argued that any relationship between colors and sounds is entirely arbitrary.[29] The scientific and empirical bases and justification for color music had been completely rejected by the early years of the twentieth century.

Nevertheless, Helmholtz' critique is different from earlier objections to color music. The earlier critiques, such as those of Goethe, were based in a conception of a universal harmonic principle in which both color and sound were examples—thus they were a rejection of the color music as an empirical demonstration and art. Ironically, Goethe's rejection was made in support of the theistic system that color music was supposed to demonstrate empirically. Unlike these earlier critiques, Helmholtz does not reject color music, only the suggestion of a possible absolute, universally invariant relationship between specific tones and particular hues: in a reversal of previous critiques, Helmholtz only attacks color music's status as a *scientific demonstration,* not its basis as an art.

While Rimington's "*Colour–Music*" is remarkably similar in execution and scientific claims to Castel's, his aesthetic claims suggest a foundation for the art in synaesthesia.[30] Rimington employs the Romantic ideal of a synaesthetic art where sound and image are linked as a different foundation for the art of color–sound

relationship found in his *Colour–Music*.[31] However, his aesthetic justification retained the idea of absolute synchronization as a central, defining characteristic dependent on its "scientific" foundation in the vibratory theory of light. Rimington's adoption of synaesthesia–as–justification is symptomatic of the shift from formless color play to the use of colored forms in motion. His invention is transitional from earlier *color* music to the later form of *visual* music: Rimington's work was later criticized for its lack of form by another visual music inventor, Thomas Wilfred.[32]

However, unlike the Aristotelian vibratory theory of light, where the lack of form was justified and logically required, the linkage of color and sound in synaesthesia is never formless. Yet, the synaesthetic color–sound linkage is *entirely* arbitrary, reflecting Helmholtz' findings. By seeking to justify color music in synaesthesia, the shift to visual music was inevitable—just as the reliance on the vibratory theory of light and modification theory of color determined the formless character of color music, the use of synaesthesia to justify it introduces an implicit requirement for form and an arbitrariness of relations between color, form and sound resulting in the shift from color music to visual music—the *empirical* claim disappears and "visual music" begins.

o

In considering this strict definition for *color music* we can recognize that it is an indicator of the beginning for a paradigm shift apparent in the seventeenth century debates over the nature of light and color. Its role in these inquiries only becomes apparent by acknowledging the connections between color music systems and universal harmonic systems through a rigorous definition of color music as based on the creation of chromatic scales that directly link specific colors to specific notes, where the artist justifies their particular arrangement of the spectrum–scale by claiming that the connection is empirical rather than an arbitrary aesthetic decision: *color music* was meant to "scientifically"demonstrate the validity of Kircher's *harmonia mundi* and by extension, all of Aristotelian theory and Church dogma.

This definition clearly separates *color music* from the role of sound and color in Greek philosophy, such as Aristotle's

discussions, or in religious theory, such as Kircher's, where both color and sound result from a common cause, the *harmonia mundi*. Recognizing this difference enables a consideration of the historical origins of color music and its subsequent development out of the modification theory of color. Such a separation is more than a rhetorical division. It illuminates the relationship between ancient and mediaeval thought, early modern understandings of color, and the debate about the physical nature of light that Newton's *Opticks* produced. The fundamental differences between color music and visual music are implicit in this discussion. Color music emerges from this historical context as an illustration of how mysticism and science can combine in art. Color music's relationship to synaesthesia (and the shifts this change produces) was therefore inevitable, since it demonstrates the late nineteenth century artistic criticism of empirical psychology and science, repeating the earlier criticisms of Goethe and the Jesuits of those same approaches.

The change from color music into visual music emerges from the implicit redefinition/transformation of color music via synaesthesia. Visual music, by contrast with color music, does not claim an empirical dimension to its color–sound relationships and typically gives form to the play of color. The transformation this shift implies is logical given its historical origins and the relationship between color music and the debates surrounding Newton's *Opticks*. In considering the historical foundations of this definition, it is possible to distinguish color music from both visual music and other discussions of color and sound relationships. The connection of color music to claims about the nature of light and sound reveals that color music has its origins with Aristotelian philosophy and theories of color that were codified into Christian dogma during the mediaeval period and was meant to be a "proof" of the validity of this theistic paradigm. This concept's persistence as *visual music* is a testament to its aesthetic nature, divorced from its origins with religious dogma.

REFERENCES

1 Aristotle, quoted by Charles Eastlake in his translation of Goethe's *Theory of Color* (New Haven: MIT Press, 1970), p. 418 is an example of parallelism: "It is possible that colors may stand in relation to each other in the same manner as concords in music, for the colors which are (to each other) in proportions corresponding with the music concords, are those which appear to be most agreeable." However, he is ambiguous about these ratios—these proportions could mean actual surface areas of color as easily as something else. This statement could be metaphoric.

2 Hankins, T. "The Ocular Harpsichord of Louis–Bertrand Castel; or, The Instrument That Wasn't" *Osiris*, No. 9, 1994, pp. 141–151.

3 Selfridge–Field, E. "The invention of the pianoforte as intellectual history," *Early music*, Vol. XXXIII, No. 1, (February 2005) pp. 81–94.

4 Lippman, E. "Hellenic Conceptions of Harmony" *Journal of the American Musicological Society*, Vol. 16, No. 1 (Spring 1963) p. 3.

5 Bush, D. "Calculus Racked Him," *Studies in English Literature, 1500–1900*, Vol. 6, No. 1, (Winter 1966), pp. 1–6.

6 Bush, D. "Calculus Racked Him," *Studies in English Literature, 1500–1900*, Vol. 6, No. 1, (Winter 1966), pp. 1–6.

7 Moritz, W. "The Dream of Color Music, and the Machines that Made it Possible" *Animation World Magazine*, Issue 2. 1, April 1997, www.awn.com/mag/issue2. 1/articles/moritz2. 1.html.

8 Bush, D. "Calculus Racked Him," *Studies in English Literature, 1500–1900*, Vol. 6, No. 1, (Winter 1966), pp. 1–6.

9 Shapiro, A. "Artist's Colors and Newton's Colors" *Isis*, Vol. 85, No. 4, (December 1994) p. 610.

10 Shapiro, A. "Artist's Colors and Newton's Colors" *Isis*, Vol. 85, No. 4, (December 1994) p. 603.

11 Aristotle. "On Sense and the Sensible" translated by J. I. Beare, The Internet Classics Archive, classics. mit. edu/Aristotle/sense. mb. txt.

12 Platnauer, M. "Greek Colour–Perception" *The Classical Quarterly*, Vol. 15, No. ¾ (July–October, 1921) p. 162.

13 Shapiro, A. "Artist's Colors and Newton's Colors" *Isis*, Vol. 85, No. 4, (December 1994) p. 604.

14 Gage, J. "Colour in History: Relative and Absolute" *Art History*, Vol. 1, No. 1, p. 119.

15 Shapiro, A. "Artist's Colors and Newton's Colors" *Isis*, Vol. 85, No. 4, (December 1994) p. 606.

16 Caswell, A. "The Pythagoreanism of Arcimboldo" *The Journal of Aesthetics and Art Criticism*, Vol. 39, No. 2 (Winter 1980) pp. 155–161.

17 Caswell, A. "The Pythagoreanism of Arcimboldo" *The Journal of Aesthetics and Art Criticism*, Vol. 39, No. 2 (Winter 1980) pp. 157–159.

18 Caswell, A. "The Pythagoreanism of Arcimboldo" *The Journal of Aesthetics and Art Criticism*, Vol. 39, No. 2 (Winter 1980) p. 159.

19 Kircher, A. "Liber III, Caput XIII, SII: De Genere Chromatico" *Musurgia Universalis*, facsimile edition, (New York: George Olms Verlag, 1970) p. 240.

20 Kircher, A. "Liber III, Caput XIII, SII: De Genere Chromatico" *Musurgia Universalis*, facsimile edition, (New York: George Olms Verlag, 1970) pp. 141–150.

21 Findlen, P. "Jokes of Nature and Jokes of Knowledge: The Playfulness of Scientific Discourse in Early Modern Europe" *Renaissance Quarterly*, Vol. 42, No. 2 (Summer, 1990) pp. 292–331.

22 Eastlake, C. "Introduction" Johann Wolfgang von Goethe, *Theory of Colors* trans. by Charles Eastlake (New Haven: MIT Press, 1970) p. xxxii.

23 Kircher, A. "Liber III, Caput XIII, SII: De Genere Chromatico" *Musurgia Universalis*, facsimile edition, (New York: George Olms Verlag, 1970) p. 240.

24 Franssen, M. "The Ocular Harpsichord of Louis–Bertrand Castel: The science and aesthetics of an eighteenth–century *cause celebre*" *Tractrix: Yearbook for the History of Science, Medicine, Technology and Mathematics 3,* 1991, p. 20.

25 Shapiro, A. "Artist's Colors and Newton's Colors" *Isis*, Vol. 85, No. 4, (December 1994) pp. 607–609.

26 Schier, D. *Louis–Bertrand Castel, Anti–Newtonian Scientist* (Cedar Rapids: The Torch Press, 1941) pp. 137–142.

27 Selfridge–Field, E. "The invention of the pianoforte as intellectual history," *Early music*, Vol. XXXIII, No. 1, (February 2005) pp. 81–94.

28 Rimington, A. *A. Wallace Rimington's Colour–Music*, ed. Michael Betancourt, (Wildside Press, 2004) p. 82–83.

29 Helmholtz, H. *Psychological Optics, Volume 2*, (Menasha: The Optical Society of America, 1924) pp. 117–118.

30 Rimington, A. *A. Wallace Rimington's Colour–Music*, ed. Michael Betancourt, (Wildside Press, 2004) pp. 82.

31 Dann, K. *Bright Colors Falsely Seen* (New Haven: Yale, 1998) pp. 67–68.

32 Wilfred, T. *Thomas Wilfred's Clavilux*, ed. Michael Betancourt, (Borgo Press: 2006).

Mary Hallock–Greenewalt's "Abstract Films"

published in
Millennium Film Journal
nos. 45/46, "Hybrids," Fall 2006
pp. 53–60

NOURATHAR AND "ABSTRACT FILM"

While the oldest surviving abstract films were produced in Germany by Walther Ruttmann, Hans Richter, Viking Eggeling, and Oskar Fischinger in the 1920's, earlier films were produced by Italian Futurists Bruno Corra and Alberto Ginna circa 1909 by directly painting on clear film. An American named Mary Hallock–Greenewalt, better known for having patented a system of visual music, may have also produced a number of abstract films at the same time. An examination of the historical validity and context of her claims enables one to create a more detailed understanding of the relationship between abstract film and visual music performed with color organs.

The relationship between color music and abstract film was discussed by Malcolm Le Grice in *Abstract Film and Beyond*. In his examination of the now lost films produced by Corra and Ginna, Le Grice notes that their work with film developed from earlier experiments with a color organ of their own design. He explains the linkages between the two:

> The production of the [Futurist's] 'color–organ' introduces another element which has a general place in the development of abstract cinema. As early as 1880 in America, Bainbridge Bishop, and, soon afterwards, [A.] Wallace Rimington constructed color–organs. The beginning of this concept, though, can be placed much earlier, at least as early as 1734 with the *Clavecin Oculaire* of Louis–Bertrand Castel. In fact, experimenters in this field in and around the end of the nineteenth century would make quite a considerable list. Extensions of the idea persist to the present, and experiments with various forms of 'light–machine' have often been made by abstract film–makers.[1]

Le Grice observes that the history and aesthetics of abstract film and color organs have been closely linked throughout the twentieth century. The movement between color–organ and abstract film is a logical extension of the musical analogy between color and sound introduced by Isaac Newton's description of splitting sunlight into a spectrum. The desire to establish an analogy between abstract color and musical form is common to abstract artists generally.

The Futurists' movement into film from the color organ came as a result of their inability to create a satisfactory color music instrument. Corra explains this transition as the result of attempting to find a new art based solely on color:

> It could be said that the only display of the art of colors currently in use is the painting. A painting is a medley of colors placed in reciprocal relationships in order to present an idea. (You will note that I have defined painting as the art of color. For brevity's sake, I will not concern myself with line, an element taken from another art.) [. . .] After the violet of the first octave came the red of the second, and so on. To translate all this into practice we naturally used a series of twenty–eight colored electric bulbs, corresponding to twenty–eight keys. Each bulb was fitted with an oblong reflector: the first experiments were done with direct light, and in the subsequent ones a sheet of ground glass was placed in front of the bulb. The keyboard was exactly like that of a piano (but was less extensive). [. . .] This chromatic piano, when it was first tried out, gave quite good results, so much so that we were under the illusion that we had resolved the problem definitively. [. . .] But at last, after three months of experimentation, we had to confess that with these means no further progress could be made. We obtained the most graceful effects, it is true, but never to the extent that we felt fully gripped. [. . .] We turned our thoughts to cinematography, and it seemed to us that this medium, slightly modified, would give excellent results, since its light potency was the strongest one could desire.[2]

Corra and Ginna's trajectory from creating a color organ to creating hand–painted abstract films demonstrates the close links these two parallel practices have, not only formally

but aesthetically and historically. Yet the desire to create an independent "art of colors" is not unique to the Futurists. In 1895, A. Wallace Rimington, a British painter, announced his own invention of "*Colour–Music*" in conjunction with his receiving a UK patent for an instrument to play it.[3] His design anticipates the Futurist one fifteen years later in its relationship between a keyboard and lights connected to a reflector array.[4] Oskar Fischinger later created his own variety of color organ called a *Lumigraph* that directly translated the performer's touch on a screen into visual imagery.[5] While these two histories are parallel and often intersecting, the history of visual music and the history of abstract film remain separate fields of inquiry with the key figures of one history often being completely unknown in the other, even when their work has significance for both histories. Mary Hallock–Greenewalt is such a figure in the history of visual music whose work has relevance to the history of abstract film

In an experience parallel to the Futurists', Mary Hallock–Greenewalt became an electrical engineer in order to invent the *Sarabet*, her "color organ." By the time of her death, she had received eleven patents for devices necessary for her variety of visual music she called *Nourathar*. Her patents provide a factual foundation for the examination of her claims related to visual music and to their neighboring field of abstract film. In a letter, held by The Historical Society of Pennsylvania (HSP) dated January 12, 1941,[6] and addressed to the Simon and Schuster publishing company, she claims that abstract "Films painted into being by myself around 1909—1912" prove that she, not Walt Disney, *invented* abstract cinema. These dates make her films of the same vintage as those produced by Corra and Ginna in Italy and place them among the earliest known abstract films. If her claim is correct, she should be recognized as an inventor of abstract *cinema*; her trajectory would be opposite that of the Futurists—from film into visual music, rather than from visual music into film. The validity of her claim requires a closer examination of her films and their place in the broader aesthetic structure of *Nourathar*.

An examination of her claim immediately encounters difficulties with the available evidence. The most obvious problem is the lack of any evidence that she produced or exhibited a motion picture publicly. While the HSP does have several rolls of hand–painted nitrate roll film (neither perforated nor of a gauge used with motion picture projection), nowhere in the archive are

there programs, flyers or other references to screenings of films. However, these materials are present for *Nourathar* concerts. (Hallock–Greenewalt preserved these films along with other papers and materials used in her patent infringement suit against General Electric et. al. over her invention of the rheostat.)

The films stored at the archive are curious objects. They more closely resemble the roll film used in aerial photography—large format still images shot on long rolls—rather than motion picture film. Each roll is loosely spooled around a solid core rod, and each strip is connected to the next with either metal staples, or tape, or both. The holdings at the HSP consists of separate rolls of hand–painted film, approximately 6 and 10 inches wide, with lines along the edges evenly spaced in groups of four. The patterns on these films appear to have been produced with a spray and templates cut with organic and geometric shapes, and when back–lit on a light table, they reveal brilliant, saturated colors and rhythmic organization across the roll as a whole. In many respects, they resemble the scroll paintings produced by Viking Eggeling and Hans Richter, but using organic forms instead of linear geometry.

Hand–painted films by Mary Hallock–Greenewalt

However, unlike the Eggeling/Richter scroll paintings, her films are continuous lengths of color rather than divided into specific "frames." In this regard, their visual form relates to the hand–painted films by Len Lye and Normal McLaren from the 1930's where the color and image continue across the framelines.

The description of these films is hand–written on an index card. Unlike the colored film used for tinting light in her original *Sarabet* patent,[7] these films are patterned and clearly are the ones reproduced in *Nourathar: The Fine Art of Light–Color Playing*. Her explanation is ambiguous about their role in the performance while being specific about how they were produced and that she regards them as "films" of some type:

> Color sprayed acetate of cellulose roll used to furnish
> required sequences for accompaniment to music
> played by me at my disclosure of the fine art of light–
> color play. September, 1916

This card, the films, and her other materials in the HSP are largely related to her patent infringement suit. Noting that she claims in 1941 that these films date from 1909–1912, that she identified them as being from 1916 is surprising. This discrepancy suggests a degree of unreliability in her dating. In addition, the discrepancy in the chronology for these films increases with an examination of her patents.[8] The earliest patent for the *Sarabet*, her *Nourathar*–playing instrument from 1918 (US Patent no. 1,481,132) makes no reference to roll *film* as a guide to performance even though it includes a means to display colored light along with a roll film attached to a player–piano mechanism for autoplay; this mechanism becomes a colored light–score display mechanism with a later design. Another US Patent, no. 1,385,944 describing her *Light–Score* (1919), presents a notation system that can accompany traditional music notation, implying that the later use of colored, hand–painted films as a score notation system were a way to overcome the cumbersome written notation she originally produced.

The disagreement between these dates implies that her claim of 1916 is false, or at least that the films she used for autoplay in her earlier *Sarabet* were merely colored gels—this early instrument includes no lenses or other means for projecting any kind of imagery. Hallock–Greenewalt mentions in her book on *Nourathar* that she was forced to create her own colored gels for

lights,[9] and while it is possible that these films were used in that fashion, a colored gel is not an abstract film.

The earliest date for any of these films is much more likely to be from sometime between her initial filing of the original patent in 1918 and her first patented revision filed in 1925 (US Patent no. 1,714,504). Her changes to the *Sarabet* include more precise lighting controls and a display system near the controls that would accommodate these roll films. The design that includes this scoring system is an elaboration designed around this score–display system; it is not simply an addition that could have been omitted from her previous patent.

As her patent clearly shows, these "films" are not meant to be visible to anyone but the performer, and then only as intermittent motion across an illuminating bar: the film is marked along the edge in increments corresponding to 4/4 time in music. Every film held at the HSP includes these edge marks. Every fourth mark is larger than the previous three, serving to identify "beats" and "measures," and allows the correct understanding of these "films" as scores, not motion pictures. In contrast, the colored light gel films "played" by her original patent scrolled continuously at the same speed as the player piano score. The identification of the first *Sarabet* patent as a "method and means for associating light and music" and the later revision as a "control system for light and color players" supports the changed role of the film in the performance.

However, given the automated aspect of her performance system still contained by this version of the *Sarabet,* it is possible that these films could be displayed in the manner of a nickelodeon during the course of an autonomous performance. In that regard, the films, while still not presenting true motion, would become a visible intermittent image rather than a score. Their imagery, while elaborate when viewed in toto, is not visible in this way during the performance and is not shown to the audience; while such an autonomous performance and nickelodeon–type view is possible, it is not a potential she acknowledges. Her book on *Nourathar* discusses this score system and makes its relationship to the audience clear. It is for the performer only:

> An early use of a roll of film stained for the
> transmission of a pre–arranged color sequence.
> Separate means for control of darkness and brightness

M. H. GREENEWALT 1,714,504

CONTROL SYSTEM FOR LIGHT AND COLOR PLAYERS

Filed July 16, 1925 4 Sheets—Sheet 4

US Patent no. 1,714,504, "Control System for Light and Color Players,"
Mary Hallock–Greenewalt, 1925

and shade or tint degrees. Note also an apparatus for
the automatic reproduction of such sequence.[10]

The transformation of her *Sarabet* from its origins in an
automated system built around a phonograph to a manual
instrument connected to a network of remote actuated lights
with variable color filters passes through a stage where it can
function both autonomously and manually. An examination of
the her 1925 patent design reveals that the controls for the light
(darkness and brightness and shade or tint) are separate from the
roll film that serves as a guide to the performer; her automated
system runs on a punched roll of paper, as with a player piano.
While the 1925 version resembles her original 1918 design, the
structure and purpose of the film is entirely different: in the
second version, the "film" remains an invisible component in the
performance. This shift in the film's role is the most significant
change between the original version and the intermediate stage.

The rolls of film preserved at the HSP are not projectable.
They lack consistent registration (the timing marks are hand–
drawn and slightly irregular as a result) or any means to load
the film into a projector. Also lacking is any suggestion of a
"frame" that would be necessary for the imagery to be in motion
as in a film. Her "films" are fundamentally different from motion
pictures. While the lights she patented for use with (or more
correctly as part of) her *Sarabet* project colored lights and are able
to change their color filters on demand, they neither project film
nor are designed to project imagery by using metal gobo filters.
Nourathar does not include imagery.

> The very form of light–color play used as a medium for
> human expression is made through time. The picture
> features through lineament, through line. In *Nourathar*, it
> is a matter of asking at what *moment* did this brightness
> begin to wax or wane? *What* instant did shade give way
> to another? *When* did the highest climax attain? When
> the instant that all light became gradually extinguished
> into the total of darkness? When this color? When that?
> It does not ask at what spot on this canvas or sheet does the
> value begin to shape a nose, a mouth, or image of any sort.[11]

Nourathar is thus an amorphous art, more akin to color field
painting in its form than to the kinds of painterly abstraction
created by artists such as Vassily Kandinski. By defining her art as

without imagery, the nature of these "films" becomes puzzling: they present clearly defined areas of color and shape with very sharp edges, completely unlike the variety of performance suggested by her description. The *Sarabet* and its lights would not be readily capable of presenting the sharp–edged abstraction these "films" present but would produce a soft–edged color field.

To further clarify her position on imagery and *Nourathar*, Hallock–Greenewalt added a disclaimer filed December 23, 1933, to her renewal (US Patent re16,825 in 1929) for the original *Sarabet* patent from 1918:

> I disclaim the use of stereoptically focused images
> such as are known as painted pictures and the like,
> projected between lenses as distinguished from the
> sue of substantially shapeless flood of light.[12]

The disclaimer to patent reissue 16,825 demonstrates her art's lack of specific visual shape. Thus her "films" are not examples of what her performances would be like; the precise relationship between them as scores and the resulting performance is uncertain.

However, on January 12, 1941, Hallock–Greenewalt wrote a letter to Simon and Schuster regarding Deems Taylor's book *Walt Disney's Fantasia*. While the claims made in Taylor's book may be of questionable factuality,[13] Mary Hallock–Greenewalt asserts her own priority:

> In Stokowski's forward, p. 2: "Synchronized with this
> music is an art of color and form in motion, as conceived
> by one of the most outstanding creative minds of the
> world today—Walt Disney". "He has brought to life a new
> phase of art—painting in motion"—"The imagination
> of Disney—has unfolded a new and freely flowing way
> of painting with color, light, form and motion". And
> then again by Walt Disney himself in his foreword "At
> last, we have found a way to use the great music of all
> times and the flood of new ideas which it inspires".
>
> THESE GENTLEMEN TOGETHER WITH YOURSELVES
> CLAIM A PRIORITY TO WHICH THEY ARE
> NOT ENTITLED AND YOU WILL OF COURSE
> MAKE RESTITUTION WITHOUT DELAY.
>
> Films painted into being by myself around 1909–1912
> are in my possession and cover these descriptions.
> There were considered important exhibits in court

> actions brought by me and in various ways the proofs
> of my priority as to these having constituted a step in
> my having created the fine art of light color play are
> irrefutable.[14]

These claims are quite shocking given the nature of her art and the very minor role these "films" play in that art as a technical aid to performance, not as a presentation in themselves. Her letter is a direct contradiction of her 1933 disclaimer. While the distinction between "substantially shapeless" and "form" may be a moot point since "shapeless" is a description of a variety of visual "form," nevertheless, it is not a description that is readily applicable to *Fantasia*. This fact makes her claim of priority very strange and unlikely to be taken seriously by the recipients of the letter. The irony that she falsely claims priority over Walt Disney, who in many ways stole *Fantasia* from Oskar Fischinger, tarnishes what rightfully are her accomplishments.

That the creation of abstract film and visual music so easily overlap aesthetically means that the history of abstract film needs to include borderline figures such as Hallock–Greenewalt. While her films are not motion pictures, their formal similarities to the work of filmmakers make their consideration as part of a history of abstract film useful in acknowledging the links between live, performative visual music (and the VJ tradition it has evolved into) and the abstract film tradition. While it is possible that she simply altered the existing films to work with her later device as a scoring system, the dramatic differences between a scrolling colored lighting gel and an abstract film could not be clearer. There is no clear evidence to support or deny this possibility. Her reuse of an earlier design with modifications implies that this may be the case, but her claim that these colored roll films should be regarded as abstract motion pictures is not supported by either possible role her hand–painted films might have had. A continuously scrolling lighting gel with various colored patterns on it would create only a gradual shift in over–all, shapeless color, while the intermittent scrolling of the score would not be called a "motion picture" except in its broadest meaning. This examination of her claim and films suggests that Mary Hallock–Greenewalt's assertion that she produced abstract films is untrue, and that her documentation of her own work is ambiguous, if not completely suspect, in its claims.

REFERENCES

1 Le Grice, M. *Abstract Film and Beyond* (Cambridge: MIT Press, 1981), pp. 17–18.

2 Corra, B. "Abstract Cinema——Chromatic Music" *Futurist Manifestos* ed. Umbro Apollonio, trans. Robert Brain (Boston: MFA Publications, 1970) pp. 66–69.

3 Rimington, A. *Colour–Music* (Wildside Press: 2004).

4 Betancourt, M., ed. *Visual Music Instrument Patents: Volume 1* (Holicong: Borgo Press, 2004), pp. 16–26.

5 Moritz, W. *Optical Poetry* (Bloomington: Indiana University Press, 2004), pp. 137–138.

6 The letter in question is held in the Historical Society of Philadelphia's Mary Hallock–Greenewalt collection (867) "Color Organ" box.

7 The 1918 *Sarabet* contained a light–colored film array. This device becomes a score display system in her 1925 revision of the instrument.

8 Betancourt, M., ed. *Mary Hallock–Greenewalt: The Complete Patents,* (Wildside Press: 2005).

9 Hallock–Greenewalt, M. *Nourathar: The Art of Light–Color Playing* (Philadelphia: Westbrook Publishing Co., 1946), pp. 301–304.

10 Hallock–Greenewalt, M. *Nourathar: The Art of Light–Color Playing* (Philadelphia: Westbrook Publishing Co., 1946), p. 407.

11 Hallock–Greenewalt, M. *Nourathar: The Art of Light–Color Playing* (Philadelphia: Westbrook Publishing Co., 1946), p. 221.

12 Betancourt, M., ed. *Visual Music Instrument Patents: Volume 1* (Holicong: Borgo Press, 2004), p. 106.

13 Moritz, W. *Optical Poetry* (Bloomington: Indiana University Press, 2004), pp. 89–108.

14 The Historical Society of Philadelphia's Mary Hallock–Greenewalt collection (867) "Color Organ" box.

published in
VJTheory
September 1, 2006

SAME AS IT EVER WAS— ACTS OF DIGITAL RE-AUTHORING

The idea that recombinatory practices commonly found in new media constitute a challenge to traditional author/viewer conventions is a well–known proposition. Placing this view in both a historical perspective and in relation to the suggestion advanced by Umberto Eco that these works assume a principle of "variation to infinity", it is possible to recognize that instead of challenging or critiquing traditional author/viewer conventions, recombinatory practices serve to reify those positions and assert an authoritarian role for the original source material. The idea that these practices challenge authorship is thus a form of false consciousness.

There is an approach to making "new" art that begins by taking existing reproductions of other art—whether images, sounds, movies or text—and then recombines these in some fashion, using this pre–existing material as the source for a new work. This action has been called by various names—sampling/ appropriation/cut–up/mash–up/remix/collage/montage— and each of these names refers to one of its many historical incarnations. Without the associated technologies of distribution, reproduction and mass marketing, the recombinatory work as it emerged in the twentieth century would be unimaginable. It is an aesthetic form that has recurred almost identically with each 'new' technology becoming readily available. This reassembly from reproductions is characteristic of artistic responses to the emergence of technological reproduction over the course of the twentieth century and extends into present uses of digital technologies without any sign of abatement.

While recombination of existing works into new ones has origins in folk art and elsewhere before the twentieth century,

historical discussions of this approach often begin with Pablo Picasso who combined reproductions with his cubist paintings in the 1910s; the Soviet filmmaker Dziga Vertov who experimented with wax recordings to make "remixes" in the late 1910s and early 1920s. [1] Soviet montage itself owes its existence to experiments with the reassembly of existing film materials. Surrealist Max Ernst cut up engravings to make "novels", and Joseph Cornell re–edited Hollywood films with other movies to create his own work *Rose Hobart*. The author William Burroughs created "cut ups" with audio tape. . . . As new technologies of reproduction became available, new artists performed some kind of recombination of those materials. The listing of these artists and their works could easily continue. This approach is so common it could be called "typical" when artists confront a new technology.

But what is most striking about the repeating pattern of artistic reuse is the increasingly strident claim that this approach constitutes a "questioning of authorship," especially evident in the later forms that appear at the end of the century around the idea of "appropriation art."[2] It is against this background that the reappearance of these forms (with new names like "mashup" and "sampling" and "database") in computer based media art— *new media*—should be considered.

Their historical continuity with work by the historical avant–garde suggests these approaches (whatever their name) have become banal rather than disruptive since popular entertainment can successfully redeploy these approaches. Acknowledging this fact raises a basic question about how these recombinatory practices challenge traditional author/viewer conventions, as well as why this approach continues to make fundamentally the same claim that these actions constitute a "questioning of authorship."

By examining the belief that recombination "questions authorship," it becomes apparent that these approaches constitute a means to avoid the potential shocks each new technology implies by an assertion of traditional roles for audience and viewer. Thus, their repetition takes on a dual character: at the level praxis where it appears through the reuse of reproductions (the "raw" material of the work), and at the conceptual level as the specific procedure of adoption and reassembly.

These repetitions, instead of disrupting conceptions of authorship, (and originality, etc.) serve as a means to assert

these values through the principle of "variation." Umberto Eco has noted that viewers, aware of the rupture in appropriated or quotational works (and sampling cannot be anything but quotational) is aware of their nature as a repetition. What is of interest to the viewer is the way the new work reconfigures the old.[3] With the shift to "variability," the more explicit the quotation, the more the audience may be expected to recognize it, and thus the more directly it plays the new instance against the original one. Variations imposed by the artist become the critical focus in relation to the original work. Instead of eliminating the authorship, or even critiquing it, the remix/appropriated work emphasizes the role of the author precisely because it is the differences (if any) that matter: the role of artist–as–author is not minimized here, it is maximized. The artist reestablishes traditional positions for both artist and viewer: the artist dominates, transforming an existing work into something "new."

This image of artistic domination over materials is familiar—it is the traditional view of "genius" in a different guise. The coupling of such a traditional view of authorship with a consistent artistic practice whose name mutates, (but whose procedures vary only slightly), imposes a specific conclusion about the recombinatory procedure: that instead of challenging traditional notions of authorship, it tends to assert them while inviting the audience to (un)critically engage the work using their encyclopedic past knowledge of the sources for the "new" work. The audience is active in their engagement with the work, but such "activity" is a potential in any viewing situation and should not be regarded as unique to recombinatory works.

At the same time, this engagement with a "critical" or "active" audience is only superficial. The "activity" is one of comparing the new instance to established forms. This action assumes the prior authority of the existing work. The recombinatory actions exist in parasitical relation (as variations) to their source materials. By drawing together existing materials in new ways, the "variability to infinity" Eco describes comes into the interpretation, creating a false consciousness of challenge to authority and the conventional role of the viewer: the repetitions inherent to remixing existing materials escape the psychological dangers *unheimlich* works may pose through a reliance on established expertise and the implicit understanding of the "rules of the game" involved in appropriations.

To claim the recombinatory practices commonly found in new media—sampling, appropriation, remixes, mash–ups, etc.—challenge traditional author/viewer conventions can not be accepted as true. As Eco has noted, these practices constitute a shift to a pre–modern convention set where the traditional established work that is the subject of the transformations is elevated in status, and the artist appropriating serves to reify that status, while viewers, aware of the conventionalized variability at the heart of appropriation, recognize in the artist's actions an assertion of authorial dominance over the original work as well as a (paradoxical) subservience to that work.

REFERENCES

1 Petric, V. *Constructivism in Films: The Man with a Movie Camera* (Cambridge: Cambridge University Press, 1987); see also: Vertov, D. *Kino–Eye: The Writings of Dziga Vertov* ed. Annette Michselson, trans. Kevin O'Brien, (Berkeley: University of California Press, 1984).

2 There are many sources for this claim, but it figures prominently in Douglas Crimp's "Appropriating Appropriation" *On the Museum's Ruins*, (Cambridge: The MIT Press, 1995) pp. 126–136.

3 Eco, U. "Interpreting Serials" *The Limits of Interpretation* (Bloomington: University of Indiana Press, 1994) pp. 83–100.

published in
"1,000 Days of Theory: td041"
CTheory
September 5, 2006

and

The Critique of Digital Capitalism
Punctum Books, 2016

THE AURA OF THE DIGITAL

By dividing the interpretation of art work into several distinct "levels" it becomes possible to recognize a fundamental distinction between digital and non–digital art works, as well as recognize an underlying belief in the illusion of infinite resources: it replicates the underlying ideology of capitalism itself—that there is an infinite amount of wealth that can be extracted from a finite resource. It is an illusion that emerges in fantasies that digital technology ends scarcity by aspiring to the state of information. The digital presents the illusion of a self–productive domain, infinite, capable of creating value without expenditure, unlike the reality of limited resources, time, expense, etc. that otherwise govern all forms of value and production. The rise of automated, immaterial production reflects this process in action.

Digital forms also exhibit what could be called the "aura of information"—the separation of the meaning present in a work from the physical representation of that work. As digital works, via the "aura of information," imply a transformation of objects to information, understanding the specific structure of digital art makes the form of the "digital aura" much more explicit. This clarity allows a consideration of the differences between the scarcity of material production in physical real–world fabrication versus the scarcity of capital in digital reproduction: the necessity for control over immaterial commodities (intellectual property) in the virtuality of digital reproduction. Because capital is a finite resource itself subject to scarcity, yet also caught in the capitalist paradox of escalating value—in the dual forms of interest and profit on capital expenditures—there is the constant demand to create more commodity value in order to extract more wealth from society in order to maintain the equilibrium of the system: digital capitalism necessarily moves between "boom and bust" because of this inherent imbalance.

Understanding this "aura of information" requires an acknowledgement about the nature of the digital object: it is composed from both the physical media that transmit, store and present the digital work to an audience; the digital work itself is actually composed of both a machine–generated and a human–readable work created by the computer from a digital file (itself actually stored in some type of physical media). This "digital object" is the actual form of the digital work—a series of binary signals recorded by a machine and requiring a computer to render this unseen "code" readable by humans. The "digital object" becomes the human readable forms of image, movie, text, sound, etc. only through the conventionalized actions of a machine that interpreting the binary signals of the digital object and following the built–in interpretative paradigm that renders this binary code into a human–readable form and thus superficially distinct works. All 'digital objects' have this singular underlying form—binary code—a fact that makes the digital object fundamentally different from any type of physical object precisely because it lacks the unique characteristic of specific form that defines the differences between paintings, drawings, books, sounds, or any other physical object or phenomenon. Unlike physical objects, digital objects are all basically the same, whatever their apparent form once they are interpreted by a machine. This transfer from instrumental code to human–readable object happens autonomously—no human agency is required to set the translation in motion; the illusion created by the ideology of automation proceeds from an extension of this active element in digital technology beyond these generative dimensions of digital reproduction's display of (art) works.

(1)

Walter Benjamin's 1936 essay, "The work of art in the age of mechanical reproduction" initiated the critical discussion of the idea that artworks have "aura," and proposed that this "aura" is destroyed by the process of mechanical reproduction. His notion of "aura" quickly expands to include more than just art—anything that is reproducible is folded into his construction. While this description of Benjamin's article is highly reductive, it captures his essential thesis that inherently suggests a historical loss brought about by technological change. Following Benjamin's argument it is logical to suppose that art would be without "aura"

once mechanical reproduction gives way to digital reproduction. As Dutch artist/economist Hans Abbing has noted in his study, *Why are Artists Poor?* in discussing Benjamin's "aura":

> Walter Benjamin predicted that the technical reproduction of art would lead to a breaking of art's spell ('Entzauberung'). Art became less obscure, more accessible and thus less magical because of technical reproduction. [. . .] Benjamin's prediction is not difficult to grasp. Technical (re)production enables a massive production of artworks at low prices. It would be very strange indeed if this didn't reduce the exclusive and glamorous allure of art products. [. . .] But thus far, this hasn't happened; [the composer] Bach and his oeuvre maintain their aura. In general, if one observes the high, if not augmented status and worship of art since Benjamin's essay first appeared, his prediction was either wrong or it is going to take longer before his predictions are borne out.[1]

Abbing's observations about Benjamin's thesis that technological reproduction and mass availability result in diminished "aura" suggest that instead of diminishing the "aura" of art, reproduction helps to extend the aura of the works reproduced instead of destroying that aura. This inverted interpretation of "aura" produced by the readily accessible and available art work shifts the emphasis in Benjamin's article from the traditional 'cult' value of art objects to what he terms their commercial 'exchange' value. This emphasis on what Benjamin supposes to be the traditional role of art works in religious practices appears in his concept of aura as the physicality of the art object, what he refers to as "authenticity":

> The authenticity of a thing is the essence of all that is transmissible from its beginning, ranging from its substantive duration to its testimony to the history it has experienced.[2]

As Abbing's proposition implies, Benjamin's idea of 'authenticity' only becomes a meaningful value once there are reproductions of an art work, similar in appearance, but not identical to their source. Thus, the more widely promoted an art work through reproduction, it is possible to suppose that its "aura" would logically then increase as well; there is an inversion

of Benjamin's thesis. What Abbing suggests is that "aura" is not as Benjamin proposed it, but is instead a function of the reproductive process itself. This shift in conception of Benjamin's "aura" suggests that art objects have a dual character. Their "aura" is both the physical traces of the particular history that an object has experienced, and the relationship of that object to the tradition that produced it. These are two distinct values: one resides in the physical object, the other lies in the spectator's knowledge (and past experience) of the object's relationship to other, similar objects. If the first value is a "historical testimony," the second value can be called a "symbolic relationship." Even though the relationship to tradition is an independent value, separate from the physical properties forming the "historical testimony," it cannot be reduced to a set of physically present characteristics because it depends upon conceptual relationships produced in the minds of the human audience—functionally a semiotic 'reading' of a work guided by past experience with similar works. Separating these two values results in a new conception of "aura" independent of Benjamin's initial proposition that is specifically applicable to digital technology: the idea of "aura" results from the role the work plays for its audience sociologically (how they employ the work in their society.) This conception, as related to the audience's access to that art work, makes conflicts over "intellectual property" an inevitable consequence of the emergence of digital technology.

Mechanically or manually (re)produced objects always have an implicit limit on their availability (thus their accessibility); digital objects do not have a limit of this type—in principle an infinite number of any digital work could be produced without a change or loss, or even deviation between any of the works.[3] This distinction between all physical objects and digital objects reveals a fundamental similarity between the original art work and its mechanical reproductions; such similarity does not conflate the older relationships of copy with original: instead it reveals the basic difference between the digital and the physical. Every digital reproduction is identical to every other; digital objects are stored as a form of information, rather than limited as physical objects inherently are; thus, the digital state can be understood as a form of instrumental language—instructions for executing the "retrieval" that is a specific digital (art) work.

With physical objects each object is in fact unique, even when it is an identical example of a given type: while two sheets of white paper may be apparently identical in every way, each sheet is a unique example, physically discrete and independent of all others. Digital reproductions are all the same, rather than being unique examples of a given type (as with sheets of paper), each is an identical execution of uniform, constant instructions, a "copy." Information theory describes works of this kind as exhibiting zero information–theoretic entropy: because the execution of the instrumental data of digital objects (the electronic file stored by a computer) is an entirely predictable process within the framework of a given digital system, no information is required to produce a digital work from a digital object (electronic file).[4] Digital reproduction is therefore fundamentally different from any kind of reproduction previous to it, and the digital objects subject to this type of reproduction can be seen to constitute a new class of object.

Digital (art) works retain their initial form over time without degradation because there is no physical object that is subject to the decay of time. They can be edited, compiled, combined, and distributed without any change in any subsequent reproduction; "copies" can then be reproduced further, infinitely, without ever being subject to the necessary loss inherent to physical media. One "copy" is not only equivalent in content, it is identical to its source. The concept of a digital "original" disappears because all versions are all identical "originals," or are all identical "copies."

Contemporary language lacks the terms needed to describe the relationship between distinct instances of an identical digital object: "copy" assumes the traditional mode of originals and replicas; "clone" introduces a biological analogy that nevertheless suggests some anterior original source that (at least) potentially exists as the source. Because the data comprising the digital work itself remains constant, digital objects are indistinguishable; the distinction between any two iterations of a singular digital work is not an issue of content or form because the digitized information remains constant; it is an issue of location and physical presentation—where a specific version is located on (or in) the physical media that carries its imprint and/or displays it in a human–readable form.

(2)

The distinction between physical objects and digital objects is absolute. These distinctions are related to a duality between symbolic meaning and physicality that begins with the earliest forms of mass reproduction: minting currency. The stamping of emblems on coins renders each token valuable by dual means: though its material (precious metals), and symbolically identified as authentic (that its value is real) by the markings emblazoned on its surfaces (its symbolic content). Authenticity is an interpretation based upon a second order of interpretation, derived from a decision about the symbolic content of an object. The digital object, lacking a physical component, exists as symbolic content that becomes a physically accessible form only when presented through a technological intermediary, (for example, a video on a computer monitor) or transformed into a physical object (such as a paper print–out).

The separate valences of material and symbol can be understood as existing at different levels of interpretation: the physical provides the first level, with all the conclusions about the object's age, etc. forming a first order; the symbolic content, including its connection to traditions, similarity or difference with other objects, the interpreter's relationship to the particular object, etc. all form a second order of interpretation. While the second, symbolic order does require the first order (some type of physical presence) for its presentation, the interpreted content exists as an excess to the first order. It is information provided and created by the interpreter using past experience with interpreting the form and character of the first order that produces the second order.

The dualism of "aura" in physical objects appears as a function of both the material object and its symbolic content. That the dualism of "aura" is connected to the invention of exchange value (currency) is not accidental. Exchange value depends on human agency in social and political ways to achieve its meaning and maintain its value. It is precisely in the establishment of value through recourse to a particular scheme of many different objects governed by human agency that "value" emerges at all. Awareness of the symbolic relationship between one object and another is an interpreted result of human agency, and does not inhere in the object itself. Aura for digital works retains

this dualism while shedding the literal constraint of specific physicality. The encounter with a digital object remains a material engagement, but one where the physical form is separate from the digital work, serving as a presentation of that work—i. e. what is seen and heard watching a videoclip on a computer.

The separation of the specific presentation of a digital work from our conception of that work literally inscribes the Modernist desire to isolate the art work from the context that produces it[5] into our consciousness and our interpretation of the digital (art) object: instead of requiring the sanitized, clean white gallery space to eliminate external context from the interpretations of art, with digital works this eliding of the specifics of location, presentation, context, etc. happens in the mind of the spectator. This effect derives from the digital aspiration to the state of information. It reflects the aura of information.

Because the material aspects of digital works are ephemeral, lasting no longer than the phenomenological encounter with the presentation of the digital object, (typically on a screen of some type), the "aura of information" suggests that the digital itself transcends physical form. This illusion defines the "aura of information." Because digital works emerge from a second–order interpretation, they belong to the same category of objects as music encoded for playback by a machine, as with the player–piano scroll. Digital objects are not readily human–readable, and only become sensible as works when processed by machine. Like the music encoded on the player–piano scroll, the digital object is separate from its physical embodiment, often produced in ways and with technologies (like language) that are independent of digital forms, but are readily reproducible without loss and totally dependent on the specific technologies of their performance or presentation.

As digital objects do not degrade with time; they will not disappear over time. The limit for a digital work is not based on its physical demise, but rather on its availability within contemporary technology. Older digital works are only "lost" because the technological support for accessing them vanishes: the digital work, theoretically, endures and can be retrieved at some future time. Digital reproduction then becomes not only an inherent characteristic of digital objects, it is also their means to effective immortality. The digital reproduction and transfer of files from older technology to new technology enables the

continuation (perpetual maintenance) of digital works regardless of what technology they may have begun within; early computer programs, such as 8–bit arcade games that originally existed as ROM chips in, for example, the *Atari 2600 Home Entertainment System* game cartridges are still accessible because contemporary technology is able to emulate these discarded, obsolete systems, thus enabling otherwise inaccessible digital works to be read with equipment vastly more powerful and otherwise incompatible with the older digital files. In the case of the digital works contained by the *Atari 2600 computer game system* there is a large, although limited, number of functional *Atari Home Entertainment Systems,* and when the last system irreparably breaks down, access to the original versions of the files on those ROM cartridges by their original hardware systems will be lost. Such a loss constitutes the historical testimony of this technology and the digital works accessible to it. However, the historical testimony these systems have is completely separate from the files contained by these ROMs, and the survival of the data on them is of a different nature than the survival of the original, physical system itself. (This reading is a result of a newer system emulating an earlier digital systems' function.)

The ability to separate the digital file from the hardware dramatizes the aura of digital objects: the digital work as immortal, transient, adaptable to any new presentation technology that comes along. It also connects the aura of digital objects to the aura of information since information is a function of interpretation and so can theoretically be transferred from one representational system to another as when ancient, "dead" languages such as Ancient Greek or Egyptian hieroglyphics are translated into contemporary ones such as English. Theoretically the content of the earlier language remains constant; with digital objects this theoretical aspect of human language and meaning becomes actual fact because of the distinction between the machine language of binary code that is prescriptive, and human language that is descriptive and denotative. Because the binary machine language is a set of commands, the transfer and conservation of information held within that language is not subject to the semiotic "drift" of meaning that affects all human language. Thus the contents of even "dead" digital systems can be recovered, assuring the immortality of any digital object.

Yet, the immortality of digital files also leads to an accumulation of works whose management and accessibility inevitably will begin to become an issue in itself, beyond simply the question of being able to access antiquated files constructed and used with hardware that is obsolete and irreplaceable.

Once the immortality of digital works is understood to mean these works will accumulate and be immanently present indefinitely into the future, a *Malthusian* problem emerges. As more and more materials accumulate in digital form they will become increasingly difficult to organize, access and use. The quantity of information will impede its ability to be used or evaluated. The "aura of information" implies that this continual databasing of information is a positive value in itself, separating information from the ability to use it or determine its significance. The "aura of information" gains its apparent value from information–poor pre–digital societies where access to and possession of information was a positive value because the volume of information even potentially available was limited both physically to specific objects, and by the ability to reproduce that information. In such an info–poor society, stockpiled information has value in itself because the amount of information remains limited. For digital technologies, the creation, storage and distribution of information are not limited in the ways they are for traditional societies. Because digital information aspires to immortality, is infinitely reproducible, and claims the "aura of information"—the accumulation and management problematics of digital files necessarily emerges as an inevitable outcome of the development of digital technology.

(3)

All mechanical reproductions are objects in themselves; they carry their own "historical testimony," and are subject to the effects of time and decay as are any other physical objects. This is true for the mechanical reproduction at all levels of its existence; even the photographic negative is subject to decay and loss, just as the metal plate used in printing gradually wears away as it is used to make reproductions. The mechanical reproduction can therefore be regarded as having the same potential to authenticity (via historical testimony) as any other physical work of art.

In contrast to the mechanical reproduction, the digital reproduction is a multivalent object. The physical representation

of a digital object, as on a computer screen for example, does not subject that file to the wearing away that physical objects suffer; nor does the copying, sending, or storage of these digital objects necessarily damage them. The digital transfer of files produces perfect, identical copies not subject to the historical testimony of physical objects. In effect, the digital object—the information contained in/as the digital file—is independent of historical testimony. However, the medium that stores the digital file is subject to "historical testimony." This container is distinct from its contents, and should be understood as separate from them.

The types of "historical testimony" that do impact digital files can thus be divided into three types: (a) those that impact the container, whether it is the disk, CD, ROM, or other storage medium, (b) those that effect the digital file in itself as distinct from the storage medium, and (c) the accessibility of the file using contemporary technology (the issue of obsolescent software, hardware, and the files produced with that older technology). A broken CD may render the data it contains inaccessible, but it does not actually destroy the data. A damaged or corrupted computer file is a result of errors made by the system storing and displaying the file, and are not examples of historical testimony, but are more akin to misprints and errors made with the machinery of mechanical reproduction.

The accessibility of a digital object produced with obsolescent technology leaves no trace on the digital object itself; it is the ability to read that file's content that becomes attenuated with time, not the file itself. Its contents remain constant even when we can no longer access those contents. This situation is akin to our ability to read ancient, "dead" human languages written in hieroglyphics or cuneiform: the contents of the text are independent of their storage medium or the format (language) in which they are written.

Technological failures, or glitches, do not constitute a historical testimony for digital objects; instead, they demonstrate the digital work's nature as second order interpretations presented for viewing. This explains their lack of physical presence and the uncomfortable relationship between the digital "template" or original digital file and the physical versions produced from it as print outs, displays on monitors, etc. . . The conflict surrounding intellectual property rights is most concerned with access to the art "object" itself, since in the digital realm the potential

to reproduce and distribute does not necessarily include the right to read (access) the work—this is why every digital rights management (DRM) proposal limits and controls access to the (digital) art work: the right to read.[6]

(4)

First order interpretations of historical art works such as the *Sistine Chapel* proceed based on the fact that it remains the *Sistine Chapel* in all circumstances; however, this assumption reveals its attenuated character with mechanical reproduction, and announces itself clearly with digital works (if it is not rendered completely invalid by the myriad variability between different displays of the same work through the disparate presentations of projectors, monitors, different user parameters on various computers, etc.) to such an extent that it becomes less appropriate to think about digital works in terms of the specifics of a particular display than it is to think about them independent of the particular display where they may appear.

Consider the issue of color, for example. Different computer monitors display color differently, depending on the age of the monitor, how long it has been in use, the particular construction of the pixels in its screen, the specific settings it has at the moment of display. Stores selling monitors will set up comparisons showing their available models because these differences impact the appearance of digital works displayed on them. The question of color becomes even more variable when consideration of presentation expands beyond desktop monitors to include other kinds of display such as projection, TV broadcast, or even video on cell phones. Each expansion of potential display increases the variation in how a digital file appears, rendering the question of which version is the "authentic version" problematic since the file being displayed can (and does) remain constant.

The superficial constancy of a human–readable form does not mean that apparently identical presentations produced by different sources are the same. Three apparently identical images may present the same human readable result, but be generated by incompatible sources. Imagine the following situation: (*a*) an uncompressed raster file specifying each and every pixel displayed; (*b*) a compressed version of the same raster data; (*c*) a version of the same image, but produced and described using vector graphics. The apparent content of the image is

irrelevant—it could be a photograph, typography, or simply a collection of linear elements—because any type of image can be stored in these three ways.

The human–readable product of each of these three images are identical, so completely similar that there is no difference between the data on display in a human–readable form in any of these images; thus it is impossible for a human observer to distinguish between them based on their human–readable form.

However, in spite being apparently identical, each of these images is produced from an individual, separate, digital object. This remains the case with these images no matter how frequently they are rendered human–readable, copied, or otherwise reproduced as digital files. The idea that they are actually the same is an illusion created by the aura of information. It is this aura—that all digital information remains constant/equivalent no matter what types of transformations are applied (in this case both compression and the distinctions between raster and vector storage of image data)—that confuses these distinct files for one another. Each digital file and the rendition of that code as a human readable object (the apparently identical images) comprise separate, individual digital objects whose human readable instantiation produces the illusion that they are the same. It is the belief in the equivalency between these distinct data files that contain unique, divergent code, that reflects the aura of information in action.

Because the aura of information demands that spectators ignore the presentation (video monitor, projector, print–out, etc.) in considering the "context" of the work—conclusions related to what would be first order interpretations for non–digital works: for example, where the painting is from, how it is lit, how old it is—all these questions generally vanish when confronting a digital projection. Age, materials, etc. do not devolve from the physical materials of a digital work's presentation, but from considerations relating to its symbolic content. To the extent that a digital work has a historical testimony, it is a result of historicizing the style and form of the work (second order interpretations.) That a digital work is shown on a flat–screen in one presentation, a cathode ray–tube in another, and as projection on another occasion does not effect our considerations of that digital work. While the display may change, the digital work is considered to remain the same whatever means are used in its presentation.

This dismissal of the variability of digital works suggests that the digital work exists and is understood as being independent of its various presentations. The same dismissal of the physically stored digital file mirrors the dismissals of the specifics of presentations; both are effects of the aura of the digital creating the belief that digital objects are divorced from physicality.

The independence of digital works from their physical presentation is connected to the contingency of both the right to read a digital file and technological basis of digital (re)production. Where both manual and mechanical reproduction always preserve the physical character of the object, leaving it subject to its particular historical testimony; digital works do not. Any type of printed matter retains its form unless physically assaulted—burying a book in peat moss may result in the book decomposing, with the resultant loss of the book; a digital work cannot be thus assaulted, but neither can it be accessed away from a technological support. Digital files only appear through the variation of display that the above consideration of the issue of color implies.

Recognizing that the lack of historical testimony of digital works creates a framework shifting these objects away from the particular, physical object–oriented attributes of their presentation towards being a non–object oriented art. The uniqueness of digital works cannot thus be a result of there being "only one," nor can the uniqueness of digital objects be a result of a solitary (individual) character because all "copies" are identical in every way. In effect, for digital works (as with mechanically (re)produced works before them), there is no first order object, in the way there is a *Sistine Chapel.*

The impact of the digital work's particular form of "uniqueness" on intellectual property reveals itself as the issue of access to the work: the right to read, rather than to own a copy. Possession and access are separated from one another. With first order objects, such as the *Sistine Chapel,* possession also confers the right of access: having possession guarantees access to the work; with digital works, possession becomes attenuated—it is possible to "own" files on a computer, but not have the ability to access those files' contents. The model that intellectual property thus adopts is much closer to the idea of a bank where only authorized persons may do business and everyone else is turned away unless they, too, invest their money in the bank. In all cases,

what the customers have access to, what actions they are allowed, and most significantly how much it costs to perform those acts is determined by the bank. What these "customers" may do is strictly limited by the particulars of their specific investment in the bank.

(5)

Mechanical reproduction is always limited by the physical materials, both in the form of the (re)productive technology (printing press, photographic negative, etc.) and the materials that form the reproduction itself. This basis imposes duration on the object; until the digital work is (re)produced physically, it lies outside this constraint, even though the digital file is always physically stored, the digital work that file produces remains a separate entity, although nevertheless inherently sourced to this digital file. And because the aura of information leads to the interpretative ignorance of the physical appearance of the work when it is presented to its audience, falling "outside" means that it is not subject to the effects of time degrading it via duration either when reproduced as an object, or in its native, digital form. Thus, the "authenticity" of the digital work lies in it being independent of the effects caused by the passage of time, its use (digital works do not "wear out" the way physical objects will), or via its replication and distribution in a digital form: unlike physical objects, digital works do not exist with physical constraint on the works themselves, only on the ability to store (and transmit) them, as with the limited ability to store files on a hard drive.

The absent physical limit means, in principle, that digital works can be regarded as immortal—making the lengthening of statutory ownership (copyrights, patents, etc.) a necessary and inevitable corollary to the conflict over intellectual property: the maintenance of the property demands that it last as long as the work in question. To do otherwise is to acknowledge the contingency of this right to read on the economics of object–based production and consumption that predate the emergence of the digital work. It is a lacuna which follows from the ideology of automation—the perpetual expansion of ownership reifies the fantasy of "self–made" success without recourse to social reproduction; in effect, the continuance of property claims in an immaterial medium is necessary for the valorization of

authorship they enable through the dispropriation of agency (this fantasy of autonomy).

The aura of the digital describes the occlusion of the real conditions of physicality from considerations of the apparently immaterial realm of the digital. These constraints and limitations are inherently imposed on all digital technologies, objects and systems. Yet because the specific ways the digital aspires towards the state of information, producing the illusion of completeness, and poses as independent from material reality, the digital, paradoxically, emerges as an immaterial physicality—spectral, it is both immanently present and creates the pretext of lacking a substantial, material link to reality.

This supposed rupture—in the form of a penumbral immateriality—is the specific illusion that defines the aura of the digital: the denial of immanent physicality in the face of apparent and structural physical limitations and material basis. The confusion of our ability to identify the falsehood that is the digital immaterialism reflects this aura in action. It is precisely because of the confusion of physical and immaterial that the aura of the digital is pervasive.

The nature of the technology itself—the semiotic, immaterial manipulation and transformation of codes—generates the falsehood that the digital is, in fact, immaterial; contrariwise, it is actually a physicality whose encounters with human actors produce the same divergence between object and form that is familiar in our encounters with language: the symbolic interpretations generated by the digital overwhelm the physical testimony of the digital presentations themselves.

The issue with the aura of the digital is not that there is an inherent connection to the physical, but rather that this very real connection is not only denied, it is stripped from our awareness; this absence is the aura of the digital.

Implicit in the right to read is the ideology of the "cutting edge" that renders digital technologies obsolete. With this technological shift from current to antique is a constraint on the particular deployments of the technology—what has variously been called cut–up / mash–up / remix / collage / montage / database–driven work—based around a reassembly of existing materials into "novel" forms. That this aesthetic form has recurred in almost identical approach and form with each new technology (Dziga Vertov experimented with wax recordings

to make "remixes" in the 1920s[7]) suggests these approaches are banal rather than disruptive, (except in the economic language currently attached to "intellectual property" and copyright). Rather than an "exploration" of the new technology, these works suggest a Freudian avoidance of the potential shocks this technology implies through repetition. The psychological dangers unheimlich works may pose are avoided in advance through the rubric of obsolescence and the repetitions inherent to remixing existing familiar materials.

(6)

The nature of digital technology and reproduction creates a fundamental paradox between the interests of ownership and the function of technology: where ownership has always already been a feature of possession, with digital reproduction this connection presents a new problematic. The right to limit access (via DRM) is the key aspect to ownership of digital works. Control over the right to read digital works finds its basis in the older laws designed to control printing and publication: copyright laws that codify assumptions about physical objects and the access and ownership of those works.

Because digital works are (primarily) second order non–object based artifacts, i. e. they are works without particular physical form (and therefore limited by natural conditions of scarcity, manufacturing and material), increasing the ability of the producer to control their digital "property" even when sold to another person becomes an inevitable consequence of the steady shift to digital technology for creating and distributing all aspects of culture.

The transformation of everything that can be digitized into a digital form (the universal aspiration to achieve the state of information as instrumentality) follows from the logic of DRM: the conflict over intellectual property is therefore inevitable, as is the elision of agency and the valorization of social action (refracted through the valorization of the author). Object–based works automatically become the consumer's property, and can be given, resold, etc. once possession is attained, but for non–object based works the digital rights management schemas mean that digital works lack this possession–based dimension of property. Even after a work has been purchased, the banking model for ownership obtains: once possession is achieved, the

consumer does not own the work—they only have a contingent right to read; in its hypothetical form, consumers are unable to resell, give, lend, or share any of the digital works contained by DRM. The mechanisms that control access to digital works also reproduce the conflict they were meant to resolve in a vicious cycle where each new restriction on the right to read intensifies the conflict. In its most basic form, this is a conflict over whether non–object based works are entitled to the same treatment as object–based works.

(7)

The "aura" of a work of art can be regarded as the tertiary interpretative effect resulting from a third interpretative act that uses past experience to create an awareness of that object exceeding both its physical form and its relationship to tradition. This difference allows the existence of "aura" (contra Benjamin) in mechanically reproduced works, via mechanical reproduction— and thus, also allows "aura" in digital (art) works. Awareness of this kind becomes possible through reproduction even though it exists to lesser degrees in traditional societies where awareness of the art works are "reproduced" as linguistic artifacts rather than visual ones. This awareness is imbued with special values (as Benjamin has observed). The earlier works can be understood as being subjects of verbal (non–visual) reproduction and the awareness this type of reproduction produces generates "aura" that is consistent with that generated by digital/mechanical reproduction.

Thus reproduction—mechanical or digital—is the source and vehicle for a work's "aura." A spectator's encounter with a "famous" work as an object is distinctly different than their encounter with an unknown work because it is the wide dissemination of that work through reproduction that creates the particular experience: cultural tourism is based on this idea of encounters with originals whose "aura" is a function of their being widely reproduced. The more fully a work is disseminated, the greater its "aura." Andy Warhol's persona, and his construction of superstars who are "famous for being famous"[8] demonstrates the transient, contingent nature of this conception of "aura," its socially–constructed nature, and its reliance upon (digital) reproduction for existence.

The semiotic/instrumental immortality enshrined as the aura of the digital reifies an ideology where the work of "genius" (literally) "lives forever" within the simultaneous frameworks of DRM and digital reproduction. The ownership of ideas is coupled with the specific material form those ideas take within digital technology. This semiotic immortality becomes instrumental immortality in the realm of digital code executed autonomously by machines: this is the "aura of the digital." The cultural drive to shift all production to this immaterial basis—the information economy—reflects how the ideology of automation enables the expansion of the digital aura.

The aura of the digital signals the digital is the site of a specific reification dramatizing an underlying conflict between production and consumption: the emergence dramatized as digital capitalism—that is, between the accumulation of capital and its expenditure. By enabling the fantasy of accumulation without consumption, digital technology becomes an ideological force reifying the conflict between the limits imposed on the value of capital via expenditure and inflation, and the demand implicit in the capitalist ideology of escalating value. The reciprocity between production and consumption is necessary for the accumulation of wealth (capital) to be anything other than an economic pathology. The lacuna that accumulated wealth presents is one where inflation appears as the necessary corrective—devaluing the accumulated capital in order to maintain the circulation necessary to maintain the dialectic of production and consumption: when capital collects, its value must diminish. The aura of the digital upsets this dialectic by reifying only one side of the construction—the illusion of production of capital without its necessary consumption. The aura of the digital is thus a symptom of the structure of pathological capitalist ideology becoming realized as digital capitalism—a fantasy based upon digital technology without regard for the illusory nature of these transfers, or the reality of the expenditures required in the creation of the digital itself.

Digital technology, its development, deployment, production and access all demand a large expenditure of capital both to create and to maintain. The aura of the digital separates the results from its technological foundation—the illusion of value created without expenditure: a pathological capitalist ideology that demands the valorization of social action it enables through

the ideology of automation, coupled with the implementation of controls over digital technology (DRM) as it aspires towards the state of information and assumes the "aura of information" is coincident with the aura of the digital and digital capitalism.

Even though the origins of the "aura of information" reside in the technical parameters of the digital, its role in the capitalist ideology–fantasy of wealth accumulation renders its conception of the digital not only fundamentally flawed, it is also a formulation that supports the disenfranchisement of human agency by the ideology of automation and its transformation into an immaterial commodity separate from concerns with social reproduction. By naturalizing the concentration of capital, the aura of information transforms digital technology into a magical resource that can be used without consumption or diminishment.

The initial effect of this magical resource appeared as the "dot.com bubble" at the end of the 20th century when the internet first emerged as a popular, commercially exploitable medium. This initial bubble was quickly followed by a larger one with an even more explicitly immaterial basis—the 2008 Housing Bubble. These collapses were inevitable since the values they produced depended upon the exploitation of the production without consumption fantasy. The shift in emphasis towards various forms of "DRM" began even before these controls were implemented by technology itself in the form of technology patents, copyright–based registrations and "subscriptions" to software etc., an initial phase seamlessly moving into technological DRM. The (re–)emergence of "walled–gardens" around proprietary hardware–software combinations affirms those connections between the aura of the digital and the aura of information needed to justify capitalist imposition of controls (DRM) over intellectual property and the technical valorization of social activity they accompany. Otherwise, the aura of the digital threatens the status quo because the illusion of profit without expenditure suggests the possibility that the digital could realize a situation where capitalism itself ceases to exist.

Thus, the aura of the digital is Janus–like, suggesting a magical production without consumption, reifying this fundamental ideology as digital capitalism, at the same time as it implies an elision of capitalism itself. However, all these suggestions proceed from an illusion based in a refusal to acknowledge the real expenditures required in the creation,

production, maintenance, and access to the digital technologies and the materials made available through those technologies which make these ideological fantasies possible. In this regard, the "aura of the digital" can be identified with a pathological myopia: it is implicit in the anti–capitalist fantasy of an "end of scarcity" abolishing capitalism, and for the capitalist ideology reified within the illusion of production without consumption. Each belief is therefore an ideological fantasy reified as instrumentality: a product of each denying the actual physicality, and therefore the expenditures and costs, of digital technology.

REFERENCES

1 Abbing, H. *Why are Artists Poor? The Exceptional Economy of the Arts*, (Amsterdam; Amsterdam University Press, 2004) p. 307.

2 Benjamin, W. "The Work of Art in the Age of Mechanical Reproduction" *Illuminations*, trans. Harry Zohn, (New York: Schocken Books, 1969) p. 221.

3 It is "in principle" *only* because infinite reproduction is a literal impossibility; however, an unlimited quantity of copies can be produced without deviation.

4 Abraham, R., P. Broadwell and A. Radunskaya. *Mimi and the Illuminati; Notes*, pages. pomona. edu / ~aer04747 / mimi / miminotes.html.

5 O'Doherty, B. *Inside the White Cube: The Ideology of the Gallery Space*, Revised Edition, (Berkeley: The University of California Press, 2000).

6 The concept of the "right to read" originates with Richard Stallman, of the Free Software Foundation.

7 Petric, V. *Constructivism in Films: The Man with a Movie Camera*, (Cambridge: Cambridge University Press, 1987); see also: Vertov, D. *Kino–Eye: The Writings of Dziga Vertov*, ed. Annette Michselson, trans. Kevin O'Brien, (Berkeley: University of California Press, 1984).

8 Smith, P. *Andy Warhol's Art and Films*, (Ann Arbor: UMI Research Press, 1986) pp. 195–202.

published in
Off Screen
vol. 11, nos. 8–9
August / September, 2007

SYNCHRONOUS FORM
IN VISUAL MUSIC

The history of visual music, both on film and in other media, is remarkably consistent in its approach to the question of how to synchronize sound and color/image: the structure of the visual music is provided by pre–existing musical form that is systematically translated into the structure of the visual composition. The ideas about synchronizing image and sound revealed by Sergei Eisenstein's discussion of how compositional structures linked to editing are meant as a visual dramatization of the music in the "Battle on the Ice"[1] in *Alexander Nevski* are essentially no different than Oskar Fischinger's animation of shapes and forms synchronized to music in his films in this regard: in both cases, the musical form is taken as given, and determines the structure, arrangement, and form of the visuals.

The approach to sound and image only rarely ever moves outside the established framework of synchronizing visuals to a predetermined score. Experiments in the direct and simultaneous translation of image and sound, as with work by the Whitney brothers, or Norman McLaren, or more recent work by composer/CGI animator Dennis H. Miller where the sound and the image are technological representations of the same thing are exceptional precisely because they are atypical. However, the resulting works these experiments produce serve to "naturalize" the arbitrary nature of their construction, implying that the only appropriate relationship between sound and image is one where they are locked into an absolute, synchronous relationship: in works such as these, there can be no counterpoint between sound and image. Technologically, works of this kind, whether recorded on film/video, or "live" in an interactive environment as with contemporary work by Golan Levin or Leo Villareal, are no different than lip–sync in dramatic film. The music and the image correspond to each other exactly.

SYNCHRONIZATION OF SOUND::IMAGE

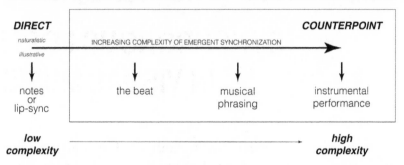

The influence of Oskar Fischinger's work with *illustrative synchronization* cannot be underestimated. The immediate links created by *direct synchronization* are the most common variety of visual music, at least in part, because it is the most commercial. William Moritz has noted in his discussion of Fischinger's films that he used *direct* "synchronization partly because of his commercial ties with record advertising and partly because he found that audiences would more easily accept abstract visual art if it were linked to known music (abstract auditory art) they already approved of."[2] The implication of this comment is clear: that abstract visuals present particular difficulties for audiences, so in order to ensure the commercial viability of his films, Fischinger was forced to make closely synchronized films. However, this also implies a subservience of image to sound—as already noted.

Fischinger's influence is coupled with much earlier assumptions about direct sound–image linkage (i. e. synaesthesia) technologically enshrined in various visual music instruments where depressing a key results in the projection of a burst of color or image. This framework leads to a restrictive understanding of sound–image relationships where the only "acceptable" one is the tight synchronization adopted by Fischinger in the 1920s.

Alternatives are possible. Image and sound can be synchronized in any number of ways other than the direct linkage of note to image. Some alternatives include: synchronization to other aspects of musical form instead of the individual note, such as the musical phrase, the division into measures, a separation based on the individual instrumentation, the relative dynamics of the music, etc. John Whitney's ideas about "visual harmony"

are another approach to creating visual music, one where the structural design of both image and music proceed from the same basis; they do not directly correspond in the manner of *direct synchronization*.[3] Each of these potentials would qualify as a "visual music" but would not necessarily follow the specific parameters of *direct synchronization*, introducing the potential for *counterpoint synchronization*.

Furthermore, it should be observed that music is rarely heard as a collection of disparate pieces, but is instead understood as an unfolding over time. The linkage between images and sounds, where one image is changed for another following the music in a rhythmic montage results in a visual music that is extremely distant from what is heard. In emphasizing the rhythmic aspects of music, all the aspects of harmony, melody, and development over time visually disappear. While this approach may be very common, it offers the fewest aesthetic potentials for visual music.

REFERENCES

1 Eisenstein, S. *The Film Sense*, trans. Jay Leyda, (New York: Harvest/HBJ, 1975) pp. 174–216.

2 Mortiz, W. "Visual Music and Film–as–an–Art Before 1950" *On the Edge of America: California Modernist Art, 1900–1950*, ed. Paul J. Karlstrom, (Berkeley: University of California Press, 1996) p. 228.

3 Alves, B. "Digital Harmony of Sound and Light" *Leonardo Computer Music Journal*, vol. 29, no. 4, Winter 2005 pp. 45–54.

**Proposing a Taxonomy of Abstract Form Using
Psychological Studies of Synaesthesia/Hallucinations**

published in

Leonardo

vol. 40, no. 1, February 2007

pp. 59–65; 48 (color)

A TAXONOMY OF
ABSTRACT FORM

Film historians William Moritz and William Wees have observed an overlap between the forms of hallucination/synaesthesia and abstract film. The parallel histories of synaesthesia, abstract painting, and abstract film, noted by these historians, theoretically allows a consideration of synaesthetic visual forms identified by psychology as the basis for a taxonomy of abstraction. This paper proposes a taxonomy of abstract form anchored in an examination of the history of synaesthesia and abstract art. Existing work on abstract film, especially Wees' *Light Moving in Time,* suggests the possible usefulness of a taxonomy but does not provide one.[1]

Because the taxonomy proposed in this essay originates in Heinrich Klüver's study of mescaline hallucinations and Kevin Dann's discussion of synaesthesia, a brief historical survey of the relationship between synaesthesia and abstraction is appropriate. While any aesthetic taxonomy is necessarily a reification, a brief consideration of the historical context that justifies a taxonomy may suggest a degree of validity for some forms of abstraction.

o

Since this paper employs a variety of terms drawn from art history and the study of synaesthesia, a clear explanation of them is needed. The crucial and most difficult to define term for this taxonomy is "synaesthesia." The use of "synaesthesia" to describe art entails an ambiguity: where for psychology "synaesthesia" refers specifically to cross–modal sensory experiences, such as seeing colors at the same time as sounds, in art the use is often metaphoric, identifying works that attempt to present analogues for one sense, typically sound or music, within another art, most commonly visual art. Bulat Galeyev has discussed these ambiguities in his "Open Letter on Synaesthesia," noting they

are a part of history of its use in art.[2] The ambiguity of use in discussing art appears because "synaesthesia" often refers to both the actual experience of synaesthesia and its use as analogy in describing an artwork.

Within this framework, the term "hallucination" is needed to refer to the subjectively encountered phenomena that individuals may experience. While "synaesthesia" has an ambiguous meaning, "hallucination" retains its technical, clinical designation.

As it is used in this paper, "abstraction" (or "abstract") refers to the broad understanding of "abstract" identified by art historian Jeffrey Schnapp that was employed at the start of the twentieth century.[3] This conception "rarely meant *abstract* in any pure, rigorously formal, non–referential, non–representational visual sense"[4]; it was instead "hybrid,"[5] a formulation that allows the overlap of abstraction in film and painting.

For some historians such as William Moritz, those abstract filmmakers whose work focused on geometric forms, (often) synchronized to music, constitutes an ongoing tradition of "visual music."[6] The creation of abstract art specifically seeking visual equivalents to the forms and structures of music defines a historical tendency that may continue in film. Filmmaker John Whitney's influential theory of "digital harmony"[7] is one example of this link between abstract film and Moritz's visual music tradition. The history of visual music implied by Moritz is one where a desire to create a synaesthetic art motivates the invention of visual music instruments and the eventual dominance of abstract film. As this relationship suggests, the history of visual music on film may be identical to the history of abstract film. These links between early abstraction and synaesthesia suggest a specific variety of abstract art predicated on an analogy between visual form and sound/music: in this paper, it will be identified as "synaesthetic abstraction" in recognition of its basis in the analogical use of synaesthesia in art and its tendency to cross the boundaries between different media.

While "visual music" is related to abstract film, instead of relying on the motion picture projector, these artists worked to invent new technologies to present their work. Perhaps the best known of these artists is Thomas Wilfred. His "lumia boxes" present continuously running sequences of abstract imagery in motion and his *Clavilux* instrument enables a *lumianist* to perform

visually in the same way that live music is performed.[8] "Visual music" is the live performance–oriented aspect of the tradition referred to as "synaesthetic abstraction."

○

The historical interrelationships between synaesthesia and abstract art are complex, as are the forces that combined in the early twentieth century when synaesthetic abstraction emerged. Some aspects of this history have been established by a number of previous studies, such as historian Kevin Dann's book *Bright Colors, Falsely Seen* [9] or in psychologist Lawrence E. Mark's studies of synaesthesia[10] that are both historiographic and experimental. There is enough work in this area that an exhaustive survey is beyond the scope of this essay. What is significant to note is that the study of synaesthesia often overlaps with art historical study of abstract painting. Dann's history of synaesthesia suggests the transcendent claims for synaesthetic abstraction are a direct heritage of the analogy between imagery and music.[11]

As noted regarding William Mortiz's comments, synaesthetic abstraction demands an interdisciplinary approach to these parallel histories. Those artists known for working in one medium often experimented in others: painter Vassily Kandinski experimented with visual music in his play *Der Gelbe Klang*[12]; the Italian Futurists Bruno Corra and Arnolda Ginna made abstract films and then abandoned them to invent a color organ[13]; Oskar Fischinger, who made abstract films synchronized to music, became an abstract painter and built a visual music device called the *Lumigraph*.[14]

The historical connections between synaesthesia and abstraction are especially clear in Kandinski's paintings that contain shapes often observed by synaesthetes, thus providing a clear link between his abstract images and synaesthesia as psychologist Cretien van Campen has noted:

> Kandinski's early abstract paintings (that he labeled
> with musical titles such as *Composition* and
> *Improvisation*) contained the sort of blobs, lines, spirals
> and lattice maps that are experienced by synasthetes.[15]

The forms and shapes in Kandinski's paintings demonstrate two things: a use of forms seen in synaesthetic hallucinations and

the direct connection of these works to a musical analogy (via their titles). These works reveal an analogy between imagery and music that follows the earlier Romantic interest in synaesthesia as a merging of "subjective" and "objective" world views[16]; the initial emergence of abstract art coincides with a wide–spread interest in synaesthesia from both a scientific and an artistic perspective. [17] Cultural groups interested in synaesthesia were also disenchanted with the rigorous, rational world of normative scientific and psychological theory. Dann notes:

> The triumph of behaviorists' view of the human mind and body as reacting machines only served to intensify the Romantic quest for art forms and theories of knowledge that de–emphasized the world of material causes. Romantics held fast to the ideal of the primacy of the imagination, and synaesthetes would continue in their eyes to offer proof positive of the possibility of attaining new ways of knowing.[18]

The nineteenth century viewed synaesthesia as an escape from the predetermined, mechanical world described by the empirical methods and rational procedures of materialist science and behaviorist psychology. As Dann suggests, both synaesthetic art and the physiological phenomenon of synaesthesia were viewed as escapes from the predetermined, mechanical world being described by the empirical methods and rational procedures of materialist science.

The possibility that some artists initially promoting abstraction—Kandinski especially—were themselves synaesthetes [19] suggests a further connection between synaesthetic abstraction and synaesthesia. As Dann has observed, in Romantic ideology, synaesthesia's sensory fusion attained a primordial purity superior to the 'fallen' state of normal perception.[20] Synaesthesia offered a recovery of primal experiences—a more "accurate" depiction of reality. Since some forms of early abstraction are linked to Romantic "non–rational" world views, they have a quasi–religious universal "spiritualism" via transcendental beliefs. Synaesthetic abstraction, by adopting the form of cross–sensory modality, presents the transcendent reality that Romanticism found in irrational states of consciousness and perception.

Dann's commentary on artist A. B. Klein further reveals the links between the transcendence of synaesthesia and the universal, utopian aspirations of Romanticism as they refer to synaesthetic abstraction.[21] The dualism of Dann's observations about Klein are typical of the utopian proposition of synaesthetic abstraction: this utopia/decay dialectic is the meaning of the spiritualism contained by synaesthetic abstraction. It is the Romantic rejection of rationality, materialist science, and behaviorist psychology that Dann identified as their universal claim. However, objecting that abstract art is not, in fact, universal is to ignore the *critical* dimension of that claim. The discrepancy between the empirical belief that a 'universal' must be uniformly the same and the critique of rationality synaesthetic abstraction proposes is resolved by its original context: the claim of 'universality' for what are subjective responses presents a criticism of empirical claims.

As this brief sketch shows, synaesthesia can be correlated to the birth of abstraction, thus offering the potential for a taxonomy of abstract form independent of individual meanings. This outline suggests the spiritual meanings of synaesthetic abstraction result from its relationship to Romanticism; this taxonomy is, therefore, also a description of those forms that convey spiritual content.

o

Neurological and psychological studies have found that while different subjects produce variable associations between specific sounds, colors, and forms, there are constants in these associations that can be empirically described.[22] As William Wees has observed in his book *Light Moving in Time*, Heinrich Klüver's study of mescal intoxication and the resulting visual and synaesthetic hallucinations provides a listing of visual form constants that describe some of the potentials employed in abstract movies.

Klüver's analysis of hallucinatory phenomena appearing chiefly during the first stages of mescaline intoxication yielded the following *form constants:*

> (a) grating, lattice, fretwork, filigree, honeycomb, or chessboard; (b) cobweb; (c) tunnel, funnel, alley, cone or vessel; (d) spiral. Many phenomena are, on close examination, nothing but modifications and transformations of these basic forms. The tendency

towards "geometrization," as expressed in these form constants, is also apparent in the following two ways: (a) the forms are frequently repeated, combined, or elaborated into ornamental designs and mosaics of various kinds; (b) the elements constituting these forms, such as squares in the chessboard design, often have boundaries consisting of geometric forms.[23]

While Klüver is concerned with perceptual distortions resulting from the drug mescaline, he notes the forms of these images are derived from perceptual structures in the eyes and brain.[24] In Klüver's study *Mescal and Mechanisms of Hallucination*, he further makes a series of observations about these form–constants: they evolve and become more complex, compounding their appearance over the course of the hallucination[25]; there is also a progression from organic to complex geometries[26]; and they are shared among a variety of visual disorders and are not limited to mescaline.[27]

Kevin Dann identifies a similar collection of forms as common to synaesthesia: sparks, spots, lines, streaks, and zigzags.[28] Both Dann's forms and Klüver's forms have either a linear character or the quality of objects in space. Klüver further observes that these forms become apparent to normal sight by lightly pressing and rubbing the eyes; this action is often necessary to begin the visual hallucinations associated with mescaline intoxication.[29] Stan Brakhage in *Metaphors on Vision* (1963) has described this "closed eye" vision as the starting point for his own development of non–optical film that culminates in his hand–painted films of the 1980s and 1990s:

> The hand painting was always in a direct relationship to the particular kind of "closed eye vision" that comes only in dreams. The commonest type of "closed eye vision" is what we get when we close our eyes in daylight and watch the moving shapes and forms through the red pattern of the eyelid. . . . Painting was the closest approximation to it; so I painted, throwing down patterns and controlling them in various ways. Shapes emerge out of that kind of eye–nerve action and reaction.[30]

The point that Brakhage makes is that 'abnormal vision' coexists as a liminal perception, and with careful observation, these unseen aspects of sight become visible. Brakhage's closed–eye

FORM CONSTANTS

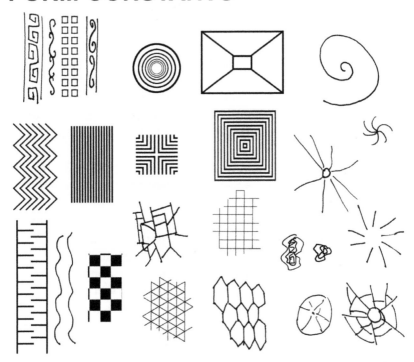

forms appear in synaesthetic abstraction and synaesthesia, and as Wees has noted, these form constants describe a "breakdown of the basic elements of most abstract films!"[31]

By taking Wees' rhetorical comment literally, a taxonomy for synaesthetic abstraction can be constructed based in Klüver's form–constants. They suggest underlying constructive principles; identifying these principles creates the taxonomy:

(a) grating, lattice, fretwork, filigree, honeycomb, or chessboard;
(b) cobweb;
(c) tunnel, funnel, alley, cone, or vessel;
(d) spiral

Analysis of the form–constants yields a series of variables whose relationship and combination can generate synaesthetic abstractions: *symmetry; repetition; form* (shape appearance, curvature, organization; surface color {hue, saturation, value}; luminosity); and *motion.* Klüver's form–constants further suggest

a fluid relationship between the over–all image structure (the "frame") and the structure of individual forms.

(1) Symmetry

Symmetry and regularity are constraints that apply to all levels of this visual construct——to the over–all construction and the forms. These issues are the central parameters that determine the relationships and structure of everything else in the taxonomy. They can describe the overall structure of the entire image as well as the specific shapes located within it. Because of this dual role, there is an unavoidable ambiguity in their description. Symmetry organizes individual forms and the over–all structure of the image.

Regular structures/forms tend towards a simplicity either in symmetrical shape or arrangement or as uniformity in motion (i. e. in a single direction). Irregular structures/forms are combinations of several regular structures/forms——i. e., an asymmetrical form may have symmetrical components.

Whether the forms are 2D or 3D is irrelevant to this level of organization. The form–constants provide a framework for this consideration: Tunnels suggest a recession (symmetrical) into distance, the spiral implies the same monolithic form as the cobweb but recedes in the same way as a tunnel. Thus, the regular/irregular dynamic can be linked directly to a question of symmetry:

irregular	asymmetrical	(0 axes of symmetry)
regular	symmetrical	(1 axis of symmetry)
	radial	(2 or more axes of symmetry)

However, the relationships of regularity and irregularity to symmetry are fluid, not rigidly defined. Where forms may be asymmetrical, the over–all structure may be symmetrical; at another level, asymmetrical forms may be composed of symmetrical parts whose component sections are asymmetrical. Thus, symmetries are a dynamic issue of form/structure.

As the number of symmetrical axes increase, the symmetric forms become closer to infinite (perfect) symmetry—the circle. Regular polygons are the simplest way to visualize how multiple axes of symmetry look. Even numbered symmetrical forms (4, 6 . . .) present two types of "fold": through the corners of the form and through the mid–point of the sides; odd numbered forms

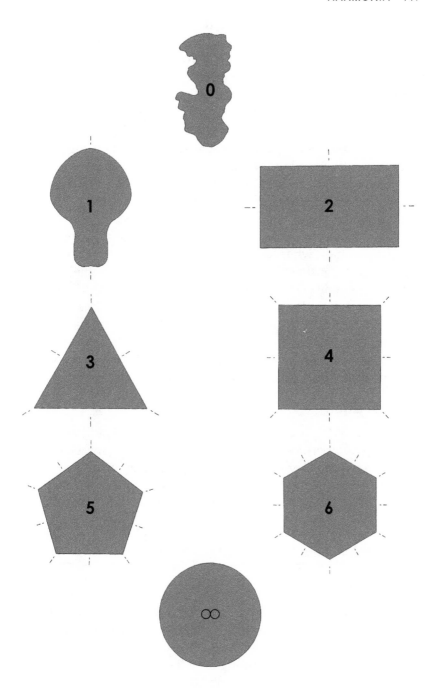

A series of symmetry axes diagrammed to show their "folds."

(3, 5 . . .) present only one "fold" through a corner bisecting the flat side opposite. It is easy to recognize how increasing the number of axes of symmetry can produce the grid, lattice, and honeycomb. . . . These are symmetrical forms repeated across a flat plane as a tessellation (or tiling).

Symmetries, especially ones with large numbers of axes, tend towards the creation of regular forms by their nature; at the same time, increased symmetry also suggests a lower level of complexity, favoring an increased tendency towards all–over patterning, particularly when the symmetry is at the level of the spatial arrangement of forms. The treatment of the frame as symmetrical or asymmetrical determines the visibility of forms in the image. The symmetrical frame results in a radically constrained set of potentials when compared to an asymmetrical frame. In symmetrical constructions, it is much more likely the over–all organization will elide the demarcation between individual forms and create a singular structure that dominates the image. While this is also a potential in irregular compositions, it is much more common that over–all image structures are also symmetrical. Treatment of the frame determines whether the forms are visible as a singular objects or are subservient to the over–all composition.

(2) Repetition

Related to the occupation of the frame is the repetition within that image. Repetition within the frame implies symmetry, but it is not necessarily a form of symmetry. The key difference is the reuse of a single constructive principle across the entire form / image that can describe the organization of individual forms within the frame:

|||

NONE	CONCENTRIC	LATTICE	TESSELLATION

Repetition, however, is not the same as symmetry. Forms repeated at irregular intervals, but forming a series of concentric rings, exhibit repetition but do not follow an all–over symmetry and are not a form tessellation. Tessellations (or tiling) are collections of forms that fill a geometric plane without leaving gaps. The difference between repetition and symmetry is that symmetrical forms are regular by necessity and repeated forms may be asymmetrical. Within this framework for repetition,

forms can be repeated in any number of dimensions (or scales)—laterally, vertically or recursively (as in fractal geometries).

(3) Form

While the regularity or irregularity of a form depends on its symmetry, it is not the only factor in the determination of the form as a separate entity from the frame itself. Symmetry produces regular form, while asymmetry produces irregular form. The issue of regularity and irregularity is no different with individual forms than it is with the entire image.

However, because all the particular values of forms can be manipulated separately and independently, they can be treated as a secondary set of values within the taxonomy, thus forming a parallel set of parameters. These potentials are nevertheless deeply connected to the visual structure of the image since that structure only appears through the organization of form. It constitutes the graphic nature of the visual space within the frame. *Forms* are the units that *symmetry, repetition,* and *motion* act upon to create the image (frame).

(3. 1) Shape

Form is described by a series of independent ranges that enable apparently contradictory forms to emerge, and this relationship suggest the possibility for transformation of the character of forms over time.

(3. 1 a) appearance

|||

LINEAR SOLID

The distinctions between linear and solid forms are more a matter of degree. Because every form inevitably has some degree of width, they can be treated in the same way as solid forms.

(3. 1 b) curvature

(CURVED) (STRAIGHT)

|||

ORGANIC GEOMETRIC

This range is determined by the number and degree of curved (arabesque/baroque) contour lines, providing a sliding

scale between the wholly curved and the wholly linear. The tendency towards geometricization that Klüver notes appears in this schema as a steady movement toward straight lines. The distinction between organic/geometric forms emerge as a direct result of the degree and character of the curvature of the form. This distinction also describes both the extreme ends of a spectrum describing the character of the outline qualities of forms displayed in the image. However there are intermediary stages that are neither and both.

(3. 1 c) organization

||
LINEAR **A R C** **SPIRAL**

The organization of the form describes the apparent over–all shape of the form, rather than the particular character of individual parts of the form. This is akin to the over–all arrangement of the frame, but is limited to a singular form.

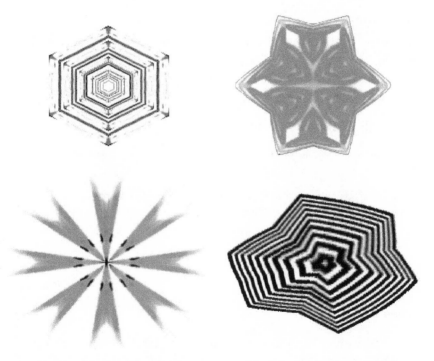

Symmetrical forms displaying repetitions employed in *Eigen* (2007)

(3. 2) surface

The qualities of the forms, as separate from shape, symmetry and motion can be described by two variables: *color* and *luminosity*. They are linked to the relationship between the individual forms, the areas around those forms, and, in the case of motion pictures, what precedes and follows a given form temporally.

(3. 2 a) color

Color is conventionally described by hue, saturation, and value. However, as a value, "color" can be understood differently. Single forms may display either one color or several colored areas. When a form is broken into colored areas, each of these parts can be treated as an individual colored form in itself, subject to all the same variables as single–color forms. Additionally, the colors within a form can be animated within the form itself (i. e., what animated film calls "a color cycle") or used in a combinatory fashion for building up solid areas, thus allowing alternations between figure–ground relationships.

(3. 2 b) luminosity

Luminosity is both an absolute value (the actual luminosity of a form) and a relational one (apparent luminosity). It it generated by the contrast with surrounding forms both physically adjacent in a particular image and temporally adjacent in preceding and succeeding frames. Apparent values are often more important to the encounter with a form than its actual values. The apparent luminosity can also alter the perceived color(s) of a specific form. This conception of luminosity is identical to "value" in color.

The texture of a form is a composite value relating to the interaction between color and luminosity across the expanse of the colored form's area. Texture in a form becomes apparent in the same ways and for the same reasons as in everyday life: subtle nuances and changes in luminosity give the appearance of shadows (inflections) on the surface of the form.

(REGULAR) (IRREGULAR)
||
FLAT T E X T U R E SHADING

Irregular luminosity produces both textural effects at small scales and shading effects at larger scales. It is possible for

multiple shading effects to be in use at the same time within a single form.

(4) MOTION

"Time" appears within this taxonomy as "motion." A motion picture consisting of a single, unchanging frame would be as immobile as a traditional painting, especially if it were a continuous loop without an end. Thus, "motion," by necessity, requires and implies both time and a volumetric space. (Any animation textbook would contain much of this information on motion.) The *apparent* depth of this space is either two dimensional (flat) or three dimensional (moving within a volume). The type of space determines the variety of forms and the motions available to those forms within that space:

> **planar**
> along **x, y** axes
> creating a two dimensional, flat (graphic) space

> **spatial**
> along **x, y, z** axes
> creating a three dimensional, "realistic" space

Planar motion implies an orientation of the plane to the surface of the frame (i. e. the "picture plane"). Any divergence of planar from this orientation introduces an illusory space via foreshortening while still confining the abstraction to two dimensions.

Motion can be divided into the same paired categories of regular/irregular. However, "irregular motion" is simply a complex series of regular motions. Regular motion can be broken into movement along the same (**x, y, z**) axes that define three dimensional space: vertical; horizontal; oblique; curved arc (follows a curve), concentric (moves in circle or spiral), and rotational (the form spins); scale (growing larger or smaller, i. e. **z**–axis motion). Complex, compound motions may become irregular simply through the degree of their complexity. Also, sudden shifts from one type of motion to another may appear irregular.

The character of the motion describes how the motion appears in the sequence, whether it is a constant, continuous movement or not. Discontinuous motion is necessarily irregular

simply because it appears suddenly, without previous indicators for its presence.

(REGULAR)		(IRREGULAR)
CONSTANT	SUDDEN	'JUMPING'
II		
(CONTINUOUS)	(RHYTHMIC)	(DISCONTINUOUS)

The character of motion exhibited is a continuum stretching from constant, continuous motion through increasingly interrupted kinds that exhibit an increasing discontinuity until it simply "jumps" from one position to another.

o

What is significant about this taxonomy is the subordination of the whole framework to issues of symmetry; the interrelationship of motion and form within the regularity / irregularity opposition; and these issues connection to the over–all image. Klüver's form–constants provide a useful model; however, while it is possible to separate the hallucinatory visions into components, this separation is artificial. The reality is a multifaceted visual experience where even though each part can be described, it is their action together that is significant.

What this taxonomy proposes, while limited only to synaesthetic abstraction, has suggestive possibilities when compared to other forms of non–synaesthetic abstraction such as Islamic Art, the geometric forms found on classical Greek vases, and other kinds of decorative abstract patterns. The choice of synaesthetic abstraction as focal point for this discussion of a taxonomy is logical given the foundation of the taxonomy in the psychological study of both hallucination and cross–modal synaesthesia.

This proposal should not be regarded as a negation of the historical idiosyncrasies of the individual art or artists who make abstract art. The irrational referents of the Romantic ideas of synaesthesia–as–critique of rationality might appear to argue against the usefulness, or even the validity, of such a taxonomy for anyone except a researcher. The connection to Romanticism suggests that artists might be likely to resist a taxonomy in favor of subjective, intuitive approaches. For artists working in traditional ways, this may be the case; however, for

artists working with computer–driven "generative" systems, a taxonomy might provide a framework for greater variety and complexity of form in works that are only partially determined by intuitive approaches or direct human commands.

REFERENCES

1 Wees, W. *Light Moving in Time: Studies in the Visual Aesthetics of Avant–Garde Film* (Berkeley: University of California Press, 1992).

2 Galeyev, B. "Open Letter on Synaesthesia" *Leonardo*, vol. 34, no. 4, 2001, pp. 362–363.

3 Schnapp, J. "Bad Dada (Evola)" *The Dada Seminars* ed. Leah Dickerman with Matthew S. Witkowski (Washington DC: National Gallery of Art/ DAP: 2005) pp. 50–51.

4 Schnapp, J. "Bad Dada (Evola)" *The Dada Seminars*, ed. Leah Dickerman with Matthew S. Witkowski (Washington DC: Naional Gallery of Art/ DAP: 2005) p. 50.

5 Schnapp, J. "Bad Dada (Evola)" *The Dada Seminars* ed. Leah Dickerman with Matthew S. Witkowski (Washington DC: National Gallery of Art/ DAP: 2005) p. 50.

6 Moritz, W. "Visual Music and Film–as–an–Art Before 1950" *On the Edge of America: California Modernist Art, 1900–1950*, Paul J. Karlstrom, ed. (Berkeley: University of California Press, 1996), p. 224.

7 Whitney, J. *Digital Harmony*, (Peterborough: Byte Books, 1980).

8 Wilfred, T. *Thomas Wilfred's Clavilux* ed. Michael Betancourt, (Washington: Borgo Press, 2006).

9 Dann, K. *Bright Colors Falsely Seen* (New Haven: Yale, 1998).

10 Marks, L. "On Associations of Light and Sound" *American Journal of Psychology*, (1974) Vol. 87 No. 1–2, pp. 173–88 and "On Colored–hearing Synaesthesia" *Psychological Bulletin*, (1975) Vol. 82, No. 3, pp. 303–331.

11 Dann, K. *Bright Colors Falsely Seen* (New Haven: Yale, 1998) p. 65–119.

12 Originally published in *Der Blaue Reiter*, 1912. The Thomas de Hartman Papers, Irving S. Gilmore Music Library, Yale University, Series II. A. 1, folders 22/192, 22/193, 22/195.

13 Corra, B. "Abstract Cinema——Chromatic Music" *Futurist Manifestos* ed. Umbro Apollonio, trans. Robert Brain (Boston: MFA Publications, 1970) pp. 66–69.

14 Moritz, W. *Optical Poetry: The Life and Work of Oskar Fischinger* (Bloomington: Indiana University Press, 2004).

15 van Campen, C. "Synasthesia and Artistic Experimentation" *Psyche*, 3(6), November 1997, np.

16 Dann, K. *Bright Colors Falsely Seen* (New Haven: Yale, 1998) p. 94–95.

17 Ione, A. and C. Tyler. "Is F–Sharp Colored Violet?" *Journal of the History of the Neuroscience 2004*, vol. 13, no. 1, pp. 62–64.

18 Klüver, H. *Mescal and Mechanisms of Hallucination* (Chicago: University of Chicago Press, 1966), p. 93.

19 van Campen, C. "Synasthesia and Artistic Experimentation" *Psyche*, 3(6), November 1997, np.

20 Dann, K. *Bright Colors Falsely Seen* (New Haven: Yale, 1998) p. 94–119.

21 Dann, K. *Bright Colors Falsely Seen* (New Haven: Yale, 1998) p. 91.

22 Klüver, H. *Mescal and Mechanisms of Hallucination* (Chicago: University of Chicago Press, 1966),pp. 65–80.

23 Wees, W. *Light Moving in Time: Studies in the Visual Aesthetics of Avant–Garde Film* (Berkeley: University of California Press, 1992) p. 66.

24 Klüver, H. *Mescal and Mechanisms of Hallucination* (Chicago: University of Chicago Press, 1966),p. 67–68.

25 Klüver, H. *Mescal and Mechanisms of Hallucination* (Chicago: University of Chicago Press, 1966),p. 66.

26 Klüver, H. *Mescal and Mechanisms of Hallucination* (Chicago: University of Chicago Press, 1966), pp. 66–67.

27 Klüver, H. *Mescal and Mechanisms of Hallucination* (Chicago: University of Chicago Press, 1966),p. 67–68.

28 Dann, K. *Bright Colors Falsely Seen* (New Haven: Yale, 1998) p. 73.

29 Klüver, H. *Mescal and Mechanisms of Hallucination* (Chicago: University of Chicago Press, 1966),p. 20.

30 Sitney, P. "Introduction" *Metaphors on Vision* (New York; Film Culture, 1963), np.

31 Wees, W. *Light Moving in Time: Studies in the Visual Aesthetics of Avant–Garde Film* (Berkeley: University of California Press, 1992) p. 127.

published in
Vague Terrain
issue 09: "Rise of the VJ"
2008

WALLPAPER AND/AS ART

A common concern when considering VJ as an active practice, outside the confines of the gallery, is the issue of the relationship between the audience and the performance work: the question of what constitutes "wallpaper" and what constitutes "art." This is an often contentious question; however, it is also spurious—a reflection of an established hierarchy between venues that has less to do with the performance itself and more with the status of the site where that performance happens. It is a question of whether (in extreme cases) the performer dominates the viewing situation or the audience dominates. In order to understand the dynamic where the audience chooses to see a work in a non–art venue as "art" requires a consideration of the audience's choices, rather than the demands of the performer.

The key question being posed is not a question about the definitions of "art" or "wallpaper"—although a great deal has been written about both in relation to VJ practice—but about the relationship between audience and the performance. Art can be transformed into wallpaper, just as wallpaper can be transformed into art. (There are many examples of both from art history.) However, aside from the literalness of Andy Warhol's *Cow Wallpaper*, the transformation is conceptual: it is a matter of how the audience chooses to engage with the work itself. It is a question of whether the audience *engages* the performance or *consumes* it. Context plays a role in framing the performance as something to engage or consume—a performance in a gallery-type setting invites engagement, while the same performance in a nightclub invites consumption, as do the performative strategies that invite one engagement over the other.

The question being asked, then, is *what strategies tend to invite engagement rather than consumption of the work in question, regardless of context?*

Context is a crucial determining factor for the conceptual approach most likely to be adopted in relation to a given work. Setting aside context has several consequences. First, it emphasizes the formative, internal aspects of a work. Second, it recognizes the potential for works whose underlying construction forces engagement no matter what their context is. Eliminating context from this consideration is important because context provides a foundation of assumptions that can prevent our recognition that audiences are always actively engaged in a work, making the decision moment–to–moment about how to approach it: either passively as consumer, or actively. Much of the distinction between a VJ performance called "*wallpaper*" and one called "*art*" depends on whether the audience decides the work needs an active engagement rather than the continuous partial attention a "wallpaper" performance receives. This decision is the difference between an engaged viewing and a consuming one.

Semiotician Umberto Eco's description of serial form[1] enables the identification of what can cause an audience member to decide to change the category of their viewing. Eco states that spectators implicitly use an internal model derived from their past experience with other examples of type. Audience members past experiences define their expectations, and it is these expectations that are either met or violated by the work in question. The spectator's interpretations employ frameworks created through previous encounters with similar types to anticipate and recognize divergences from established norms (Eco 1994: 90–95). It is important to note that when an audience member encounters something new, they quickly establish a set of expectations based on what they see while watching the work and then make decisions about how to watch based on these quickly–formed expectations; their past expertise with other visual media—TV, movies, etc.—also inform their decisions about how to watch the work.

Creating an actively engaged audience is therefore more complex than simply violating established norms of either common media viewing or those of VJ itself. It requires a dynamic engagement where the internal parameters of the performance itself shift during the performance: a break–up into distinct "movements" or "actions" whose relationship to each other, as well as to the audience's established expectations is not instantly apparent, but emerges from the organization of the

whole. Blanks spaces of darkness, counter–point rhythms, shifts in synchronization between sound and image, or the intrusion of the unexpected (a fire alarm for example) are all potential points of rupture that violate the expectation of VJ as background for other activity—these examples can prompt a shift in awareness from consumption to active engagement.

There is a tendency to ascribe to performative situations (gallery/theater) a high level of "art" simply through the dominance over audience these venues often provide; (this view is the converse of the idea that audiences in such venues treat VJ performances as art rather than as wallpaper). However, it is equally possible to see a reversal of dominance in the non–art venue (for example, the night club) where VJ performance is often treated as wallpaper: the question of encouraging a non–wallpaper response in such a venue can be seen as either a question of re–asserting dominance over the audience, or of "negotiating" an actively engaged viewing situation.

The choice to engage or consume (disengage) depends on the perception that the visuals are more than simply background (wallpaper). It is a decision that develops (in a key way) from the perception of there being an unseen human agent directing the visuals. It is the suggestion that there is a more conscious relationship between sound–image than mechanical synchronization or mere accident that is essential. The performance, to merit an engagement with it as art, necessitates the potential that it has an "intentional" component—the possibility that something may be communicated through the performance itself. Thus, what matters in a performance is the perception by the viewers of an intelligence directing the work (whether such an intelligence is *actually* doing so is different than the audience reaching that conclusion).

There are three kinds of relationship between visuals and their audible accompaniment—*synchronous, asynchronous,* and *variable*. A synchronous relationship is one where specific images are linked directly to some aspect of the sound, most often it is the image changes on specific notes. Asynchronous is occasionally confused with "counterpoint" because it has no direct relationship with the sound, being instead a essentially independent entity that just happens to run at the same moment as the sounds. Variable relationships are the broadest group of linkages: any synchronization that is tied to musical phrasing,

rhythmic structure, or other less–than–instantly apparent connection between sound and image. True counterpoint structures belong to this class of relationships.

What these three descriptions provide is a general framework that allows a consideration of greater complexity in the performance; multiple levels of relationships running through a performance at the same time are the most likely to provoke an active engagement—i. e. constructing a performance that uses synchronized, variable and asynchronous elements together, and which brakes the performance into sections where the "rules" that govern the audio–visual relationships change, forcing a re–engagement by the audience in order to understand what is happening.

REFERENCES

1 Eco, U. "Interpreting Serials" *The Limits of Interpretation* (Bloomington: University of Indiana Press, 1994) pp. 83–100.

Intellectual Process, Visceral Result:
Human Agency and the Production of Artworks via
Automated Technology

published in
Journal of Visual Arts Practice
vol. 7, no. 1, June 2008
pp. 11–18

INTELLECTUAL PROCESS, VISCERAL RESULT

In the *New York Times* art review "Computer Generated Pictures," published on April 18, 1965, Stuart Preston made an eerily prescient prediction in his review of the first computer art exhibit:

> [Some day] almost any kind of painting can be computer–generated. From then on all will be entrusted to the *'deus ex machina.'* Freed from the tedium of techniques and the mechanics of picture making, the artist will simply create.[1]

When one considers the painting– and sculpture–making machines of Roxy Paine for example, it is tempting to believe this situation has come to pass, raising the implicit question of Preston's comment: what does the artist do that qualifies as "simply create" if the artist actually needs to do nothing to produce a particular art work? This question is the problematic provoked by autonomous systems: if computers can produce art without the need of the artist to guide them, then what could be called "Preston's problematic" appears: the artist may surrender their agency in the creation of art to a machine, rendering themselves irrelevant to the creation of art.

Automated systems for making art present specific problematics for human agency, and they apply equally well to earlier developments in automated technological art, such as Mary Hallock–Greenewalt's *Sarabet*, a technological instrument that began as an automated, mechanical system for visual accompaniment to music; or in the work of other artists who constructed automated color organs such as

Richard M. Craig.[2] The implications of Sol LeWitt's comments on "conventions" suggest a possible framework for thinking about art making in a way divorced from human activity, if not human agency.

LeWitt's *Sentences on Conceptual Art* (1968) includes four sentences that directly mention working with/within the "conventions of art." These sentences are significant because they propose that art making is explicitly a matter of conditions that determine the work of art by creating a network of potential approaches to its facture. As a whole, the twenty statements suggest that the conventions of art are historically contingent objects,[3] directly influenced by the art they describe. This is a dynamic situation, where the conventions constrain the potential objects which can be art as they are affected by those objects. [4] These sentences are representative of shift in Conceptual Art from the creation of objects to the generation of specific conditions for the creation of art based on "the artist or somebody else fabricating or describing the piece as equal conditions for the production of [the art], thereby abolishing the notion of artist centered production,"[5] a situation that has explicit implications for automated art, since the role of the artist is extremely attenuated when compared to, for example, a handmade (manually produced) painting.

However, where Conceptual Art abolishes the object as well as the artist's physical labor in creating the art work, LeWitt's *Sentences on Conceptual Art* still assume that there will be some type of object produced from the artist's activity; this feature of his articulation makes his comments more directly applicable to any theorization of human agency in relation to automated art– making systems. The significant factor in such a framework is how the human agency is separated from the mechanical aspects of actually making the work. LeWitt's comment that "The idea becomes a machine that makes the art."[6] is a good example of this framework in action and provides a point of reference for considering these statements as the basis for a theory of human agency:

(17) All ideas are art if they are concerned with art and fall within the conventions of art.

(18) One usually understands the art of the past by applying the conventions of the present, thus misunderstanding the art of the past.

(19) The conventions of art are altered by works of art.

(20) Successful art changes our understanding
 of the conventions by altering our perceptions.[7]

While LeWitt mentions "conventions" and uses the term as if it is unquestioned what these "conventions" may be, the precise nature of that concept is unclear. Understanding the specific nature of these "conventions" clarifies their application to contemporary work by artists, such as Roxy Paine, where the question of human agency is central: when devices create art autonomously, determining what constitutes human agency is necessary in order to decide what constitutes the art. What is at stake in this situation is the status of the objects produced; this interpretation assumes that art is dependent on human agency, so the relationship between human agency and the autonomously produced object is crucial.

Creating a framework for human agency in relation to autonomous systems depends on understanding the meaning and role of "conventions." The two most apparent approaches to the meaning of this term are not directly opposed, but neither do they provide an understanding of what can be done with the conventions. The first would take "conventions" to mean those rules for selecting from possible objects for inclusion in the category "art," and would provide guidelines for ranking those objects hierarchically. The second understanding of this term shows methods to interpret the works already in the category called "art," and aids in developing arguments about their significance and meaning.[8]

Both approaches to the meaning of "conventions" assume that the received meaning of "art" (i. e. the traditional definition) is not in doubt. Such a usage of "conventions" takes the form of a lexicon of established ways and means—practices having particular meanings as a result of their repeated use. Making art with this view of conventions is essentially academic; the conventions are received dicta not open to question, debate or investigation.

However, within LeWitt's statements there is a third understanding of these sentences that suggests the "conventions" are directly connect to the process of making the works themselves: a set of rules invented by the artist based on their particular interests, using history as source and referent. This approach

can be understood in terms of (*a*) avant–gardism and those objects that may be included as art; or (*b*) interpretation, work commenting on its historical embeddedness; or (*c*) as a comment on the direct influence that an artwork can have on subsequent work—how all art is interpreted by each new work's expansion / comment on the history of art. The third interpretation is one which emphasizes process. This would be the "productive" interpretation of the *Sentences on Conceptual Art*.

This third interpretation raises (again) the question of human agency in making art. Approaching conventions as a set of rules whose application will determine a particular work enables a view of human agency separated from the fabrication of the art work, an approach that has ample historical support ranging from Marcel Duchamp's readymades through the use of commercial reproduction, and even the historical debate about photography as art. It is a history where the removal of direct, clear human agency (as in manually produced artworks) results in a denial of the status "art." Each of these historical examples raises the question of human agency anew. They are all examples of Preston's problematic where deciding a work is "art" demands a new consideration of human agency in regard to fabricating artworks.

The concept of "axioms" from the field of mathematics provides a useful parallel for "conventions" in art. Viewing conventions as axioms makes them into a function of the framework used in the working process. LeWitt states that these constraints—when drawn from the history of art—form the conventions an artist employs in the process of making art work. The crux of his sentences is the relationship an artist has to the source of those conventions: given the breadth of art history, it is arguable that these conventions could take potentially any form; his comments suggest that creating the boundaries necessary for working becomes part of the artist's work (or is the art itself).

Art objects exist simultaneously as objects for interpretation and as expressions of specific conventions whose relationship may not be self–reflexive: the conventions themselves are separate from any meaning that may result from following those conventions. The concept of "style," as used to describe traditional art, can be understood to perform this role. The creation of a convention set (whether explicitly as "conventions" or implicitly through "style") provides the logic of the sequence.

These conventions produce a network of potentials that enables the creation of the individual work. This framework necessarily constrains the physical form of the work and the possibilities for depiction within that form.

LeWitt's conception of "conventions" suggests a radically different view of artistic creative process, one much closer to mechanical design than the action of "genius." The artist chooses / creates the conventions that are the operational parameters for the artwork, then constructs objects within that field of potentials. Whether this fabrication is manually or autonomously done makes no difference to the issue of human agency because the crucial decisions about the art takes the form of conventions, rather than the artist's labor in making objects. LeWitt's sentences propose a typical approach to Conceptual Art that can allow the instructions become the work, eschewing objects in favor of the audience mentally creating the art; Yoko Ono's fabrication of her "instruction paintings" in the 1990s[9] demonstrates the feasibility of these instructions in the actual creation of objects.

When making art becomes an autonomous process, the aesthetics of the work are literally built into the machine itself. This issue is especially clear with an entire category of art–making devices called "color organs." Mary Hallock–Greenewalt, an early developer of color organs (and inventor of new technologies), described two specific potential approaches[10] to visual music: (*a*) the live, virtuoso performance and (*b*) automated performance, where a machine performs using a prearranged set of instructions of color music.[11] The automated approach (*b*) has been employed by various other artists whose machinery responds to music following a predetermined set of potentials; this latter variety is the "music visualizer" now a common feature on most computers.

What these machines all have in common is the decisions about the relationship between sound and image must be made by the artist a priori to the construction of the device: the visualizer cannot exist without these conventions. The determining factor separating one "music visualizer" from another is what it does—i. e. what conventions it establishes in how it visualizes music.

Hallock–Greenewalt's machines create very different effects than Richard M. Craig's *Radio Color Organ*. His machine was specifically designed to generate autonomous visual accompaniment to broadcast music. [12] Whether the artist or

someone else then manufactures the machine is irrelevant since the significant choices—the artist's agency as artist—determine the machine's function. The artist chooses which conventions to follow and which to ignore, constrained only by the technology available; Hallock–Greenewalt was forced to invent new technologies to enable the construction of her visual music instrument, the *Sarabet*. This technologic limitation is not one of aesthetics derived from art history, but an engineering problem.

The historical development proposed by Clement Greenberg in "Modernist Painting" where each successive new art is a historically mandated reduction towards "purity"[13] cannot apply to works created within this framework because the conditions which would allow such development no longer apply.[14] Any art that asserts such a framework would (ironically) appear either ahistorical or quotational rather than simply a manifestation of a historically mandated art. LeWitt explicitly states this situation in sentence "(19) The conventions of art are altered by works of art." As philosopher of art Arthur Danto has observed,

> The philosophical question of the nature of art, rather, was something that arose within art [following the 1960s] when artists pressed against boundary after boundary, and found that all the boundaries gave way.[15]

These boundaries were defined by the traditions which the avant–garde systematically attacked and destroyed between the 1860s and the 1960s, with the resulting effect that artists entered into the new historical moment, unconstrained by tradition that Danto describes; LeWitt's sentences are a product of this changed relationship to the past.

o

Implicit in this framework is an understanding that conventions are specifically serial; a particular historical framework presents constraints on the potentially available forms (called "aesthetics"). Making art requires the elaboration of specific groupings of conventions whose choice is fundamentally arbitrary (a matter of the individual artist's choice rather than mandated by any external authority such as an academy or

Feb. 3, 1931. R. M. CRAIG 1,790,903

RADIO COLOR ORGAN

Filed Sept. 23, 1929

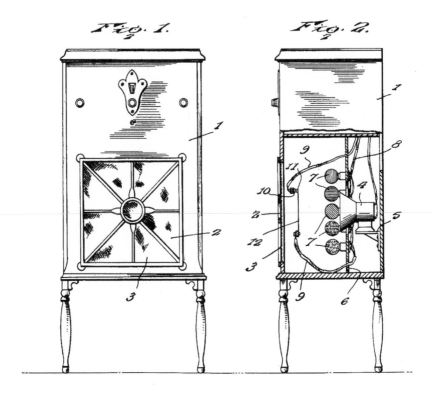

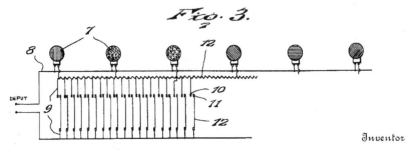

Inventor

R. M. Craig.

By

Lacey & Lacey,

Attorneys

US Patent no. 1,790,903, "Radio Color Organ," Richard M. Craig, 1929

tradition). Umberto Eco explains what this conception of "seriality" means:

> The real problem is that what is of interest is not so much the single variation as "variability" as a formal principle, the fact that one can make variations to infinity. Variability to infinity has all the characteristics of repetition, and very little of innovation. But it is the "infinity" of the process that gives a new sense to the device of variation. [. . .] What becomes celebrated here is a sort of victory of life over art, with the paradoxical result that the era of electronics, instead of emphasizing the phenomena of shock, interruption, novelty, and frustration of expectations, would produce a return to the Cyclical, the Periodical, the Regular.[16]

In describing serial forms, Eco also identifies the atomization effected by conventions. The return to repetitious, continuous forms is not as surprising as it sounds from Eco's description. The demands imposed by the adaptation of aesthetic methods towards procedures adoptable by automated production, with its historical foundations in the assembly line breakdown into modular components joined into a seamless whole. Eco's observation that the "era of electronics" effaces fragmentation in favor of continuity is a return of the classical idea of "transparency" where the actual manufacture of the art work is hidden from view, instead presenting an illusion of seamless facture; this transparency is also a goal of designers who develop computer software,[17] suggesting a possible inverse correlation between the experience of interruption provided by the technology and transparency, i. e. the greater the interruption, the more it will be used to create a transparent experience.

As Paine's machines or Hallock–Greenewalt's *Sarabet* demonstrate, constructing a machine of any type is an issue of engineering, and in order to build a device capable of producing the desired result it requires an explicit description of any physical product that particular machine will make. An explicit iteration of conventions is required for the design of machinery for the automated creation of artworks. Machines for fabricating art therefore make the conventions of art an immanent part of their design; i. e. their conventions (the aesthetics they employ) are an emergent property available by examining their design.

These conventions are also apparent through the product (the art) created by the machine's operation. At the same time, the approach to creating art this framework describes is one where the artist assumes the role of designer, in effect separating the fabrication of the art (including the manufacture of the machinery) from the decision making process that leads to that art.

Situating human agency at the decision making stage of the art's production creates two distinct ways to view the function of the framework in producing the art. Emphasis can be placed on either (*a*) the machine itself, or on (*b*) what the machine produces. Robert Scott's discussion of Paine's robots for making art—built to function like an automated assembly line—clarifies this issue:

> Paine's PMU (Painting Manufacture Unit), 1999–2000 provides a perfect example of this rigorous engineering. [. . .] To make just one painting, the process [the machine follows] may repeat itself between 80 and 200 times, without any intervention whatsoever from the artist. [. . .] Paine's insistence on this technical exactitude and lack of superfluous detail reveals his surprisingly mechanistic understanding of the inventions he aptly regards as "labor saving devices." By automating processes lasting from may hours to many days, they spare the artist's time and attention, rendering his engaged presence irrelevant to the creation of the work.[18]

Paine's use of the computer as a technical device avoids the physical labor of the artist, since once set in motion it will make art without any further need for assistance. If the artist's programming and design of the machine gains emphasis as in Scott's description of the Painting Manufacture Unit, it makes the result simply a proof that the machine does what it should. This "proof of function" interpretation literalizes Sol LeWitt's comment that "the idea becomes a machine that makes the art." Viewing what the machine makes as a "proof of function" renders those works simply an iteration of following the instructions, specifically displacing the art from the fabricated works to on the machine itself and its processes, something Paine's concept of "labor–saving devices" argues against. The same lingering skepticism that denied photography the status of art for the first century of its existence is evident here in the tendency to deny

the art produced by a machine status as an art work, even though that machine follows the artist's specifications precisely.

What is at issue with these works is the question of human agency in the creation of art: what role must the artist have in relation to the creation of the art for it to be immediately acceptable as art? Paine's work, while provocative in this regard, "plays it safe" by exhibiting both the mechanism and the results of its functioning. The presentation of both autonomous machine and its products together avoids the problematic this work suggests by allowing the "proof of function" interpretation, an approach that is less readily available if the machine is not exhibited in conjunction with the work produced.

This proposed framework for understanding art–making based on human agency divorced from direct human action is implicit in the idea of conventions suggested by Sol LeWitt in his *Sentences on Conceptual Art*. The ability to break the process of making art into a set of descriptive instructions (the network of potentials that conventions produce) is a prerequisite to being able to produce art–making machines. By focusing on the decision–making aspects of human agency in determining the final art work rather than the active, physically engaged dimension of art creation, it becomes possible to consider the distinctions between these two activities and the ways they combine to literally inscribe aesthetic concerns and beliefs about the nature of the work in the construction of machineries for making art. This framework recognizes the artist's role as the designer of art, rather than as necessarily the fabricator of those works. Understanding the creation of art in these terms extends the recognition that skilled laborers employed by an artist (in the form or technicians or assistants) in making art can be applied and understood as in the use of automated technology as well.

REFERENCES

1 Preston, S. "Reputations Made and in the Making" *The New York Times*, 18 April, 1965, np.

2 Betancourt, M., ed. *Visual Music Instrument Patents, Vol. 1* (Holicong: Borgo Press, 2004).

3 Poggioli, R. *The Theory of the Avant–Garde* (Cambridge: Harvard University Press, 1968) pp. 56.

4 Eco, U. Postscript to *The Name of the Rose* (in Italian) trans. William Weaver (New York: Harcourt Brace Jovanovich, 1984) pp. 66–67.

5 Alberro, A. "Reconsidering Conceptual Art" *Conceptual Art: A Critical Anthology* Alexander Alberro and Blake Stimson, eds. (Cambridge: The MIT Press, 2000) pp. xxii–xxv.

6 Lippard, L. *Six Years: The Dematerialization of the Art Object* (Berkeley: The University of California Press, 1997) p. 28.

7 LeWitt, S. "Sentences on Conceptual Art, 1968" *Art–Language* Vol. 1, No. 1, 1969, reprinted in *Conceptual Art* ed. Ursula Meyer (New York: Dutton, 1972) pp. 174–175.

8 Danto, A. *Beyond the Brillo Box* (Berkeley: University of California Press, 1990) pp. 217–231.

9 Ono, Y. *Instruction Paintings* (New York: Weatherhill, 1995).

10 Hallock–Greenewalt, M. *Nourathar: The Fine Art of Light–Color Playing* (Philadelphia: Westbrook Publishing, 1946).

11 Betancourt, M., ed. *Mary Hallock–Greenewalt: The Complete Patents* (Wildside Press, 2005).

12 Betancourt, M., ed. *Visual Music Instrument Patents, Vol. 1* (Holicong: Borgo Press, 2004) pp. 167–171.

13 Greenberg, C. *The Collected Essays and Criticism, Volume 4* (Chicago: University of Chicago Press, 1986) pp. 85–93.

14 Danto, A. *Beyond the Brillo Box* (Berkeley: University of California Press, 1990) p. 46.

15 Danto, A. *Beyond the Brillo Box* (Berkeley: University of California Press, 1990) p. 15.

16 Eco, U. "Interpreting Serials" *The Limits of Interpretation* (Bloomington: University of Indiana Press, 1994) p. 46.

17 Pold, S. "Interface Realisms: The Interface as Aesthetic Form" *Post Modern Culture*, vol. 15, no. 1, 2005, par. 6. www.iath. virginia. edu/pmc/current. issue/15. 2pold.html.

18 Rothkoff, S. *Roxy Paine* (New York: James Cohan Gallery, 2001) pp. 21–25.

published in
Vague Terrain
January, 2009

TECHNESTHESIA
AND SYNAESTHESIA

There is an analogous relationship between technological translations of data from one type to another with synaesthetic responses: the transcoding of electromagnetic telemetry by Dr. Donald Gurnett is one a striking and direct example of this type of sonification of non–sound data; however, it is also, in many ways, a non–significant transfer: the data in question are readings of wave–form encounters. The electromagnetic information produced from the Cassini mission, among others, has a long–recognized analogous relationship to sound, so the transfer from light waves to sound waves should come as no surprise—each is a physical phenomenon whose transfer is less dramatic than the cross–modal sensory transfers familiar from synaesthesia.

Sonification is not a synaesthetic process; it is an adaptation either of one wave–form description to another (light to sound) or the technical translation, following an arbitrary series of parameters. Both these cases, while they can generate non–trivial effects, are entirely different from the biological phenomena of cross–modal processing known as synaesthesia. The assumption that dominates in discussions of aesthetic synaesthesia in relation to technical apparatus is that an analogous transfer, following a human–determined and controlled paradigm, results in a technical approximation of synaesthesia. For non–digital systems, such as those devised throughout the twentieth century by inventors such as Thomas Wilfred or Mary Hallock–Greenewalt, alternatives to this assumption were not available; generative and expert systems suggest the limits of this assumption.

A more intriguing potential for transcoding lies within digital technology, and there may be a more fruitful comparison to be made with this model: whatever the initial input into the digital system, once it has been processed (digitized) all inputs become equivalent. While the human sensory apparatus is not a digital

or digitizing system, all sensory inputs are translated into the same medium—nerve impulses—and are interpreted into the dynamic reality we experience by different "modules" of the brain. Synaesthesia appears within this organic model as the interpretation of one senses' inputs by a different "module" than typically interprets those inputs. The occasional mis–attribution of digital files and their consequent mis–interpretation through the "wrong" software is thus a logical analogy for synaesthesia within a technical matrix, a technesthesia.

Organic cross–modal experiences are autonomous, functioning outside of direct conscious control, the associations generated in the processing being specific to the particular individual synaesthetic experience. It arises spontaneously from the interpretative dimensions of consciousness which are responsible for taking sensory experience and transforming it into the world we interact with. Projects with facial recognition, such as Ethan Ham's *Anthroptic* (2007) or Alexander Mordvintsev's *Deep Dream* (2015), both of which use software meant for facial recognition tweaked to produce irrational, non–face results, suggest the potential for non–trivial overlaps between digital interpretative systems and our own organic interpretations.

However, to assume a literal overlap between the human synaesthetic experience and the technesthetic is to make a fundamental category mistake. The apparent results of such "errors" do not necessarily resemble the human sensory experience; however, they do reveal something similar—underlying and inaccessible structures of the interpretative apparatus itself. With the human mind, what appears are aspects of the synaesthetic individuals' idiosyncratic interpretative apparatus and how that normally inaccessible apparatus functions, with a machine, what is revealed are some of the assumptions ingrained in the design and programming of the software itself.

It might be tempting to identify the technical synaesthetic effect as a "glitch" would be an error. The mechanical misinterpretation in question is not a result of an error in the coding, but rather a result of misattribution—a confusion of type rather than a mistake in execution. The digital file in question is intact, it is merely being decoded following an incorrect interpretative paradigm, akin to the errors that appear as a result of incompatibilities between different versions of the same program.

Sound–to–image visualizers, or image–to–sound translators do not qualify as examples of technesthesia. The audible translation of an image following a predetermined (or user–mappable) set of parameters is nothing more than the attempt to recreate synaesthesia following a set paradigm; the autonomous translation of a *QuickTime* movie into a sound file is, in contrast, an example of technesthesia. It is autonomous, uncontrollable and follows the underlying structure of an otherwise normally–functioning software. It is a special case of misattribution within a normally functioning system, not the normal function of a program designed to produce some specific transcoding. This abnormality of function in an otherwise normally functioning system is the key to this analogical relationship to synaesthesia—synaesthetes (typically) are not crippled by their conditions, nor are these experiences the results of some special intervention against otherwise normal function. A technical analogue to the organic experience must meet the same base–line criteria of exceptional experience within otherwise normal function.

The custom creation of "patches" or codecs to enable these transfers so long as they do not destabilized normal functions, however, would meet the base–line criteria for a technesthetic "player" or software program.

Yet, it might be more conceptually fruitful not to look for a "visualizer" but rather to follow the model implied by simulations of human abilities such as facial recognition. In such a model, the human capability is modeled as a series of rules and the results either match our experience or deviate from it: this is the "false positive" that such programs can generate; however, these "false positives" can be thought of not as failures, but rather as a discovery of technical 'fantasy' within the digital system, non–conscious, but redolent of human failings. A technesthetic result might initially appear as such a technical failure, rather than as a positive effect to be explored and examined. It is precisely the rupture from responses mirroring the human that makes technesthesia difficult to differentiate from glitch—it is also a result of a mistake in the processing, but rather than being a break–down, it is a confusion of type, and as such is repeatable, stable and consistent in its effects—the opposite of the prominent features of glitches: their transitory appearance and instability. A glitch may not be repeatable, but technesthesia is.

published in
Hz
no. 19
July, 2014

CRITICAL GLITCHES
AND GLITCH ART

'Glitch art' is ambivalent. It confuses the relationship of signal::noise, while at the same time establishing the glitch as a definitional precondition: it is a recovery of technical failure as the formal basis for media practice. These mechanical interruptions of the typical functioning of digital media—whether in audible or visible forms—have been employed in electronic media for decades (Nam June Paik's video processing effects initially appear in technical repair manuals for television receivers produced by RCA in the 1950s.[1]) The aura of the digital's separation of the physical and digital dimensions of digital art from consideration is especially pronounced with media works; user–audiences for these technologies rarely become concerned by the interruptions posed by technical failures: just as the aura of the digital serves to strip the physical dimensions of media from consideration, the identification of these digital artifacts as 'glitches' equally insures that they vanish from consciousness, naturalized as momentary (transient) failures in an otherwise functional system.

The theorization of 'glitches' in media art function as an index for the intersection of earlier Modernist aesthetic and theoretical priorities with more contemporary concerns with digital capitalism and its ideology produced in/through media. The fundamental issue for this analysis and its object, the glitch, is the status of the audience; in examining these issues, this analysis returns to a set of underlying problematics: the interconnection of active::passive conceptions of audience with the formal conception of media, the cul–de–sac posed by Formalist conceptions of glitch, and the potential for a critical media praxis.

(1)

The appropriation of technical failure in digital technology is commonly theorized by writers on glitches, such as Iman Moradi in his thesis *Gltch Aesthetics* (2004), or artist Rosa Menkman in her book *The Glitch Moment(um)* (2011), as a critical activity that draws attention to the material basis of digital technology. Their claims that 'glitch art' is a critical activity originate with earlier, Modernist aesthetics, in particular—although unacknowledged in either work—is Theodor Adorno's posthumously published book *Aesthetic Theory* (1970) where he argues that because art violates the functional demands of bourgeois society, it is *inherently* critical. This theoretical framework is extended to technical failures because they interrupt the normative functionality of the media being glitched. The critical rupture described by theories of 'glitch art' claim that the 'glitch' reveals both the material foundations and processes of digital media, yet these dimensions *only* appear when an audience member chooses to interpret the glitched work critically—i. e. *actively* engages it. Theorizations of glitch (technical failure) as inherently critical bring this Modernist conception of audience's spectatorship as a *passive* activity into focus: while media is always *interrupted* by the glitch because it is a technical failure, its critical meaning depends on the role it has when compared to other, similar works (the glitch's semiotic function within a particular work), not the Formal *origins* of that glitch (ontological nature).

The understanding and theorization of glitches in digital art is uniformly concerned with Modernist conceptions of a passive audience rendered active by the disruptive affect of art. Problematizing this simple binary relationship of active::passive are the ways that the aura of the digital strips those technical failures from consciousness, naturalizing them as digital artifacts of various types (glitches of all varieties: compression, signal failure, momentary drop–outs). Critical interpretations based in a Formalist understanding of digital media are captured by how digital capitalism and the ideology of the digital develop from earlier Modernist theories of critical aesthetics. Disentangling these Formalist and critical interpretations becomes an essential theoretical activity for any media praxis that seeks a heuristic capable of either critiquing contemporary digital capitalism, or engaging its instantiation in digital media.

Various video compression glitches created with databending.

(2)

The aura of information reflects the nature of digital technology as a semiotic system where each encounter has been produced anew, rendered specifically for the moment of its engagement by an audience. Digital failures in particular have become common, in part due to the rise of the internet in the 1990s as a mass medium, and partly due to their employment in art and music produced since that decade. Instead of being an exceptional occurrence, they are a commonplace part of using digital technology. Considering the *datastream* (information contained by/in the digital file) as the fundamental material for digital art—makes the emergence of '*glitch art*' as a Formal demonstration of the datastream inevitable. The "digital object" becomes a human readable form (image, movie, text, sound, etc.) *only* through the conventionalized interpretations of the binary signals that are the digital object, and whose decoding follow an interpretative schema built–in to that machine to render this binary code into each human readable (superficially distinct) form; it is a semiotic process of immanent, automated facture. The term 'glitch art' is an attempt to distinguish between the specific *use* of glitches in an artwork, and those happening *spontaneously* in non–art contexts/works.

Various writers on 'glitch art' have proposed terms to identify this ontological distinction between a transitory technical failure (always called "glitch") and other variants designated differently, but which may have the same form: "glitch–alike" (Morandi), "domesticated glitch" (Menkman); what is identified with the term "glitch art" is a reflection of how artists have produced and exploited the "errors" emergent in digital technology. Rosa Menkman's *Vernacular of File Formats* (and its accompanying exhibitions) is a specifically Modernist and Formalist response to digital technology. It dramatizes the tendency to identify and discuss only those glitches placed and exhibited in an art context.[2] The *Vernacular of File Formats* is typical, developing and elaborating a purely Formal engagement with glitches. Her project demonstrates the dependence of such Formal approaches on definitions of necessary and sufficient characteristics for any given medium. The particular technical means in achieving each 'glitch' is subject of a careful study and examination, which is then formally documented as the essential element to the work/presentation. As with the other glitch presentations and

explorations visible online, Menkman's *Vernacular of File Formats* is organized to identify and describe specific failures and their results when rendered by digital technology.

The foundation of digital facture in semiosis renders the entire distinction identified with 'glitch art' questionable: the human–readable form of a digital work is fundamentally different than the machine–readable code that generates it. The distinctions between 'glitch' and 'glitch art' are problematic, as artist Curt Cloninger observed in *The Glitch Reader(ror)*:

> The term 'glitch art' might apply to all domesticated glitches and all wild glitches that have been 'captured' and recontextualized as art.[3]

The "might" opens the potential scope of 'glitch art' beyond simply those glitches "captured" in a recording to include actual technical failures, "wild glitches," orchestrated to occur on demand within a specific performance; thus, the distinction between an unpremeditated technical failure, unstable and transitory, and the use of audio–or–visual artifacts that coincide with these incidental errors, stable and repeatably a part of a finished work may be difficult to identify when encountered. As the aura of information demands, these categories of glitch can be, and in artistic practice often are indistinguishable: the ontological origins of any particular glitch are not necessary apparent in it because the meaning presented by a work is separate from the physical representation of that work. The accompanying and implicit denial of the distinctions between human and machine readable objects, as with the passive conception of audience, all emerge from this same Modernist foundation. The 'unmasking' it appears to perform—in the use of the glitch itself—develops from a confusion of operation of the digital machine with the codes that organize its automated facture. In refusing this distinction between machine– and human–readable forms for glitches, the implied fantasy is that the glitched human–readable form is somehow more "pure" (closer to the machine–readable form, the digital code) than a typical product; in fact, both works are rendered with the same processes, and are simply human–readable forms of a digital work that exhibits unanticipated formal characteristics to that human audience. Instead of enabling a consideration of the ideological dimensions of these media, it acts to hide them. In this regard, 'glitch art' belongs to the same category of symptom

emergent in the arts as the 'new aesthetic'—both develop from a physicalization of what was / is more commonly purely digital—a realization of immateriality as physicality. Both develop from the same displacement of human agency: in the new aesthetic, this takes the form of production, while in glitch, the attempt is to create an autonomous, critical aesthetic form independent of the human interpretation, reflecting the law of automation's elision of human agency and its replacement by digital, autonomous processes.

(3)

Digital sampling is a fundamentally distinct phenomenon from continuous experience—it is precisely those aspects of continuity that are lost *in between* the samples that become masked in the encounter with the human–readable form of a digitally–generated object. Menkman's discussion in her book *The Glitch Moment(um)* is typical of how glitches have been theorized as a bringing to consciousness of this fragmented (im)materiality of digital media:

> Another example of the *intentional faux–pas*, or glitch art that is in violation of accepted social norms and rules is *Untitled Game* (1996–2001), a combined series of 11 modifications of the first person shooter game (FPS) *Quake 1* by the Dutch/Belgian art duo Jodi. Jodi makes subversive glitch art that battles against the hegemonic flows of proprietary media systems. They work to reframe users' or consumers' perception of these systems. The duo's work is often simultaneously politically provocative *and* confusing. This is partly because Jodi never originally prioritized attaching explanations to their work, but also because of the way in which their practice itself overturns generic expectations. They challenge the ideological aspects of proprietary design by misrepresenting existing relationships between specific media functionalities and the aesthetic experiences normally associated with them.[4]

Menkman's argument for a "critical materiality" (a Formalist digital art based on technical failure) is the assignment of a critical function to the glitch qua glitch. In her argument, the glitched game produced by Jodi achieves a critical position through a

formal manipulation of the functionality of the work in question mediated by the glitches which are her primary interest in the work. The shift from a game that can be played to one that cannot is a direct effect of how the technology has been "broken." By transforming a functional video game into a dysfunctional (non–functional) version, *Untitled Game* acts against the conventional 'bourgeois functionalization' of the video game; thus, in Menkman's discussion, the work is 'critical.' However, it is the rupture with the normal function of the work—its nature qua game—and not the glitching per se that results in this critical potential. It is the "violation of accepted social norms and rules" that is the significant part of this work, not the means employed to achieve that result.

Glitches are incidental to the critical dimensions of *Untitled Game*: by transforming the function (use value) into dysfunction (glitch) it becomes critical, not through a Formalist self–referential use of the "materials" of digital media which an "intentional faux–pas" implies. The glitch is not the point here, it is the inability to play the game in the typical, established fashion that produces its critical dimensions—the particulars of the failure in relation to its use, not the formal device of introducing glitches. It is worth remembering that *Untitled Game* is a modification of a relatively low–resolution graphics–driven game, *Quake 1*, released by id Software in 1996, so while the particular failures are essential to the non–productive dimensions of *Untitled Game,* their significance depends on how they break the game for the player (audience) not the transformation of the graphics in particular. Menkman's implication is that there is a physical, self–evident distinction between everyday "technological failure" and the "technological failure" employed in an art work. It consistently returns to an inherently critical formulation of 'glitch' dependent on an a priori distinction between a 'real' and 'unreal glitch' that transcends the actual form either might take. However, there is no consideration of the audience's role in this recognition:

> At the same time, however, many works of glitch art
> have developed into archetypes and even
> stereotypical models, and some artists do not focus on
> the post–procedural dialectics and complexity of
> glitch at all. They skip the process of creation through
> destruction of a flow and focus only, directly, on the
> creation of new formal designs for glitch, either by

creating the final imagistic (or sonic) product, or by developing shortcuts to recreate the latest–circulated glitch reformation.[5]

These "post–procedural dialectics" are problematic. Her discussion simultaneously suggests an argument for an exclusively performative conception of glitch (i. e. glitch as part of a limited and constrained performance created/by an artist) and, at the same time, a rejection of such performative dimensions entirely. Employing an ontological distinction to describe these glitch variants poses logical problems: this contradiction appears clearly when the underlying *performative* nature of all digital media is acknowledged—that every digital work is specifically produced "live" at the moment of encounter.

Digital technology itself, based in a semiotic process of facture, enables the creation of an always "perfect," new example of the work in question, made specifically for the moment of encounter. This digital technology makes an idealized "original" possible, even when the work encountered is imperfect: the actual human–readable form is a pure product of the digitized samples (datastream) transformed by the decoding protocol; its specifically imperfect character is elided from consciousness by the aura of the digital. However, the errors and imperfections in the digital reproduction tend to disappear from perception precisely because that encounter is secondary to an idealized digital perfection: the audience "tunes out" errors as they occur. The seeming paradox of an induced 'glitch' as "technical failure" (i. e. a *desired* glitch whose production was the focus of the technique employed) is a false paradox: it confuses the *intentions* of the machine operator with the *operations* of the machine itself. This issue confronts all 'glitch art,' whether the glitches being seen are part of the work, a novel result of some kind of transient technical failure, or a mixture of the two (there is no reason a recorded glitch cannot also be subject to glitches arising from an independent, later technical malfunction).

The discrete samples that produce digital media are emergent through/hidden by the fragmentary nature of the digital itself: everything "inside" the computer exists as numerically encoded data that when 'replayed' for a human audience appears continuous. The glitch makes this apparently perfect 'reproduction' become a contingent phenomenon, as glitch artist/theorists Hugh S. Manon and Daniel Temkin noted:

Glitch art does not "dirty up" a text, but instead undermines its basic structure. Glitch damage is integral, even when its effects manifest at the surface.[6]

Again, a Formalist conception: the breakdown that glitch imposes on a work (the "text") is totalizing, a failure that is a transposition of the material itself—unlike analog or physical texts, the digital "work" encountered is an immaterially *generated* work where the glitch is a "breach" in the underlying instructions made apparent at the "surface"—the moment of human encounter. Their description reflects the aura of the digital: the datastream as the 'real' form of the work, the human–readable (or physical) is thus simply an epiphenomenon, inconsequential. By discounting the physical dimensions of the encounter, in favor of the "pure" error that resides within the code, this Formalist dimension becomes evident as the aura of information. The indeterminate nature of glitches comes into focus when all three variants of "technical failure" have the same semiotic function and formal appearance within a given work: a 'glitch' can emerge from *either* technical failure or *not*–failure, and still play the *same* role (have the same human–readable form) in the work's interpretation; thus, there is no meaningful difference between a *technical failure* that produced a glitch, a *recorded* version of that same glitch, and a *machine designed to produce that same glitch* 'live, on demand.' The ontological origin of any particular 'glitch' prioritizes the immaterial foundations within the instrumentalist code, in the process eliminating the encounter from consideration. Yet, for "glitches" to become critical, the audience's recognition of "glitched" must allude to a deviant engagement with the anticipated "norm"—whether at the level of datastream, software or hardware (if not all three).

All glitches are a product of the autonomous digital creation (semiotic production) of a given work whose physical characteristics lead to an identification of it as being "glitched" by the interpreting human audience encountering it. The hypothetical *perfect reproduction* is reified as 'norm' in digital reproduction, making the identification of a glitch as a 'failure' possible only because a human interpreter has identified it as at variance from both the *anticipated* imperfections of the immanent work *and* the ideal form. It is by making the fragmentary nature of the underlying medium—the unseen, unencounterable

digitized data of the machine–readable form—become a part of the audience's immanent encounter that the critical dimensions alluded to by Menkman, Manon and Temkin become apparent in place of a seemingly continuous media presentation. This context–dependence renders ontological distinctions irrelevant to critical interpretations.

Digital technology is instrumental, its coded instructions specifically determinate: the same set of instructions will decode in the same way by the same software every time it is run, whether those instructions themselves contain mistakes (glitches) or not. Thus, an ontological distinction is irrelevant to the consideration of a glitch's meaning in any particular work, because that distinction depends on information that may not be apparent in the glitch itself. This use of ontology to define the 'glitch' does not clarify interpretation, it confuses it: what appears as 'glitch' is a product of the digital machine functioning *properly* (either at the level of hardware or software), but producing results that in a human readable form may appear anomalous—this fact remains true for all glitched works, perhaps most especially in those cases of 'glitch art' where the hardware (or software) has been specifically modified to 'short circuit' and generate the glitch form—it is producing what it is *designed* to create. The treatment of glitches as idiosyncratic ruptures with the mechanical functioning of the digital machine reflects the aura of the digital's mystification of digital technology as a magical realm beyond constraints and human control.

(4)

Theodor Adorno's *Aesthetic Theory* argues that art is an inherently critical mode of production, where the emergence of the material basis of art brings the audience an awareness of the reality of its production. It is this dimension of his theory that provides the "inherently critical" claim for Formalist media; it provides the unacknowledged supports for Menkman's argument that glitches are a revelation of the digital artifice. *Aesthetic Theory* gives this revelation a specifically political dimension, inherent to 'art' itself:

> Art, however, is social not only because of its mode of production, in which the dialectic of the forces and relations of production is concentrated, nor simply because of the social derivation of its thematic material. Much more importantly, art becomes social

by its opposition to society, and it occupies this position only as autonomous art. By crystallizing in itself as something unique to itself, rather than complying with existing social norms and qualifying as "socially useful," it criticizes society by merely existing, [. . .] a denunciation of useful labor, the strongest defense of art against its bourgeois functionalization [. . .] the ends–means–rationality of utility. This is enciphered in art and is the source of art's social explosiveness.[7]

Adorno's argument for certain forms of media being inherently critical depends on a specific conception of 'art' that places this concept outside of the social frameworks ("its opposition to society") that enable its identification: his description of 'art' follows the specifically avant–garde formulation common prior to World War II. This dimension is readily apparent in his statement that art "criticizes society by merely existing" because, for his argument, art necessarily has no function at all: art exists in a separate domain from use value. Such a definition ignores the anthropological role of art as a social status marker—both for distinctions between different classes, and within the same class: "art" is *not* a neutral designation. Instead, the readily apparent stratification of the art world into distinct markets focused on promoting, distributing and presenting various works whose formal characters are quite divergent, are nevertheless united by a constant social function—*art as marker of distinction*. Art serves to separate different classes into subgroupings whose *status* and membership in those groups is reflected by the art they embrace: art's *function* depends on its social context. [8]

Whether this social function for art is a formally apparent is irrelevant; any argument for an emergence into consciousness of the productive dimensions of art depends on a monolithic conception of *all* audiences as passively manipulated consumers. Manon and Temkin describe this passivity as an implicit element, essential to the *inherently* critical meaning for glitch:

Paul Virilio is often cited in discussions of glitch art;
however we need to be clear that glitch art is most
often not, strictly speaking, an effort to "[p]enetrate the
machine, explode it from the inside, dismantle the system
to appropriate it." (Sylvère Lotringer and Paul Virilio,
The Accident of Art (New York: Semiotext(e), 2005), 74.)

> Real sabotage cannot be undone. Indeed any instance
> of real sabotage risks spinning out of control to the
> point of harming the saboteur. In this way, the
> prevalence of the undo function in glitch practice
> renders it a kind of pseudo–sabotage. This is not to
> say that the resultant file—publicly exhibited in some
> venue—does not disturb, vex, or interrupt the flow of
> its beholder, and thus work to "dismantle the
> system." Indeed, despite its simulation of sabotage,
> glitch art nonetheless loudly announces the
> hegemony of digital representation and the passivity
> of its subjects.[9]

The interruption that the glitch poses is the breakdown of the "perfect surface" of digital works, a signifier of violating what Adorno calls "bourgeois functionalization." The ontological concern is raised by Manon and Temkin as the difference between a "pseudo–sabotage" and a "real–sabotage." An indeterminate ontology provides the foundations for their assumption of passivity, supported by an assumption that the digital is a perfect, immaterial, other–world remote from the constraints and material limitations of analog media. Their analysis succumbs to the same stripping of the physical from consciousness (the aura of the digital) that their discussion attempts to critique. Digital 'production' is the autonomous action of a machine, rather than the particular labor of a human: the difference between the anticipated form and the one produced suggests (and is understood as) a discrepancy between encoding and decoding, rather than as an event emergent from human action; this issue is both immediately obvious and well known when considering both sampled data and the secondary use of compression algorithms in digital technology. The "reappearance" of the underlying digital material whose assembly creates the perfect surface can also be understood in terms of a rupture in that work's functionality—in their argument the glitch is a break in continuity *only* if the audience is passive in relation to the work they encounter; however, as Umberto Eco has noted, "It is evident that even the most banal narrative product allows the reader to become by an autonomous decision a critical reader."[10] The assumption that the audience is passive is one this is *not* how audiences engage media: to assume a passive audience mistakes physical immobility into a lack of mental activity.

Adorno proposes these breaches as inherently political because they interrupt the functional continuity of the media work and in its place substitute an awareness of the work as a product. One constant in these discussions of glitches is that they can make the fragmentary nature of the digital apparent through how the technological presentation becomes 'visible' in its failure. Cloninger's observation in the Glitch Reader(ror) that

> The attempt to regulate and filter out the irruptive
> "noise" and return to the ideal of a pure signal is the
> same metaphysical/Platonic attempt to downplay the
> immanent and maintain (the myth of) the pure
> transcendent. Subverting (literally "deconstructing,"
> in Derrida's original sense) this dichotomous, binary
> metaphysical system is a radical (root level)
> "political" act.[11]

The subversion that Cloninger identifies as a political act is one based in rupture experienced by the audience, and does not inhere in the formal material of the work itself. His assertion of an inherently political dimension for glitch (and interruptive/disruptive techniques generally) is the heritage of the Modernist aesthetics that emerged during the first half of the twentieth century apparent in the conceptualization of rupture itself. This interpretation depends on an assumption of singularity, one that is both normative and standard, where any deviation from that 'norm' necessarily carries a political charge; this singularity assumes a passive audience that is not/cannot be engaged with the work in an autonomous fashion. This issue lies with aesthetic semblance (*Schein*), as theorist Peter Burger explains in his book *The Theory of The Avant–Garde*:

> [Herbert] Marcuse outlines the global determination of
> art's function in bourgeois society, which is a
> contradictory one: on the one hand, it shows
> "forgotten truths" (thus it protests against a reality in
> which these truths have no validity); on the other, such
> truths are detached from reality through the medium
> of aesthetic semblance (*Schein*)—art thus stabilizes the
> very social conditions against which it protests.[12]

The political failures of the historical avant–gardes all originate with the idea of an autonomous aesthetic, separate

from social function, one that finds its most direct support in the Formalist theories of Modernism. The paradox for glitch to be an inherently critical practice (as with political art generally) is the distinction between aesthetic resemblance (*Schein*) and reality. However, this "veil of nature"—the creation of a natural appearance in which the glitch is understood as simply "technical failure" (*Schein*)—traps aesthetic objects in a position where their *forms* cannot directly engage in political action. This limitation has been internalized for interpretations of digital works as the aura of the digital, so the earlier neutralization posited by exhibition in gallery spaces has become a function of the audience interpreting the work. In contrast to this dynamically adaptive audience, the proposal of an inherent critical Formal structure depends on a passively receptive audience to whom the meaning of a work is dictated *a priori*. For this conception, there is a singular meaning contained by the work, by which the audience is manipulated and responds autonomously.

The glitch may serve as an interruption of the aura of the digital's illusion of perfection, at the same time, it is countered by—as Manon and Temkin observe—the readily reversible nature of the semiotic: in place of destructive noise, the glitch is more often simply a transient limitation that is quickly elided from consciousness following the aura of the digital, actively "tuned out" by the audience: *non–functional (broken) technology is not engaged critically; it is trashed and replaced*. The problematic inherent to glitch is not readily resolved through an examination of the instance of the glitch; the wild/domestic distinction requires prior knowledge of origins. So long as the reassembly process follows a standardized protocol, the human readable work remains 'coherent' (i. e. matches an anticipated formal 'norm') masking that underlying semiotic procedure. The indistinguishability of wild/domestic glitches further reinforces this ambivalence for glitch as a class of works, a failing that can be generalized to any critical praxis simultaneously linked to a specific Formal structure; critical interpretations depend on the precise context of a glitch's generation/use. This 'break' results from a violation of established (anticipated) structures within the work—an unanticipated variance from the audience's expectations: the necessary factor in this process is an actively engaged audience that is challenging the work as it proceeds and whose violated expectations produce the glitch. There is no formalist mode that

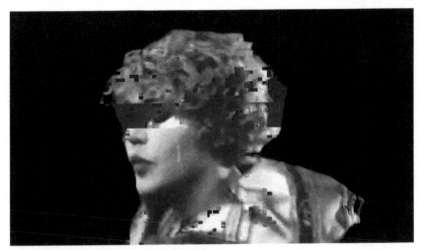

Still from *The Kodak Moment* (2013).

can present an inherently critical meaning—the emergence of a *specifically* critical meaning depends on active choices made by the audience encountering the work, not the formal design of that work.

(5)

Specific formal ruptures rapidly become assimilated as signifiers within the already established formal language of the medium being glitched. The incompatibility between the passive/active conceptions of audiences is apparent in how the spectator responds to failures and assimilates glitches following what critic Brian Larkin described as 'recoding' in his discussion of media piracy and the informal distribution systems of Nigeria:

> If infrastructures represent attempts to order, regulate,
> and rationalize society, then breakdowns in their
> operation, or the rise of provisional and informal
> infrastructures, highlight the failure of that ordering
> and the recoding that takes its place.[13]

The failure of one system does not result in a wasteland, abyssal, but rather an emergent replacement—a reorganization of the (dys)functional elements around the precise (dys)function itself—what was a point of failure becomes the central feature of a return–to–normal: hence a *recoding* of the existing order to integrate the 'failure.' The glitch ceases to be rupture and

Glitched Allegory of the Knight, Death and Dürer (2013)

becomes instead the *signifier of rupture*, and with this transposition to signification (recoding) is a regeneration of the "norm"— Adorno's 'bourgeois functionalization.' This transformation is an emergent phenomenon of perception and the always already imposed constraints of past experience on that immanent encounter: a glitch *may* provoke an awareness of the materiality of the medium when it is contained in an otherwise *unglitched* work; however, a work composed from glitches poses a radically divergent awareness, one in which the medium itself does not necessarily become physically present, suggesting the emergence of a different mode that is no less normative in its operation. The assertion of continuity is a feature of how the digital aura imbues digital works with their specific valence as immaterial, quite apart from whatever physical example may be encountered at any given moment, enabling the discounting of the glitch and technical failure, in a specific elision where they are always conceived as only momentary, a feature only of *this* presentation, thus irrelevant to consideration.

The transformations effected by 'glitch art' (in fact all re-enactments of the inherently 'critical' claim) depend on the audience recognizing the ritualized 'critical' position posed by the work's formalist organization as non–function: a recoding of the 'failure' as a signifier for 'failure.' This understanding is a recuperation of failure as meaning, the assimilation of form to natural appearance (*Schein*). Recoding results in a normalization of this superficially disruptive element posed by the 'glitch'— whether its origins lie with technical failure or the 'domestication' of the "glitch–alike." Larkin observes that the resilience of the capitalist system that produces the conceptual and physical infrastructures of media utilizes this human capacity for adaptability:

> The difficulty here is that much of the work on the
> transformative effects of media on notions of space,
> time, and perception takes for granted a media system
> that is smoothly efficient rather than the reality of
> infrastructural connections that are frequently messy,
> discontinuous, and poor.[14]

The duality he assumes in media between a seamless, perfectly efficient (digital) media, as opposed to a "messy, discontinuous, and poor" physicality, while perhaps especially obvious in the

Nigerian context he describes, is also applicable elsewhere in the world; however, it is the capacity of the audience to ignore these physical traces in the media work that is significant—this disappearance of the 'noise' is the aura of the digital stripping that imperfect physical presentation from consciousness, a rendering–transparent of the technological failings (thus, meaningless and non–critical). The impact that the aura of the digital has on our encounters with all media—whether "perfect" or "imperfect"—undermines the potential of 'glitch' to function disruptively as a breach in the "(im)materiality" of media works. Glitches emerge not from "errors" but from the audience's *interpretation* of elements within a specific work as technical failure—'critical' engagement does not depend upon the *formal* nature of the art.

(6)

A contemporary semiotic model of interpretation is incompatible with the 'inherently critical' mode derived from Adorno's *Aesthetic Theory*—the particulars of any interpretation are contingent not only on the work, but on what and how the encounter with that work develops, a factor Menkman notes in *The Glitch Moment(um)*:

> The post–procedural essence of glitch art is opposed
> to conservation; the shocking perception and
> understanding of what a glitch is at one point in time
> cannot be preserved for a future time. The artist tries
> to somehow demonstrably grasp something that is by
> nature unstable and ungraspable. Their commitments
> are to an unconventional utopia of randomness,
> chance and idyllic disintegrations that are *potentially*
> critical.[15] [emphasis original]

While interpretation is constrained by and focused through the apparent features of any given work, at the same time, it is dependent on past experience and expertise brought to that work: her implication is that the potential for criticality depends on the (momentary) disruption—but then fails to recognize that for functionally–motivated interpretations, the glitch is a stoppage, not a point of rupture. It is an interruption that requires action different than a consideration of the actual physical nature of the work itself. The critical element for glitch that is the underlying concern of Menkman's argument emerges from *how* the glitch interrupts the *anticipated*

flow of a work, and the significance of those interruptions when they do appear: as noted before, all these are dependent not on the glitch itself, but on its meaning *within* a given work.

The problematics of glitch as a politically engaged media practice foreground these ruptures and conceptual differences, demanding an approach that accounts for the role of context, audience adaptation and the recoding of interpretation: this recognition does not eliminate the potential for an engaged media practice—instead, it places an emphasis on the *actual* form of that work. The construction of a work entirely from glitches would then seem to preclude the potential for any critical position, effectively transforming the glitched work into a normative (but still glitched) example of the same "bourgeois functionalism": since criticality is not an inherent property of a work, but a function of how the audience interprets that work, the issue of criticality must instead develop from the particular features of the work, its presentational context, and structured form—to do otherwise would be to reassert an *a priori*, inherently critical position for *all* works of a given class such as 'glitch art.' This difficulty may be a reason why so many discussions attempt to employ an ontological division between "glitch" and "glitch–alike."

Thus, the argument for an inherent critical mode is a false one; the transformation from functional to non–functional does not render the art object *necessarily* critical. These are issues not isolated to digital art and glitch, but inhere in art generally. Marcel Duchamp's *Fountain* (1917) is a paradigmatic example of how assuming an inherent criticality to the form is to misapprehend the *critical* meaning of the work: it is not the non–functional orientation of this urinal that renders the work critical; *it is the installation of a urinal in an art gallery that generates the critical meaning*—a function of its specific exhibition *context*. Functional or non–functional, it is the frission of object::context that is the factor in its interpretation as a *critical* work. That *Fountain* can function as an aesthetic object independent of its utilitarian origins (urinal) demonstrates the contingency and ambivalence of critical modes and reveals that the intrepretation of work via spectatorship is *not* a passive experience or activity. Instead, the audience for *any* work will dynamically adapt to the semiotic structures *implied* in the construction of any particular work[16]— enabling the recoding of 'glitch' as normative, as an aesthetic

semblance (*Schein*) of technical failure; thus posing a paradox for any procedure that attempts to create a rupture purely via glitch. A Formal revelation of the *medium as such* is only a temporary phenomenon.

The self–similarity of 'real glitch' and 'simulated glitch' (domesticated or glitch–alike) demonstrates the contingent nature of how any particular glitch has been employed semiotically within the human–readable form: it is possible to imagine a reversal where the '*un*glitched' serves the same disruptive role in the semantic structure as the 'glitch'—a bringing to consciousness of the process and transformations posed by the work itself—in a recoding of the *already–recoded*.

(7)

Critical interpretations depend on the audience for a work (via established expertise and past experience) recognizing both the 'glitch'—i. e. the acknowledgement that it is a feature of the work rather than a technical failure to ignore—*and* being able to understand the role it has as disruption within the continuous media work—the semiotic role that a *specific* glitch has in determining the meaning of the work compared with other works. In contrast to Jodi's *Untitled Game* (1996–2001) is Cory Archangel's *Super Mario Clouds* (2002), a work structured in similar ways—appropriated commercial video game altered by the artist to produce different–than–normative results. Where *Untitled Game* mimics the form of dysfunctional game (unplayable because of seeming malfunction), *Super Mario Clouds* is equally unplayable, but not from visible malfunction, but rather from an absence of function: the game elements have been elided, leaving only a scrolling background of white cartoon clouds. The sense of rupture in comparing these two otherwise superficially similar glitches of technology lies with the distinction between a 'glitch' that renders the work recognizably *non–functional* and a 'glitch' that transforms the work into something recognizable but *afunctional*—without the capacity for the original function.

A critical role for 'glitch' in creating a politically engaged media work of the type these Formalist theories claim for technical failures requires *the glitch to make the political economy that produced the work that is failing to become apparent.* This meaning is not dependent on the Formal use of the glitch *qua* glitch, but rather on the internal semiosis of the art object as understood by the

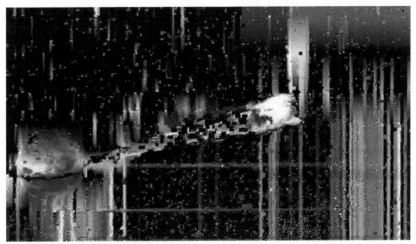

Still from *Going Somewhere* (2016).

audience. For the productive dimensions that create the work—
its physicality, the material supports required for the production,
the economic costs associated with that facture, distribution
and presentation—to emerge *only* happens to the extent that
those aspects of its production are the focus of the work itself:
it is a question of content and context, not form. It is a matter
of how the audience interprets the human–readable work. The
foregrounding of the technical 'failures' in a recognizable fashion
in *Untitled Game* assumes the readily recognized form of the non–
functional. By enabling the potential interpretation of "broken,"
it returns the glitched work to the realm of Adorno's 'bourgeois
functionalization' through exactly the potential *recognition* that it
is "broken."

Within a formally glitched work ('glitch art') the *un*glitch
has the same disruptive potential as a glitch in an otherwise
normal work. It is equally capable of bringing the critical
dimensions of media practice to the attention of the audience, as
a violation not only of established *a priori* expectations, but of the
semiosis internal to the audience's engagement (not the digital
facture). It is this ambivalence that offers the potential for these
eruptions of criticality: the capacity of the 'glitch' to become a
redirection of meaning. However, these "openings" depend on
an audience 'primed' for such an encounter, and engaged with
a work already placed within a context (such as that of 'art')
where this critical meaning can develop. The 'functionality'
of a critical context does not necessarily result in a critical

interpretation; not all interpretations developing from within such a space will necessarily be 'critical.' The choice to produce an engaged, critical interpretation is made by the audience: there is always the potential for any work to be engaged as distraction (entertainment product), just as there is always the potential for a critical response to even the most banal narrative entertainment.

While the glitch can be an interruption of the 'perfect' flow of media, these flows do not exist in actuality—in their place is the elision provided by the aura of the digital that creates this particular illusion. The conception of *any* glitch as inherently critical ignores the internalized procedures of elision (the aura of the digital) that accompany these illusions and are the defining features of both the glitch and the 'norm' in digital media. A work organized *as critical* offers an expanded consideration for active spectators because of the ways it introduces the glitched elements, organizes them within the whole, and then enables a consideration of the relationship between the glitched and the 'norm.' It is this tension between the expected form of the work (past experience) and the immanent example (encounter with a human–readable form) that identifies the critical mode and offers the *potential* for a critically oriented practice. Ambivalences are inherent to this type of interpretation: this critical mode suggests an excess apart from the observable content of the work, but dependent on what is observable in that work. The role of glitches within an engaged media practice is neither a purely formal experiment in technological failure, nor a stylistic 'decoration' that enlivens otherwise banal work, but rather an interpretation where the disembodied technological instrumentalism of the digital that is otherwise being elided from conscious consideration through the linked illusions of perfection, transparency, and immediacy becomes apparent.

A critical media praxis must therefore also contain a robust theoretical foundation, one capable of acknowledging the mediating role and dynamic action of the interpreting audience who will actively assimilate any technical failures into the 'normative' form of the media being examined. This activity has dramatic consequences for attempts at creating a critical media, and necessarily invalidates any claims of an inherently critical activity for any particular formal approach or device.

REFERENCES

1 Meagher, J. *RCA Television Pict–O–Guide*, in three volumes (Harrison: Radio Corporation of America, 1949).

2 Menkman, R. "Vernacular of File Formats" *Network Notebooks 4: The Glitch Moment(um)* (Institute of Network Cultures, Amsterdam: 2011).

3 Cloninger, C. "GltchLnguistx: The Machine in the Ghosts / Static Trapped in the Mouths" *Glitch reader(ror)*, ed. Nick Briz, Evan Meaney, Rosa Menkman, William Robertson, Jon Satrom, Jessica Westbrook, (Unsorted Books: 2011), p. 33.

4 Menkman, R. *Network Notebooks 4: The Glitch Moment(um)* (Amsterdam: Institute of Network Cultures, 2011) p. 38.

5 Menkman, R. *Network Notebooks 4: The Glitch Moment(um)* (Amsterdam: Institute of Network Cultures, 2011) p. 35.

6 Manon, H. and D. Temkin."Notes on Glitch" *World Picture 6*, WRONG 2011, http://worldpicturejournal.com/WP_6/Manon.html, par. 29.

7 Adorno, T *Aesthetic Theory* (Minneapolis: University of Minnesota Press, 1998) pp. 225–227.

8 Willats, S. *Art and Social Function*, (London: Ellipsis, 2000).

9 Manon, H. and D. Temkin."Notes on Glitch" *World Picture 6*, WRONG 2011, http://worldpicturejournal.com/WP_6/Manon.html, par. 25.

10 Eco, U. "Serial Form" *The Limits of Interpretation* (Bloomington: University of Indiana Press, 1994). p. 92

11 Cloninger, C. "GltchLnguistx: The Machine in the Ghosts / Static Trapped in the Mouths" *Glitch reader(ror)*, ed. Nick Briz, Evan Meaney, Rosa Menkman, William Robertson, Jon Satrom, Jessica Westbrook, (Unsorted Books: 2011), p. 35.

12 Burger, P. *Theory of the Avant–Garde* (Minneapolis: University of Minnesota Press, 1984), p. 11.

13 Larkin, B. "Degraded Images, Distorted Sounds: Nigerian Video and the Infrastructure of Piracy" *Public Culture* 16(2): 2004, p. 291.

14 Larkin, B. "Degraded Images, Distorted Sounds: Nigerian Video and the Infrastructure of Piracy" *Public Culture* 16(2): 2004, p. 292.

15 Menkman, R. *Network Notebooks 4: The Glitch Moment(um)* (Amsterdam: Institute of Network Cultures, 2011) p. 35.

16 Eco, U. "Serial Form" *The Limits of Interpretation* (Bloomington: University of Indiana Press, 1994). pp. 83–100.

Notes on Rhythmic Synchronization

published in
Canyon Cinemazine
issue 3, "Sound"
2014/2015

RHYTHMIC SYNCHRONIZATION
('visual music' technique variations)

EDITING cutting both on and against the rhythm [montage]

MOTION movements that correspond to the tonal
"movement" up/down scale =
up/down screen.

APPEARANCE Variation on EDITING. 'objects' appear
and disappear individually based
on what sound they sync with,
independently of anything else on
screen [linked to musical phrase, note or instrument]

Synch sound and image to create a "visual music" effect
resulting from their correspondence on screen

as
elsewhere

Kinds of motion: (axis) (movement)

spatial planar y up-down
 x left - right
 z larger - smaller

these kinds of motion work in compounds
between x, y and z motion, even when connected to a plane

THE ISSUE IS SYNC, NOT ABSOLUTE TONE TO IMAGE
CORRESPONDENCE, independent of its particular relationship within
a specific (singular) movie

173

KINDS OF FORM

regular $\left.\right\}$ both
irregular

organic — geometric forms exist in a continuum, describing the extreme ends of a spectrum concerned with the outline (linear) qualities of forms displayed on screen: there are intermediary stages that are neither and both

shapes are used in combination to create specific effects and "emotional" correspondences to the music/sound employed

Character of forms used

(irregular) (regular)
|——————————— hybrid forms ———————————|
organic geometric

range determined by number and degree of curved (arabesque / baroque) contour lines

— questions of symmetry are independent of the regularity or irregularity of the forms in use.

— relation of light / dark to "brightness" of instrument/sound or note sequence.

The Semiotics of the Moon as Fantasy and Destination

published in
Leonardo
vol. 48, no. 5, 2015
pp. 408–418; 435 (color)

CRITICAL SEMIOTICS OF FANTASY::REALITY

I grew up in the 1970s fascinated by NASA's Apollo program; the Moon is a central image in my work. My collage novel, *Two Women and a Nightengale*, functions as a codex for my later, critical motion pictures. Mine is *not* the personal, "visionary" aesthetic based in the Romantic poetics described by film historian P. Adams Sitney, whose book *Visionary Film* linked the historical "experimental" or "avant-garde film" to earlier abstraction and transcendentalism:

> The preoccupations of the American avant–garde film–makers coincide with those of our post–Romantic poets and Abstract Expressionist painters. Behind them lies a potent tradition of Romantic poetics. . . . The graphic cinema . . . continued its evolution with diminished force throughout the 1930s and 1940s. The coming of sound to film inspired several attempts to visualize music through cinematic abstractions and to synchronize visual rhythms to music.[1]

Sitney's discussion of "absolute animation" (a.k.a. abstract film/ visual music) identifies this transcendent tradition through discussions of artists such as Len Lye, John Whitney and Harry E. Smith. The visionary iconography Sitney discusses provides a way to address how our interpretations unconsciously reiterate earlier symbols through forms with multiple meanings: My imagery invokes, then critiques through conceptual dissonance, Sitney's "visionary" tradition in both abstract art and visual music. These forms have a direct relationship to the esoteric ideas of Robert Fludd, whose "musical monochord" described a pseudo–scientific organization of the solar system through an analogy with Pythagorean musical intervals,[2] (as Scott Montgomery's history of the Moon/lunar imagery noted, Pythagorean concerns have been linked to interpretations of the Moon since the 5th century BCE[3]). Whitney's theory of *digital harmony* shares this Pythagorean foundation for audio–visual synchronization. [4] My use of this tradition is semiotic and

has become increasingly explicit: Glitches and technical errors/flaws act as signifiers for earlier conceptions of the same images. It enables the critique of pseudo–scientific interpretations with contemporary ones: this contradictory reversibility of signs is inherent, an aspect I developed systematically in my film *Telemetry* (2003–2005).

Concepts of "Heavens and Earth" provide a visionary subtext to scientific exploration. Culture is a layering, where new ideas and interpretations form "sedimentary layers" over earlier ones, contradicting them, forming new meanings for old symbols. This principle organizes the historical material in my book *Two Women and a Nightengale* (1996–2004) whose imagery is a reference point for my later movies: *Telemetry* and the shorts *Aurora* (2001), *Illumination* (2001), *Contact Light* (2012) and *the Dark Rift* (2014). These ideas also emerge in my microwatt broadcast radio/video installation *Reception/Transmission* (2006). Unlike *Telemetry*, *Contact Light* and *the Dark Rift*, where the content of the movie directly addresses both space and the Moon, *Star Fish* (2012) and *Helios | Divine* (2013) both draw on this iconography, addressing the fantasy::reality dialectic posed by the Moon in an implicit fashion, through its double—the *Sun*. The reversibility of signifiers in these systems is what informs the semiosis they generate.

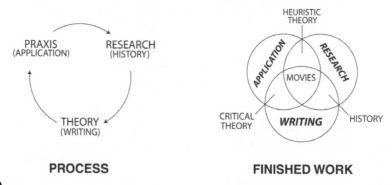

PROCESS **FINISHED WORK**

(1)

My research is bifurcated between the studio (art object) and my work as historian/theorist. The opposition fantasy::reality structures my movement between theory and practice. Semiotician Umberto Eco's chapter "Interpreting Serials" in *The Limits of Interpretation* provides a theoretical protocol for selecting imagery and structuring their assemblage into antithetical signifying systems where

> the quotation is explicit and recognizable, as happens
> in post modern literature and art, which blatantly and
> ironically play on the intertextuality [. . .] aware of

> the quotation, the spectator is brought to elaborate
> ironically on the nature of such a device and to
> acknowledge the fact that one has been invited to play
> upon one's encyclopedic knowledge. [5]

Recognizable imagery performs as signifier (earlier, quoted work) in a new context, changing its meaning. This immanent identification is essential. Archival material provides inspiration and raw material: I draw heavily on nineteenth century imagery, scientific footage produced by NASA/JPL, and public domain footage from the Library of Congress and Prelinger Archives. Explicit quotation enables a synthesis, drawing attention to my *reuse*. However, in Eco's theorization, this recognition is central; his implied protocol for quotation is the *start* of the semiotic process. The fantasy::reality conflict depends on contradictory recognitions—immanent use versus its historical meaning. By recognizing this contradiction, the audience becomes aware of the fantasy *qua* fantasy within interrelated, yet distinct signifying systems:

1. the *visual music* tradition with its explicitly synaesthetic counterpoint of sound and image
2. quotational materials functioning as collage
3. scientific and pseudo–scientific (visionary / alchemical) uses of the same symbols with different meanings

Semiosis depends on the manipulation of recognizable signifiers (the archival materials) and enables an engagement with the *meaning* of this visionary tradition through practical exploration of precedent and established forms arranged in juxtaposed and composited structures on screen. I create movies employing the formal language (iconography) of abstract film/visual music—those visual forms common to hallucinations identified in 1932 by psychologist Heinrich Klüver as "cobweb, lattice, spiral, and tunnel."[6] Klüver's synaesthetic form–constants are the implicit vocabulary of the visionary tradition— apparent in Sitney's analysis alchemical symbols in Smith's films,[7] and observable throughout the field of abstraction and visual music.[8] This semiotic system of established "transcendent" meanings emerge via formal structures. Klüver's synaesthetic form–constants establish a "vocabulary" I presented in an earlier essay[9] as a formal taxonomy; since my interest is neither formal nor visionary, but semiotic and conceptual, this taxonomy enables the linkage to visionary art; "transcendence" is the most apparent part of "fantasy" in the fantasy::reality opposition. While my work often returns to themes of space, scientific imagery is

the antithesis to this "transcendent," which is always linked to fantasy (the Moon and lunar imagery).

This unstable relationship is dependent on the immediate organization visible in a particular piece. Meaning emerges from the precise configuration of elements. Semiosis proceeds from the dynamic of current vs. past uses, creating the range of potential interpretations. The opposition of fantasy::reality (an intentionally ambiguous duality) guides editorial selections. The Moon provides a readymade source of imagery and symbolic forms: *visionary art* is a limiting fantasy, structuring and redirecting interpretation. It tempers the complexity and ambiguity of the present through the collision of mythic and scientific forms; the Moon is indexical, ambivalent symbol unifying the critical dimensions of my work.

Moon and lunar imagery (collages nos. 12, 44, 45, 46, 50, 53) from *Two Women and a Nightengale* (1996–2004).

Two Women and a Nightengale (1996–2004)

This collage novel is one of two that I composed in the mid–1990s that remained unpublished until 2004. While *Two Women and a Nightengale* and *Artemis: A Tragedy in Collage* employ many of the same 19th–century engravings as source materials, *Nightengale* poses a critique of visionary art (especially Surrealism) using the Moon as a symbol for mythic wonder.

I produced all my collages by physically cutting and pasting together steel point engravings from clip art source books published by Dover, as well as careful selection from the Dover editions of Gustave Dore's illustrations for *The Bible* and *The Divine Comedy*, thus ensuring all the materials would graphically match in style, even when taken from very different sources. The finished collages were subjected to two phases of hand retouching: (1) retouching with an ink pen to blend and bridge details on the paper collage; (2) digital scans were retouched to eliminate flaws introduced by the scanning process, but did not reconfigure the paper collages.

Two Women and a Nightengale contains five chapters with 56 paired images and captions on facing pages; 16 of them are concerned with the Moon. It has a simple, schematic plot in which a woman pursues her lover (chased away by her sister) through a sequence of strange landscapes. Each main character is a personification of language: Rose (whose name is an anagram of Eros) has butterfly wings and grows progressively older as the story advances; the Nightengale, Rose's boyfriend, is literally a bird; Marcella, Rose's sister (who appears to be the antagonist for much of the story, but who saves Rose at the end), has the head of a dog. The spelling "nightengale" is not a mistake or typo—it transforms the nightingale into a something suggesting agency, action.

Direct quotations and allusions to the historical Surrealism appear throughout: the description at the start of Chapter 3—"The day unfolded like a white tablecloth"—is a quote from the first Surrealist manifesto; Rose and Marcella each owe their names to Marcel Duchamp/Rose Selavy; the Nightengale (both the character and the plot) is a reference to Max Ernst's painting *Two Children are Threatened by a Nightingale* (1924). The quotations work to critique the irrationality posed by the plot, but also address Surrealist "creativity." These historical references become explicit in my later work, but *Two Women and a Nightengale* was my first systematic attempt at this type of organization. Visual themes introduced in this book reappear later in my movies.

The Moon is these characters' destination, literally looming over the story. The final chapter tells what happens once they arrive: It is a site of fantasy run amok. It is "loony," "madness," but also banal, prosaic, and ambivalent, filled with objects that masquerade as the un/familiar and uncanny since distinctions between the living and the non–living are unclear. This Moon is the fantasy invoked by Surrealism, a reference point for imagery and plot that structures the collision of fantasy::reality. Rose is saved by Marcella at the climax that reveals this Moon as the impediment to her understanding of who/what "Nightengale" is. Collisions of fantasy::reality condition and restrict our interpretations, an idea developed more explicitly in my movies.

Telemetry (2003–2005)

Telemetry is the longest of my abstract movies, running 32 minutes and synchronized to a score made from sonified electromagnetic radiation. (A 9–minute excerpt was exhibited in 2003.) It is the middle part of the Alchemy trilogy that includes *Year* (2003) and *Prima Materia* (2006), both silent. Only *Telemetry* contains both sound and astronomical imagery, although all three are visual music.

Telemetry begins with archival NASA/JPL footage, a colorized solar flare from October 1971 that functions as an "overture." *Telemetry* is a series of twenty–four 1– to 2–minute modular sections named for Greek letters, grouped into four "movements," each with its own visual character. Only *Tau*, the climax, approaches 3 minutes in length. Each movement is separated by variations on a "train" of circles containing multicolored arcs colliding (*Eta, Xi, Upsilon*), released separately as *Radio–Activity* (2004); *Nu* became *Neutrino* (2006).

Modular organization allows for an episodic, rhythmic composition of contrasting sections. Imagery and soundtrack are in counterpoint, but each section includes singular moments of direct synchronization where sound and image converge. Individual animations assume a symphonic character through their juxtaposition and arrangement. The source for this soundtrack is a library of "sounds from space" created as part of the plasma wave physics project directed by Donald Gurnett at the University of Iowa that studies solar flares and cosmic radiation. These "noises" from space are records of electromagnetic solar radiation. I used this material in *Telemetry* to address symbolic ideas of the universe itself by proceeding from Alpha to Omega: the film begins with a Greek letter *Alpha* and concludes with an *Omega*. The Alpha–to–Omega organization has specific esoteric and religious overtones—in the Greek Orthodox Church it refers to the beginning and end of the world. This organization finds a correlation between fantasy and the scientific: Some Greek letters (i. e. *Alpha, Beta, Gamma, Delta, Pi,* or *Phi*) also mean something in mathematics or science. Others dramatize physical phenomena. *Kappa*, for example, is used to refer to the astronomical phenomenon of Red Shift, literally shown by colors changing directly from blue to red. In my movie *Phi,* forms are organized around the golden section, even though the movie is the standard 4:3 aspect ratio of SD video. Contemporary discoveries bring earlier mythic fantasies into sharp focus.

As *Telemetry* progresses, it shifts from monochromatic to multi-colored and "messy," finally returning to a precise, sharply geometric organization. *Alpha,* which begins the movie, has the only voiceover. Autotuned to middle *C,* the voice says, "Earth auroral kilometric radiation." When two yellow rings moving in opposite directions intersect on screen, the score begins—an autotuned electrical screech harmonizing with other sounds as these rings become imagery evoking a magnetic torus.

The first movement (*Alpha, Beta, Gamma, Delta, Epsilon, Zeta*) is an abstraction of dynamic processes produced with John Whitney's system of differential motion—"digital harmony." These monochromatic sections become increasingly complex as they develop. Visual and audible violence structures each sequence around a collision of animation, color and sound almost painful to hear.

The second movement (*Theta, Iota, Kappa, Lambda, Mu, Nu*) presents a violent, inhuman domain made based on analog video processing created with Nam June Paik's *Wobbulator* while I was artist-in–residence at the Experimental TV Center, but digitally composited to

create something visually unique. Analog and digital technical failures were prioritized over seamless and successful results as the source materials for the finished movie, reflecting the role of glitches as a dramatization of culturally mistaken beliefs.

The third movement (*Omicron, Pi, Rho, Sigma, Tau*) strongly contrasts with sections before and after it. Running only 30 seconds, the *Rho* module presents a series of contemplative, landscape–like views recalling the smooth, rounded–off topologies of the Moon from lunar maps, but broken into a series of individual windows. The association of contemplation with the Moon coincides with the role it has in my work. The Heavens are metonymic with enlightenment (itself a pun on the *unseen* light described by the soundtrack). Crossing these windows of imagery is a spinning form that repeats more slowly each time, shockingly interrupting this sequence's reverie. It streaks from left to right, synchronized to increasingly complex sounds with each slower repetition—an indication of understanding produced by prolonged meditation.

The final movement (*Phi, Chi, Psi, Omega*) is a calm reflection. The *Omega* section reiterates/expands on *Tau*. The development of *Telemetry* follows from the conceptual collision of irreconcilable fantasies about space with the realities found there. Humans have been trying to understand the heavens for centuries; the multiplicity of meanings for the series "Alpha to Omega" maps these ambiguities directly as the shift from outward–inspired imagery (the torus of *Alpha*, the red shift in *Kappa*) towards interiorization (the lunar reverie of *Rho*, the climax of *Tau*) and static contemplation (*Omega*). As in *Two Women and a Nightengale*, fantasy::reality is an ambiguous duality where earlier fantasies collide with more contemporary knowledge; the Moon is the index–point for this conjunction, presenting the only meditative moment in a "vision of cosmic dynamism and balance," as critic David Finkelstein described *Telemetry* in 2005.[10]

Reception/Transmission (2006)

Telemetry provided the basis for this radio/video installation. The *Alpha* and *Omega* sections, solar flare overture and the three punctuating elements (*Eta, Xi, Upsilon*) were excluded from the final arrangement, as was the silent section *Chi*, leaving 20 modules. These individual parts were then reorganized into a permutation set of shorter, approximately 10–minute blocks entirely independent of their original sequencing.

The work was broadcast using a 1 milliwatt transmitter (allowing for reception up to 100 feet from the antenna; the only way to hear this

soundtrack was on a radio, and its reception would often also contain "echoes" of other radio broadcasts bleeding through. This chance mixing of synchronized and unsynchronized audio was the reason I used this technology: It took the radio waves that were the foundation of the soundtrack and turned them back into electromagnetic radiation, enabling a free mixing of their content with other, more familiar sounds. This idea is reflected by the installation's title—*Reception/Transmission*. These random elements—the bleed–through of other channels—drew attention to those unseen radio waves (light) also traveling within the gallery, shifting the focus away from the projected image towards what was unseen, yet present.

The movement from the visible towards the invisible made the implicit critique in *Telemetry* apparent: the ways that our measurements and expectations condition what we see and understand. The disembodied sounds on the radio were synchronized with the projected video but were haunted by ghostly echoes of human broadcasting, bringing this relationship into sharp focus.

Contact Light (2012)

This 2–minute short explores a singular symbol—*the Moon*, icon for contradictions of fantasy::reality in my longer works. It is my most explicit presentation of this critical dialectic. *Contact Light* is made from 19th– and 20th–century depictions of the Moon, Georges Méliès's famous fantasy film *Le Voyage dans la Lune* from 1902, and the reality of *Apollo 11* in 1969. The title comes from Buzz Aldrin saying, "Contact light. A very smooth touchdown."

 This archival "remix" juxtaposes a range of historical sources and combines the ghostly music bleeding through in *Reception/Transmission* with plasma wave sounds and historical audio from *Apollo 11*. Jules Verne's' predictions in his novels *From the Earth to the Moon* (1865) and *Around the Moon* (1870) anticipated the real *Apollo* program (locating the launch facility in Florida, the time it takes to get to the Moon and that the Moon is barren, lifeless), yet Méliès overlays his film journey with fantasy, even dressing the astronomers in wizard costumes more appropriate for magicians than scientists. The shot of the face of the Moon from *Le Voyage dans la Lune* provided a coherent summary of these fantastic elements, one that would be instantly recognized. These recognitions of real document and historical fantasy were required for the association of fantasy::reality. In selecting footage, I focused on evoking both historical fantasy and documentary reality. The *Apollo* missions was limited to immediately recognizable shots; the flare of the rocket engine provided a perfect bridge to Méliès' footage. Central to these visuals was the use of static imagery: (1) a picture of lovers in the Moon from an 1890s' metamorphic postcard—this optical illusion was the movie's inspiration, (2) a three–minute sequence of digitized film containing scratches and punch holes that contrast with the glitched and

digital character of the materials (carefully positioned to overlap with the Moon, linking it to these "errors") and (3) material from NASA/ JPL's archives (a contemporary satellite image of the Earth; footage from *Apollo 11*, the first mission to land there in 1969; and *Apollo 17*, the last, in 1972). Scientific footage was seamlessly combined with the fourth image, a single shot from *Le Voyage dans la Lune*, Méliès's iconic film: his capsule hitting the face of the Moon in the eye.

Three images of the Moon—(1) the metamorphic postcard, (2) Méliès's face of the Moon and (3) NASA's documentary footage— were continuously composited together, merging their different (yet graphically similar) depictions; I used them interchangeably for the Moon as seen from the Earth. The opening shot is metonymic for this entire fantasy: Aldrin's face merged with the Apollo rocket launching in Cape Canaveral. The optical illusion appears on screen as a lunar disk that is consumed by the rocket exhaust as the takeoff fills the screen with swirling white glitched blocks—scientific discovery banishes the fantasy, but only momentarily

The anthropomorphic character of NASA's lunar lander becomes obvious: It resembles a giant machine–head rolling backwards on screen before descending to the surface, an example of how our historical fantasies overlay and influence our reality. This recognition structured the choices and development of *Contact Light*. It is the focus of my critique that engages reality::fantasy.

"Databending" enabled the opposition of fantasy::reality via a fusion of archival materials. Compressed digital video files were altered using a hexadecimal editing program to introduce miscodings and other glitches into the file itself, creating visual "noise" and cascading visual break–up. Databending comes very close to corrupting the video completely, resulting in a total loss of imagery. When it succeeds, one image flows into the next without clear boundaries, suggesting fantasy spilling over into reality. This fluid connection visualizes the conceptual combination of lunar landing and Méliès's fantasy. Once all the source materials were ready, they were composited using Adobe AfterEffects. Finally, I used digital frame–by–frame hand animation to make all the individual elements "fit" together perfectly, correcting minor flaws in the compositing process. In the finished *Contact Light*, the haze of glitches is a reminder of the uncertainty of memory and of our inherited fantasies of the Moon as the *myth* of the "man *in* the Moon" becomes the *reality* of "man *on* the Moon."

Star Fish (2012)

The silent, 2–minute–long movie *Star Fish* gets its title from a nuclear test code–named "*Star Fish Prime*," that was conducted in low Earth orbit on 9 July 1962. This explosion was so powerful that it ruined the equipment meant to measure it and disrupted electrical infrastructure in the Hawaiian Islands hundreds of miles away, thereby introducing the general public to the electro–magnetic pulse that destroys technology. But the designation "star fish" has another significance: the *starfish* is also an ancient alchemical symbol for transformation—starfish were animals believed to fuse opposites (sky/sea)—a connection that influences the other imagery in this movie. Both the star fish and the Sun operate as counterpoints to the Moon of *Contact Light*—Sun::Moon are traditionally antithetical in alchemy. My focus on these ambivalences directs attention towards coincidences of meaning that emerge autonomously from our culture. The starfish also appears in *Two Women and a Nightengale* as a character who gives nonsensical advice, reappearing in the final image suspended between the Earth and the Moon (replacing the Sun, in an alchemical symbol of transformation). This substitution/linkage anticipates the connections made in *Star Fish*—but the "change" this character offers is purely banal. These connections are readily explored in visual art, which is why my studio practice functions in parallax to my work as historian.

As with *Contact Light*, *Star Fish* is a remix of new footage, static imagery and archival materials organized around glitched graphic matches. The montage employs repetitions and combinations of familiar imagery (distorted, degraded) drawn from archival footage: (1) nuclear test films of the 1950s, including the *Star Fish Prime* nuclear test (material selected based on its familiarity), (2) a short film of Betty Page wrestling another woman on the floor, (3) several advertising graphics used by drive–in movie theaters in the 1950s, in particular

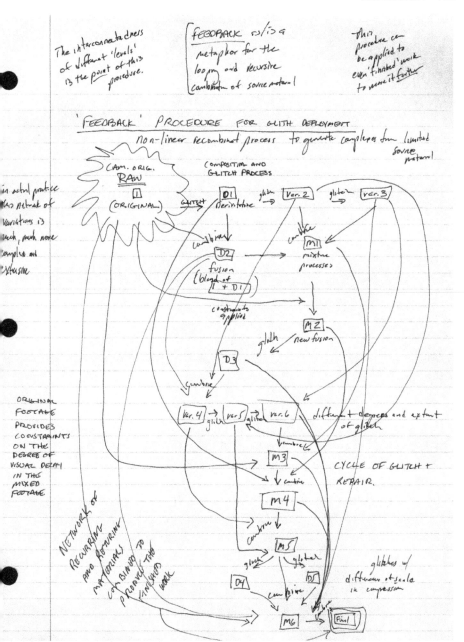

The interconnectedness of different 'levels' is the *point* of this procedure.

'FEEDBACK' ∽/is a metaphor for the loopy and recursive combination of source material

This procedure can be applied to even 'finished' work to move it further

'FEEDBACK' PROCEDURE FOR GLITCH DEPLOYMENT

non-linear recombinant process to generate complexes from limited source material

in actual practice this network of variations is much, much more complex and extensive

CAM. ORIG. RAW (ORIGINAL)

COMPOSITION AND GLITCH PROCESS

D1 Derivative

Var. 2 Var. 3

combine

D2 fusion (blend of I + D1)

M1

mixture processes

constraints applied

M2 new fusion

D3 glitch

combine

ORIGINAL FOOTAGE PROVIDES CONSTRAINTS ON THE DEGREE OF VISUAL DECAY IN THE MIXED FOOTAGE

Var. 4 Var. 5 Var. 6 different degrees and extent of glitch

combine

M3 CYCLE OF GLITCH + REPAIR.

combine

M4

combine

M5 glitch / global

D4 D5 glitches w/ different of scale in compression

combine

M6 → Final

NETWORK OF RECURRING AND RETURNING MATERIALS CAN BE USED TO PRODUCE THE 'FINISHED' WORK

Protocol for recursive compositing and glitching of motion picture footage. My working process employs a variation on the idea of "feedback" where the output of one stage becomes material to be glitched, manipulated and then mixed back into the original raw material (but can amplify the grid implicit in compression).

Engraving of the Mediaeval universe from C. Flammarion's
L'atmosphère: météorologie populaire (1888).

the warning/countdown before the show began, (4) two astronomical
videos produced by NASA/JPL, one showing the Sun, another, the
Earth spinning, (5) a graphic Sun face based on the seven–pointed
Sun partially appearing in the Flammarion engraving from 1888,[11]
and (6) video feedback produced by a digital camera interacting with
an analog TV set. The iconography of *Star Fish* combines of three
signifiers: *nuclear explosion—Sun face—glitch*, all of which signify/
are destruction. This triad governs the selection of source materials
around graphic matches—the circular Sun face—always located in the
same position on screen, facilitating a fluid movement between source
materials: ground–level, airborne and orbital views of the Earth, Sun
and orbital nuclear explosion.

Transforming this "raw" material required several phases of
databending following a recursive protocol. The initial footage was
glitched to varying degrees to eliminate/distort its content, resulting in
several pieces of footage where only swirling black–and–white pixels
remained. This material was composited with Adobe AfterEffects.
Once a preliminary edit was made, the material was databent again. The

"Sun face" derived from Flammarion.

result was then remixed with the preliminary edit. I repeated the whole process, creating a series of new variations that minimized the visibility of the editing. This new work was finished using hand animation, allowing for absolute control over individual frames. During this phase, small errors were corrected and new elements added.

Star Fish begins with a high–resolution movie of the Earth spinning in a space filled with expanding red circles and an ominous countdown going from 10 to 1, each number progressively more glitched; at the end of this countdown, the Earth dissolves into glitched blocks. This dissolution and momentary restoration (to be destroyed again) is a constant cycle. Nuclear tests are connected to an earlier, destructive alchemy—presented by the graphic Sun face, the "Black Sun," an alchemical symbol related to the star fish—that consumes (glitches) everything.

In *Star Fish,* glitches destroy the "world" on screen. The famous nuclear test footage of a house being destroyed by the blast from a nuclear explosion, glitches appear to be the force that blows up this middle–class home—fling out through the sides of the house as it disintegrates, finally dissolving the entire image into darkness. Because *Star Fish* is silent, it enabled more complexity in the visual sequences, allowing for a faster pace as looped imagery permutes all possible combinations of source materials.

Contact Light presents a positivist transcendence, but *Star Fish* focuses on the destructive dimensions of those same symbols: "the Sun" has contradictory meanings of creation and destruction. It replaces transcendence with apocalypse—a connection made explicitly by the code name for the nuclear test itself, "*Star Fish Prime*"—a potential

Still from *the Dark Rift* (2014).

implementation of the nuclear destruction being "tested." *Star Fish* and *Contact Light* engage the same alchemical symbols, exploring their implicit meanings when confronting modern uses of those same forms. Bringing these (unconscious?) connections created by contemporary reuse of alchemical symbols into focus organizes my critique: These forms structure how we describe unrelated phenomena—alchemy is pseudoscience, *and* the matrix of the Euro–American cultural imagination's memory.

○

Studio–based research enables a fluid engagement with existing iconography; it is theoretical by necessity, but practical in praxis. My ongoing explorations treat the history of visionary art as a semiotic system where the collision of fantasy::reality is its meaning. This issue appears as the ambiguous relationship between earlier interpretive systems and their relationship to scientific exploration. The dynamic focus of my work—not as a visionary but as a *re*visionary artist—emerges through the ambiguous and complex semiosis of this historical relationship: mythic interpretations of the "heavens" collide with contemporary scientific ones. Space imagery provides a direct means to consider mutually exclusive interpretations of the same imagery. The central image to my critique is the Moon, a polyvalent symbol revealing this conflict.

The critical foci of these works was a central part of their planning process, even though the particular, unique aesthetic problems posed in each piece were immediately determinate of their morphology and

structure. The high degree of technical variation among these works reflects their production over a long period using different software, tools and media, as well as my formal development. In spite of these differences, my works cohere around the same icons, aesthetic protocols of juxtaposition and combination and theoretical critiques. Writing an analytic/critical discussion of my key works provides a different perspective where I externalized myself from my own work; my movie *the Dark Rift* (2014) owes its production to my writing this article.

REFERENCES

1 Sitney, P. *Visionary Film* (New York: Oxford University Press, 1979) p. ix, 229.

2 Craven, J. *Robert Fludd, His Life and Writings* (Kirkwall: William Peace and Son, 1902) p. 174.

3 Montgomery, S. *The Moon and the Western Imagination* (Tucson: University of Arizona Press, 1999) p. 22.

4 Whitney, J. *Digital Harmony: On the Complementarity of Music and Visual Art* (New York: McGraw–Hill, 1980).

5 Eco, U. *The Limits of Interpretation* (Bloomington: University of Indiana Press, 1994) pp. 88—89.

6 Klüver, H. *Mescal and Mechanisms of Hallucination* (Chicago: University of Chicago Press, 1966) p. 66.

7 Sitney, P. *Visionary Film* (New York: Oxford University Press, 1979) pp. 232—262; see also William Moritz, *Optical Poetry: The Life and Work of Oskar Fischinger* (Bloomington: Indiana University Press, 2004).

8 For example, the recurring visual motifs and forms described in Robert Russert and Cecile Starr, *Experimental Animation* (New York; Da Capo, 1976) and in William C. Wees, *Light Moving in Time: Studies in the Visual Aesthetics of Avant–Garde Film* (Berkeley, CA: University of California Press, 1992). Wees specifically makes note of the connection between synaesthetic forms and the visionary/visual music tradition.

9 See page 109.

10 Finkelstein, D. "Telemetry" *Film Threat* (posted August 25, 2005, retrieved December 12, 2013); <www.filmthreat.com/reviews/7881/>.

11 Flammarion, C. *L'atmosphère: météorologie populaire* (Paris: Hachette, 1888) p. 163.

The Invention of Glitch Video:
Digital TV Dinner **(1978)**

published in
Millennium Film Journal
no. 65, "Architecture On Screen and Off"
Spring 2017

THE INVENTION OF
GLITCH VIDEO

In 2009, a short video from 1978 titled "Digital TV Dinner" was posted on *YouTube* by Jamie Fenton, who made it with Raul Zaritsky; Dick Ainsworth created the music.[1] Both Fenton and Zaritsky were part of the video art community around Chicago, Illinois in the late 1970s, and this video was originally produced for "Electronic Visualization Event #3" organized by Dan Sandin and Tom DeFanti's *Electronic Visualization Laboratory* in Chicago (May, 1978).[2] It was part of a program of works prepared in advance, and screened in a 500–seat theater using a high–intensity GE video projector.[3] A second version was later broadcast in March 1979 on the WTTW program *Image Union* that highlighted local video and film.[4] The importance of this early work with digital glitches is principally anticipatory: it provides an explicit connection between contemporary developments with digital glitches and the earlier innovations of analog video processing. *Digital TV Dinner* suggests future engagements with the "materiality" of the digital signal as an intervention in the execution of programming code within the computer system itself. Fenton was deeply familiar with the *Bally Astrocade: The Professional Arcade Expandable Computer System* used to create this tape since she was the programmer writing its games at the company where she worked:

> "There was ROM memory in the cartridge and ROM memory built into the console. Popping out the cartridge while executing code in the console ROM created garbage references in the stack frames and invalid pointers, which caused the strange patterns to be drawn."[5]

This implicit, thorough knowledge of the *Astrocade,* coupled with the specific context of its premiere at *Electronic Visualization Event 3* makes this early use of digital glitches less surprising. This type of performative engagement with analog and digital media was common to artists associated with Sandin and DeFanti in Chicago during the 1970s: the idea of "electronic visualization" was *performative*—an active engagement with the media technology—rather than passive, an image to watch,[6] making this adaptation of it for use with the new, cheaper home computer a logical extension of the counter cultural opposition to the military–industrial complex emergent in early video art of the 1960s.[7] This active engagement was a feature of video seeking to provide an alternative to the corporate model broadcasting common to TV where the audience was rendered passive by disparities in technology and access to media production tools.[8] This context shapes the initial distribution of *Digital TV Dinner* and its later presentation online.

After being posted online in 2009, this video was rapidly adopted by contemporary "glitch artists" as an early exemplar of visuals produced under the catch–all name "glitch." The extent of this video's embrace and recognition by "glitch artists" is immediately apparent from its common presence on websites associated with glitch art, but in spite of this general reposting and mention–citation, there is almost no information, history, or discussion of it available beyond the quotation of the *YouTube* descriptive text; it is a prominent enough early exemplar that it appears in the *Wikipedia* article on "glitch art,"[9] but even this discussion provides no additional information about the work not already contained by the original 2009 posting itself.

The early date of this tape, coupled with the approach to creating its visuals (described in a voice–over attributed to Tom DeFanti, but which is uncredited on the tape) make it one of the first, if not the *very first* "glitch" video.[10] Its production technique is an exploit of a problem with the *Astrocade.* Cartridges stuck into the console would "pop" out if you struck the case, creating the anomalous digital imagery; the video included an experimental music track created with a variation on this same exploit. Typical

for home computer games in the 1970s, the *Astrocade* attached to a TV set through its antenna connection, enabling its output to be readily recorded by connecting it to a VTR instead. The description of the version of *Digital TV Dinner* provided on *YouTube* provided technical details about its initial production, but not all of this information in this posting is completely accurate:

> *Digital TV Dinner* is a video art clip from 1979 created by Raul Zaritsky, Jamie Fenton, and Dick Ainsworth using the *Bally Astrocade* console game to generate unusual patterns.
>
> The *Bally Astrocade* was unique among cartridge games in that it was designed to allow users to change game cartridges with power–on. When pressing the reset button, it was possible to remove the cartridge from the system and induce various memory dump pattern sequences. Digital TV Dinner is a collection of these curious states of silicon epilepsy set to music composed and generated upon this same platform.
>
> DTV first appeared at an Electronic Visualization Festival in Chicago, and we hear the voice of Dr. Thomas DeFanti introducing this item to the audience.[11]

In an emailed response to an earlier draft of this essay, Fenton expanded on the information posted with the *YouTube* video about the technical details of transferring the *Astrocade* video game systems' output to videotape:

> There were two unique aspects of the *Astrocade* that made *DTVD* possible. First, the video was legal NTSC so it could be recorded. None of the other game consoles was. Second, as you note, you could change cartridges with the power turned on. All of our competitors made you power–down before changing carts.[12]

The computer game systems available in the 1970s, such as the *Atari 2600 Video Computer System* game console, separated their graphics into entirely different fields for each 'frame' of the video.[13] This meant that each frame showed two different images, making recording them to tape difficult without hardware (such as a time base corrector) to fix these inherent problems with the

NTSC video signal. The use of standard NTSC video as the output for the *Bally Astrocade* meant it was a system uniquely suited for this type of graphic experimentation with its digitally–generated output.

The description posted with *YouTube* video implies it is the same as the version shown at the festival; however, this video is not the same one included in the *Electronic Visualization Event 3 Distribution Tape* from the May 1978 event (the "Electronic Visualization Festival" mentioned in the description). The differences between these versions are subtle, and do not change the substance of the video itself: the original *Digital TV Dinner* on the *EVE3* tape has only a simple shot of a typed label that provides credits for the piece; there is no voice–over or other explanation of the tape. The version posted on *YouTube* is *not* this original, first version shown in 1978. It is a variation on what is essentially the same tape, but this second version adds a voice–over attributed to Tom DeFanti that explains how the video was produced. It also adds two title cards: the first at the head states "Digital TV Dinner Jay Fenton Raul Zaritsky" and an end card stating "Audio by Dick Ainsworth." This second version is identical to the *Digital TV Dinner* broadcast on *Image Union*. This episode focused on animation and included a variety of other digital productions where Fenton collaborated with other video artists. The only differences between these two versions of *Digital TV Dinner* are in the titling and the added voice–over narration.

The *Electronic Visualization Event 3 Distribution Tape* runs 60 minutes and contains a variety of video works; however, the approaches and techniques on display are quite disparate, and the videos are all examples of "visual music" made as video art. It is a typical example of the "Chicago school" of video art in the 1970s, where the tapes are simultaneously demonstrations of new techniques, and organized musically in ways that develop from the earlier history of visual music film animation. Of the eight videos in the collection, *Digital TV Dinner* is the only work where either Fenton or Zaritsky is credited. In reviewing this "distribution tape," their digital video is clearly produced using an entirely different technique unlike anything else on the tape—even though

some of the other pieces do resemble computer art, *Digital TV Dinner* is utterly unlike them in its imagery. These differences make the piece seem anomalous in context with other video art productions from *Electronic Visualization Event 3*, all of which have a similar aesthetic of kinetic forms suspended in a black space; several of them employ signal processing suggesting their production involved Sandin's *Image Processor.*

The *Electronic Visualization Laboratory*, founded in 1973, was devoted to interdisciplinary work—specifically the exploration and development of computer imaging as it intersected with video art.[14] Sheldon Brown, Director of the Center for Research in Computing and the Arts at the University of California, San Diego described these experiments in his introduction to an exhibition surveying Sandin and DeFanti's collaborations in 2011:

> This work has more in common with some threads of
> avant–garde conversations in art film deriving from
> poetry and painting than it did with emerging video
> art growing from conceptual art, performance art and
> cultural theory. The work of Sandin and collaborators
> could occasionally be heard characterized as "video
> wallpaper," but its reach was already influential to
> other pioneering figures such as Nam June Paik and
> the Vasulkas.[15]

Those "threads" of avant–garde film Brown describes are visible as the history of abstract film, that genre of production known as "visual music." These works tended to be oriented towards visual forms that suggested hallucinatory states and synaesthesia; it is a history in avant–garde film that converges on that of abstract painting in form, meaning and aspiration. Hallucinatory states provided inspiration and a direct referent for the synaesthetic imagery used by some of these artists; Fenton, in the same email exchange about this essay, explained her inspiration for *Digital TV Dinner* in precisely these *psychedelic* terms:

> One weekend I was tripping on a drug called ALD–52
> (which is like LSD), with some friends. At dinner time,
> I was playing around with the *Bally Arcade* by popping
> out the cartridge during the boot–up sequence and
> saw the machine go into a particularly complex glitch

animation sequence. It occurred to me that the machine
was "tripping" just like I was. Later, with a video
recorder connected, I tried to recreate that experience.
I was never able to get it into the extended animation
that I saw earlier. Instead we cut together several
glitches into the tape we later showed at the festival.

So glitches begat glitches and dinner begat dinner.[16]

[…]

Raul and Dick were not partying with me when
I "discovered" DTVD. Raul did the video editing
and Dick did the sound track. Dick wrote the
manual for a program I created called "Bally Basic,"
which for a few months held the title of "cheapest
computer you could program yourself."[17]

The relationship Fenton describes between a personal,
subjective experience and the formal organization of imagery for
a finished work is a common part of the visual music tradition's
heritage. This subjectivist dimension also found application in
the kinds of transformations Sandin's *Image Processor* could
produce—both as an analog machine, and as a analog–digital
hybrid (by the mid–1970s, Sandin and DeFanti employed a
PDP–11 computer for precise control of its effects[18]). These
transformations have become a standard part of the visual
language of media art generally, as Brown notes:

Bit–depth, gamma range, object edges and noise were
some of the new compositional elements that analog
and digital signal processing made apparent. Over the
following decades this new semantics permeated
image culture at large, becoming the *de facto* material
basis by which media is produced.[19]

Brown's analysis suggests the transformative effect of Sandin's
IP on analog video can be understood in a *materialist* sense: that
the electronic video signal is the "real" video, its display simply a
translation of those encoded instructions into tangible form shown
on a monitor/TV, or via projection. The kinds of engagement that
this approach offers for electronic and digital systems enables the
recognition of how works like *Digital TV Dinner* offer a direct

parallel those avant–garde films made by scratching the film stock, direct animations that hand–paint their imagery without a camera, or photogram and collage techniques—such as in Man Ray's *Retour à la raisonne* (1923), or Stan Brakhage's *Moth Light* (1961) made without photography. Fenton's manipulations of the digital computer as an instrumental performance are akin to music, and like music, are dependent on the virtuosity of the performer—for the same reasons. *Digital TV Dinner* participates and reflects this very specific conceptual and aesthetic context both in its form—it is a visualized performance—and in the meaning those forms have as visual accompaniment to the music (as a work of video art in a "visual music" mode).

The version of *Digital TV Dinner* posted on *YouTube* in 2009 is identical to the second version of the tape, which was shown in *Image Union* episode 11 broadcast on March 20, 1979. That the program was from 1979, rather than 1978, makes it a likely source for this digitized version, and accounts for the discrepancy in dating (1978/1979). *Image Union* aired on WTTW, the public television station in Chicago, because, unlike similar programs produced to air on "access channels" provided by CableTV in other cities such as New York where CableTV was introduced in the early 1970s (along side the introduction of portable video recording equipment), CableTV did not arrive in Chicago until the 1980s.[20] This difference impacted the development of what Michael Shamberg termed "Guerrilla Television" in his book of the same name:

> Guerrilla Television is grassroots television. It works with people, not up from above them. On a simple level, this is no more than "do–it–yourself–TV." But the context for that notion is that survival in an information environment demands information tools.[21]

The opposition to broadcast TV is an explicit part of this approach to media production/distribution, but in the Chicago area, the difficulty of distribution—provided by the cable access channel elsewhere—necessitated a compromise. WTTW's first series featuring independent video productions, *Nightwatch*, hosted by Gene Siskel as a call–in show where the programs were

secondary to his celebrity presence was replaced by *Image Union*. Organized by Tom Weinberg, who was part of the TVTV video collective, it initially drew from his connections with the local video community and work made at the *Chicago Editing Center* that provided access to video production tools.[22] *Image Union* thus reflects the interests and concerns of *Guerilla Television*, even though it aired on PBS. The program was a 60–minute long anthology of tapes and films produced in the Chicago area, broken into two 30–minute sections. In episode 11 the first half hour includes TV commercials, logos for industrial companies, student animations, and political anti–capitalism cartoons; the second half shows computer–generated video. The diversity of this first half shows a vibrant, dynamic media community where artistic, commercial, and scientific interests overlapped in an interdisciplinary fashion. The variety of materials on display closely mirrors the mixture of avant–garde and commercial works in the popular–oriented film exhibitions of the 1940s–1960s such as Frank Stauffacher's *Art in Cinema* (1946–54).[23] *Digital TV Dinner* headlines the second half of the show, what a voice–over on the interstitial credits for *Image Union* describes as "videotapes by Chicago computer image video artists." This collection of (mostly) abstract videos were all made with digital systems, and it documents the relationship between these early digital imaging systems and earlier analog video.

It is the first of a series of videos in this episode made by Fenton; in fact all of the computer videos except one (*Electronic Boogie* by Bob Snyder) credit Fenton as either the lead artist or as collaborator. *Image Union* presents her use of the game system as a creative tool, offering it as a model (and system) for artistic experimentation in a variety of different ways. However, even in context with a number of other computer works by Fenton, *Digital TV Dinner* is unusual: unlike the next video, *Grafix* by Fenton, Nola Donato, and Tom DeFanti, which demos a software designed to use the Bally home computer game hardware, *Digital TV Dinner* is *not* a use of software—it is an exploit of technical failure. The imagery appearing in this video is *not* designed. Instead, it emerges spontaneously as the processor memory faults

when the game cartridge is prematurely removed from the console. These images are a result of the digital processor glitching *after* the program being run is unexpectedly interrupted.

Image Union's episode on experimental animation by Chicagoans documents developments dependent on the historical shift emerging from the micro computer's introduction in 1974. That most of this program shows works designed for the microcomputer is a reflection of the *Guerilla Television* concern with accessibility to production tools; the position of *Digital TV Dinner* at the beginning of the second half, along with the explanatory voice–over, applies this democratic concern to the emergent possibilities of the digital computer. All the digital video works in this episode were produced with *home* computers— unlike the much more expensive–to–produce computer films of earlier in the 1970s (by Stan Van Der Beek, Lillian Schwartz at Bell Labs, or John Whitney at IBM, for example, or Sandin and DeFanti's own use of the PDP–11 to control the *Image Processor*) that were much more difficult to produce, and consequently required corporate or institutional support. These cheaper machines were readily accessible, opening up access beyond the limits of corporate/institutional control.

The *Digital TV Dinner* video is the only one shown that was not made by writing a program specifically to generate its imagery. Tom DeFanti's voice–over narration (uncredited on the tape) opens the second version, speaking over the credits and into the start of the video itself, making the differences in how it was produced a part of the tape:

> "This piece represents the absolute cheapest one can go in home computer art. This involves taking a $300 video game system, pounding it with your fist so the cartridge pops out while its trying to write the menu.

> "The music here is done by Dick Ainsworth using the same system, but pounding it with your fingers instead of your fist."

The process DeFanti describes for the creation of this audio–visual work is one that emphasizes the performative over (and against) the explicitly programmed. It necessarily

Stills from *Digital TV Dinner* (1978), Jamie Fenton and Raul Zaritsky.

contains an element of uncertainty about the result, even though an experienced and well–practiced performer would likely know approximately what the results would be: these images are an interruption in a technical protocol that is entirely predictable in a strictly determinate fashion, even if in practice, the results are less so. The stoppages inherent to this process reveal a digital failure resulting from the unintelligent mechanical protocol proceeding normally. The imagery appearing on screen reflects a stoppage of this typically proceeding sequence—creating visuals that reflect a partial implementation of the instructions contained by the digital code. Because the performance—the human initiated "stoppage" of the computational process—creates 'unanticipated imagery,' each interruption at the same point would produce identical results—these constants are the *mechanical* nature of the generated imagery. The inclusion of *Digital TV Dinner* opens the use of digital technology to non–programmers in an ironic fashion: the violent interruption ("pounding it with your fist") becomes a productive action, not simply smashing the system. It reclaims the Luddite's gesture of sabotage as a creative and productive activity.

This approach is the same engagement with the materiality of digital technology that has an analogue in the earlier materiality of both film (dirt, flicker, grain, scratches, etc.) and video (signal decay, interlacing, ghosting, etc.). The transfer of this engagement to digital technology parallels the material concern David Antin described in "Video: the Distinctive Features of the Medium."[24] In practice, causing a stoppage at *exactly* the same instant in the code's execution is problematic, giving the results their unanticipated–yet–predictable character. Individual "shots" (stoppages) have a high degree of self–similarity, but are nevertheless distinguishable as unique instances of the same underlying glitch technique applied to the same sequence of instructions.

The foundation of this glitch in the graphics system of the *Astrocade* itself is confirmed through even a cursory comparison to other graphics produced with the same system, but as the coded, expected results of normal operation. The flat geometric forms appearing during the title and introductory voice–over in the *Grafix* demo tape that follows *Digital TV Dinner* in the

Image Union program from 1979 demonstrates this similarity: the *Grafix* tape shows software created for the same technology as employed in the *Astrocade* game. While the title card for *Grafix* is abstract, and presents highly graphic geometric forms in motion, the rest of the video is more typical of consumer "computer art" systems being created in the late 1970s and early 1980s. The tape demonstrates several simple art programs: one for painting, another for music, including showing how simple the coding for them is. The educational potentials of this software are the focus of the *Grafix* video, showing that the digital computer has potential as an artistic tool. The relationship between the visuals created by the (art) *Digital TV Dinner* tape and this documentary tape is only apparent in the expressive graphics appearing at the start for the title, rather than the less dynamic, documentary footage showing both the software code and what it looks then when in use. Both videos present different engagements with the computer—a "destructive" gesture that violates the system and a "constructive" one that converges on traditional art: what the "paint" program creates is a landscape recognizable as a digital analogue to TV painter Bob Ross's work. An offhand comment during this documentary about the Bally *Astrocade* defaulting to the video game *"Gunfight"* when it reboots after crashing illuminates the final glitched image showing "GAME OVER" at the end of *Digital TV Dinner*. It is possible this image reflects such a system reboot into the game, rather than into the game selection menu, although selecting a game and then glitching it could produce the same imagery. While it is unclear if any of the other imagery shown is also from a game, the tape does contain images that are produced from the glitched boot screen, making more sources than just the menu screen very likely.

However, the selection screen (menu) appears in varying degrees of dissolution throughout this video, and occasionally in a legible, nearly unglitched form. It is possible to read the list of games available on some of these screens. This list changes, suggesting the tape is made from either several cartridges, or several different consoles: *Gunfight, Checkmate, Calculator* and *Scribbling* are all briefly on screen near the video's end. The

Title card from *Grafix* video broadcast on *Image Union,* March 20, 1979.

"Game Over" graphic and music that concludes this piece was used by games on the *Astrocade* such as *Gunfight.* Its presence is an acknowledgement of the performative aspects not only of its games, but the actions required to produce these broken graphics and music seen and heard throughout the video: this is a document of someone physically manipulating the machinery itself. What appears has a physical origin, it is not an execution of code, but the interruption in that code's execution that creates what we see in this video: while the imagery is serially structured in a repeating fashion—simple blocks of graphics repeat across the screen, and the anomalous visuals *do* have a recurring graphic form—the imagery that does appear cannot be predicted or controlled with the same precision that graphics specifically generated by code. This performance–aspect shifts what appears from the realm of programming executed automatically, to the particular touch of the individual handling the machine. That the same technique can produce both the visuals (banging the case with a fist) and sounds (tapping the same case with fingers) heard in *Digital TV Dinner* is an indication of how touch–sensitive this type of glitch–manipulation can be.

"Bally Astrocade" boot graphic from *Digital TV Dinner* (1978),
Jamie Fenton and Raul Zaritsky.

The serial graphics so readily apparent from *Digital TV Dinner*
have remained a common, formal feature of glitch: repeating
imagery, both within individual shots and across the range of
shots in the whole video, is typical of the kinds of visual produced
in contemporary glitch videos. The formal design of these failures
were explicitly noted in Iman Moradi's 2004 discussion *Gltch
Aesthetics* as a discrete collection of tendencies: fragmentation,
replication/repetition, and linearity.[25] All of these forms appear
in the failures recorded and used in *Digital TV Dinner*. This
description summarizes those distinct features associated with
serial structures, suggesting autonomously looping computer code
generating a result and then repeating/iterating it as a series of
similar patterns across the screen. This video is one of the first to
create this type of visual digital glitch and employ it as the primary
source material. While this effect is novel, it is anticipated by the
use of analog failures by earlier video art produced in the 1960s.
Many of the electronic oscillation patterns, transformations of
the gamma range, isolation of object edges, and the use of signal

"Game Over" graphic at the end of *Digital TV Dinner* (1978),
Jamie Fenton and Raul Zaritsky.

noise to transform stable video signals are identified as technical
failures in the repair handbooks made by RCA.[26]

What has been recorded and used in *Digital TV Dinner* is the
result of the system *partially* crashing: it dumps the material in
memory on screen as kinetic geometric patterns that move both
up and down on screen at different rates. The text appearing at the
top of the screen "SELECT GAME" at the beginning reappears
sporadically throughout the whole video. It shows at what point
the processes generating the screen have been interrupted: this
effect is possible in the Bally system because, as Fenton notes, it
was one of the only video game systems where cartridges could be
removed from the machine without causing a total system crash.
When there is a total crash, the machine must reboot—there is no
imagery drawn on screen. Rather than producing a procession of
strange, repeating patterns, a reboot would often default into the
game *Gunfight*, as Fenton notes during the *Grafix* video, a fact
suggested by the concluding shot where the screen says a glitched
version of "GAME OVER" and plays the "you're dead" music
that normally accompanies this screen. It is a humorous *finalé*

where it is the computer game that died, rather than the player, an acknowledgement of the violence employed in *Digital TV Dinner's* production—a smashing of the system. This concluding glitch is an appropriate end to the video—humorously acknowledging that when glitches distort and transform the computer screen, they are the 'death' of normal function: rebooting will be necessary to start over. Evidence of this necessity is scattered throughout the video. Occasionally a partial boot–screen graphic will appear, showing that the interruption is always on the verge of full system failure.

All the imagery of *Digital TV Dinner* is composed from partial failures: the system breaks, but only so much that the standard, anticipated result does not (entirely) appear. The insertion of human decisions at crucial points (the "stoppage") in an otherwise autonomous process undermines the independent function of the system in question. A breach in normal function, however visible to the audience, is at the same time *not* a failure of the digital system. System failure is *invisible,* it becomes apparent not through *mis*function, but as *mal*function, a cessation—the digital renders *nothing*. Instead of rebooting, the machine generates visuals following the partial instructions still in memory, dumping the results as the chaotic (but structured) 'noise' shown in the finished video. This process repeats for each shot with slight variations in result that reflect differences in timing: the images created by this process are highly sensitive to what point in the generation of the system menu has been interrupted. Thus, the results are utterly predictable, without being fully prescriptive of the result. The balance between predictability and a chaotic, unknown result is a common feature of glitch processes, uniting what happens in this video with more recent developments in manipulating digital artifacts produced by glitches and anomalous function. Stoppage offers a potential for critical rupture, the innate purpose of Guerrilla Television's challenge to broadcast media generally, through its transfiguration of the commonplace elements of the imagery being glitched, but this change is complicated by an equally potential, immanent recognition that the system is broken, an identification that elides any critical potential by normalizing the glitch as system failure. This dynamic renders glitch ambiguous as a critical process/tool.

REFERENCES

1 *Digital TV Dinner*'s *YouTube* posting had 3,645 views, and 76 "thumbs–up" approvals by February 4, 2014.

2 It appears in the middle of a program of 8 videos: *Wire Trees with 4 Vectors*, (video: Phil Morton, Guenther Tetz, audio: Lief Brush, Stu Pettigrew); *By the Crimson Bands of Cyttorak* (video: Tom DeFanti, Barbara Sykes, audio: Glen Charvat, Doug Lofstrom, Rick Panzer, Jim Teister); *Electronic Masks* (video: Barbara Sykes, audio: Glen Charvat, Doug Lofstrom, Tom Warzecha); *Spiral 3* (video: Tom DeFanti, Phil Morton, Dan Sandin, Jane Veeder , dance: Rylin Harris, audio: Sticks Raboin, Bob Snyder); *Digital TV Dinner* (video: Jay Fenton, Raul Zaritsky, audio: Dick Ainsworth); *Data Bursts in 3 Moves* (video Phil Morton, Guenther Tetz, audio Phil Morton, Bob Snyder); *Cetacean* (video: Chip Dodsworth, Phil Morton, audio: Barry Brosch, Chip Dodsworth); *Not of This Earth* (video: Barbra Latham, John Manning, Ed Rankus, audio: Patti Smith). Listed in Stone, Trish. *Synthesis: Processing and Collaboration*, (San Diego: The Gallery@Calit2: 2011), p. 42.

3 Fox, T. "Interview with Dan Sandin and Tom DeFanti" *Synthesis: Processing and Collaboration*, (San Diego: The Gallery@Calit2: 2011), p. 13.

4 It appears in the second half of *Episode 11: Animation*, starting at timecode 36:36. This original broadcast includes the same voice–over at the start as the version posted to YouTube. The video is available in the Media Burn archive: http://mediaburn.org/video/image–union–animation–episode–10/ accessed, February 4, 2014.

5 "Jamie Fenton" biography webpage on personal website: http://www. fentonia.com/bio accessed, February 4, 2014. Also, the quote is from provided in a private email, February 7, 2015: "I was the lead software engineer on the *Arcade* project. I had 2 engineers helping me. Part of my role was to make sure that the hardware guys created a good design. Jeff Frederiksen was the lead hardware guy—he was and is brilliant (and a little difficult to work with, since he could change a design on a moments notice). Right now Jeff is working at Apple on the *iPhone*. All this means I can point–out where in the code things went wrong."

6 Youngblood, G. "Art and Ontology: Electronic Visualization in Chicago" *The Event Horizon* ed. Lorne Falk and Barbara Fischer (Toronto: Coach House Press and The Walter Phillips Gallery, 1987).

7 Scott, F. "Networks and Apparatuses circa 1971: Or, Hippies Meet Computers" *Hippie Modernism: The Struggle for Utopia* (Minneapolis: Walker Art Center, 2015) pp. 108–110.

8 Shamberg, M. and Raindance Corporation."Manual" *Guerrilla Television* (New York: Holt, 1971).

9 The text summarized what appeared with the YouTube video: "Early examples of glitches used in media art include *Digital TV Dinner* (1979) created by Raul Zaritsky, Jamie Fenton, and Dick Ainsworth by manipulating the Bally video game console and recording the results on videotape." https://en.wikipedia.org/wiki/Glitch_art accessed, February 4, 2014.

10 In a private email discussing this essay prior to publication with Jamie Fenton, on February 7, 2014 she notes about the origins of glitches: "The first "glitch art" was seen occasionally when we debugged games in 1975. A game crash would spread "mung," (or garbage) on the screen. Sometimes the mung had a regularity to it."

11 The second version and its description were uploaded to *YouTube* on October 8, 2009: http://www.youtube.com/watch?v=Ad9zdIaRvdM accessed, February 4, 2014.

12 Private email discussing this essay prior to publication with Jamie Fenton, February 6, 2014.

13 *Atari 2600 Video Computer System Field Service Manual 2600 / 2600A Domestic (M/N) FD100133, Rev. 02* (Sunnyvale, CA: Atari, Inc., 1983).

14 The Electronic Visualization Laboratory website, https://www.evl.uic.edu/info, accessed, February 4, 2014.

15 Brown, Sheldon. "Introduction" *Synthesis: Processing and Collaboration* (San Diego: The Gallery@Calit2: 2011), p. 5.

16 Private email discussing this essay prior to publication with Jamie Fenton, February 6, 2014.

17 Private email discussing this essay prior to publication with Jamie Fenton, February 7, 2014.

18 Minkowsky, J. "Design/Electronic Arts: The Buffalo Conference, March 10–13, 1977" *The Emergence of Video Processing Tools, volume 2* Kathy High, Sherry Miller Hocking and Mona Jimenez, eds. (Chicago: Intellect Books, 2014) pp. 407–408.

19 Brown, S. "Introduction" *Synthesis: Processing and Collaboration* (San Diego: The Gallery@Calit2: 2011), p. 5.

20 Chapman, S. "Guerrilla Television in the Digital Age" *Journal of Film and Video* vol. 64, nos. 1–2, Spring/Summer 2012 p. 44.

21 Shamberg, M. and Raindance Corporation."Manual" *Guerrilla Television* (New York: Holt, 1971) p. 8. The book is composed of two sections, "Meta–Manual" and "Manual," each numbered separately.

22 Chapman, S. "Guerrilla Television in the Digital Age" *Journal of Film and Video* vol. 64, nos. 1–2, Spring/Summer 2012 p. 46.

23 MacDonald, S. *Art in Cinema: Documents Towards a History of the Film Society* (Philadelphia: Temple University Press, 2010).

24 Antin, D. "Video: The Distinctive Features of the Medium" *Video Art: An Anthology*, eds. Ira Schneider and Beryl Korot (New York: Harcourt Brace Jovanovich: 1974).

25 Moradi, I. *Gltch Aesthetics* (BA dissertation, School of Design Technology, Department of Architecture, The University of Huddersfield, January 27, 2004) pp. 28–33.

26 Meagher, J. *RCA Television Pict–O–Guide: An Aid to TV Troubleshooting, Volume 1* (Harrison, NJ: Radio Corporation of America, Tube Department, 1949) see pages 45, 49, 51, and 55 for examples of analog signal and technical glitches that reproduce visual phenomena resembling analog signal processing in early video art.

published in
Beyond Spatial Montage
Routledge/Focal Press, 2016

VISUAL MUSIC AND REALISM

Realism, as film historian Christopher Williams notes in the introduction to his study of realist theories in cinema, tends to disappear into arguments about what is "real," rather than remain concerned with the aesthetic form, mimesis, it describes. Realism devolves into philosophical argument about the nature of the world:

> The debate about realism can perhaps best be grasped through the opposition between 'mere appearances,' meaning the reality of things as we perceive them in daily life and experience, and 'true reality,' meaning an essential truth, one which we cannot normally see or perceive, but which, in Hegel's phrase is 'born of the mind.'[1]

The distinction Williams describes is the difference between works that engage in mimesis of varying degrees of verisimilitude and the interpreted, constructed work that may not resemble the world of visible objects and events at all—abstraction's claims to revealing a 'deeper reality' being a prime example of this mental reality. Within the cinema, with its basis in the photographic, the focus has tended towards this verisimilitude in mimetic form, what is often called "naturalism." However, the temporal element in cinema complicates the traditional conceptions of the distinctions between realism and naturalism, between the presentation of a photographic actuality of audio–visual appearances and their interpretation and construction as revelation of deeper meaning. This collapse of argument about in cinema into a debate over the relations of reality, realism and naturalistic form often assumes the form of arguments over the ontological relationship between realism and reality.[2] While such debates are beyond the scope of the present discussion, their contingent effects on the conception of cinematic form impact the ways that windowing develops, the uses found for it, and the potentials that receive historical development.

Cinematic realism developed out of the styles of (bourgeois) theatrical realism in the nineteenth century. Realism on stage has organized the theoretical conceptions of realist cinema over the course of the twentieth century, and is an underlying, determinant heuristic in the contemporary applications and developments surrounding windowing, in particular for the structures of 'spatial montage.' It is the subsumption of this technique within narrative as a means to demonstratively present simultaneous actions *simultaneously* that links this contemporary use with earlier theories of realism, most particularly the realist theory surrounding the long take proposed by André Bazin and his followers. Williams explains Bazin's realism through his discussion of *Italian Neo–Realism*:

> The Italians are realist because their main aim is to
> show the world and to do it as directly and limpidly
> as possible. Their aesthetic is one which 'integrates
> reality' into the film; the realistic material (provided
> by reality) permits the artist to discover realistic
> 'means of expression.'[3]

Because historical cinema (unlike digital or "postcinema," which does not share this requirement) is built from photographic reproductions—the filming of actions performed in front of a camera—Bazin's realist cinema thus proceeds from the presentation of these 'events' (actualities) with a minimum of visible mediation (such as editing). It is not a presentation that is itself reality, but a construction that functions socially as reality, one where what happens on screen corresponds to what could happen for the audience watching the events live. [4] This uninflected re–presentation of what happened in front of the camera—"the reality of things as we perceive them in daily life and experience"—allows what Bazin understands as the innate reality of cinema to become apparent for the audience in the as a specific morphology of the shots employed, their sequential relationship, and development over time—what can be recognized as the structure of film narrative. It is a construction, which as theorist Richard Rushton explains in his book *The Reality of Film*, is central to Bazin's conception of realism:

> Rather, reality is composed of a set of shared,
> potentially communicable concerns. As such, realism
> in the cinema is not a matter of a film's measuring up

to a preconceived, prior and pure reality. It is about
establishing sets of shared concerns, a matter of
discerning degrees of meaningfulness and
understanding about what we might be able to agree
upon as being real.[5]

Those elements that form the foundation of realism in
film proceed from what Bazin described as an "ontological"
foundation that provides the justification for Bazin's particular
realism; it is a construction, but one whose foundation lies in
its convergence with our everyday experiences. For Bazin, the
innate connection between the depicted image and that image's
source in the physical world is the foundation of his realist theory:
the photograph is more than just fingerprint, a material trace of
that physical world, it brings that world back into consciousness.

19428612_1157355607744018_75118531330441216_n(2017).jpg is a frame
of digital cinema photographed to show its construction.

This acknowledgement is not the same as mistaking the realism contained in a motion picture for the reality outside of it.

His conception of the photographic image is radically challenged by the photorealist digital image; Bazin is writing before the advent of this type of simulation, at a moment when "special effects" were much more limited in scope, their capacities for simulation much more constrained and immediately apparent; there was no alternative to the direct linkage of moving image to original source (a fact even more obvious when one considers the 'live' nature of television when Bazin wrote this essay). This aspect of cinematic realism is one that forecloses on self–evidently manipulated work in animation and abstraction; the relative rareness of abstraction in commercial film production reflects the same dominance of the realist approach to cinematic form that constrains the development of windowing. A consideration of how realism impacted the development of abstract film in the 1930s is instructive: Walt Disney's third feature–length animated film *Fantasia* (1940) includes an abstract section that demonstrates the mediating role *realism* (based in the faithful reproduction of the 'surface appearance of the visible world') has on the morphology and structure of abstract film in the opening section. This is a construction where the 'reality' filmed in the studio (on an animation stand) is not the determinant of its morphology, but rather incidental to the realism emergent from the images' structure. [6] The resulting connection of abstract form to a subjective experience presented "objectively" (via realism) transforms it into a superficial appearance of imaginary, yet visible events. The use of realist–derived abstractions for this sequence thus becomes logical—an expression of the realist demand common to commercial feature films imposed on non–realist form.

This relationship between realism and "subjective form" organizes the entirety of, *Fantasia*. The issue of subjectivity is an historical dimension of the debates over realism: the presentation of a "true reality," as Williams notes, is one that exists as an opposition between "mere appearances" and an (unseen) "essential truth." This pairing shows in the morphology and form of the opening sequence. Its use of nearly abstract imagery is typical of the presentation of abstract elements as the "essential truth" of a *subjective* realism—the visuals appearing on screen are recognizably adapted from the instruments used to perform the music. This direct linkage to the photographic

reality of the orchestra appearing in between musical–animation performances organizes the entire film, bringing the realism of the performance into dialogue with the interpretive nature of the visuals. The opening abstract sequence makes these connections of realism to abstraction explicit, so that the later sequences—those which contain more typical cartoon animation—seem to develop out of the abstraction of the opening performance in a clear, comprehensible fashion.

This abstract opening reaches its climax with a blocky diamond–shaped form—a *Thing*—descending into darkness as the music, J. S. Bach's *Toccata and Fugue in D Minor (BWV 565)*, draws to a close. This climactic shot is a conventionally realist example of cartoon animation. It comes at the end of an opening sequence that began as live action with the symphony musicians arranged on stage, dramatically lit so their shadows would tower above them. Even before these musicians appear, we can hear them tuning up their instruments as the curtain opens and they take their places.

The entire opening sequence is 13 minutes long, but it is not a singular piece: the prologue to the music is protracted. The first third of this opening sequence is live action organized as a standard realist documentary. Before the music begins the curtains open and for the first two minutes the musicians in the Philadelphia Symphony Orchestra take their seats on stage; then another two minutes as music critic Deems Taylor, the narrator, introduces the film and announces what will appear in the first part of the program; there are no credits. The only title card for *Fantasia*, lasting less than 30 seconds, comes in the middle in between when the curtains close and reopen for the "intermission" which normally comes in the middle of a symphony performance—a further example of the realist structure operative throughout *Fantasia*. The imagery on screen does not stray far from this foundation, remaining within the domain of realism: abstracted bows, strings and other clearly recognizable imagery are 'being' the orchestra. The abstraction reduces the representational forms towards an essentialized foundation.

Of particular note in Deems Taylor's explanation of this sequence specifically as a realist presentation of subjective imagination. For a motion picture composed almost entirely of cartoons organized as a dance–like counterpoint, this opening section—and Taylor's explanation that precedes it—reflect the

realist approach that structures and conditions the development of the abstract imagery more decisively than at any other moment in the film:

> "What you will see on the screen is a picture of the various abstract images that might pass through your mind if you sat in a concert hall listening to this music. At first you are more or less conscious of the orchestra, so our picture opens with a series of impressions of the conductor and the players, then the music begins to suggest other things to your imagination. They might be, oh, just masses of color, or they may be cloud forms, or great landscapes, or vague shadows, or geometrical objects floating in space."

Taylor's verbal prompts encourage the audience to interpret these initial "masses of color" in specifically *realist* ways, explaining the significance of the abstraction by transforming it into representational imagery. Even though Taylor narrates before all the other sequences, he does not describe their development so literally; however, in the historical context when it was originally produced and released, these explanations–as–prologue are not unusual. They are an attempt to address the perceived hostility the American public had in the 1930s to abstract art: the claim by those members of society who are 'uninitiated' into its mysteries that abstraction is "meaningless." [7] Reflecting a similar realist approach to abstraction, Mary Ellen Bute used brief opening explanations for her films from earlier in the 1930s: *Rhythm in Light* (1934), *Synchromy no. 2* (1936), and *Parabola* (1937). Mary Ellen Bute's explanation at the start of *Rhythm in Light*, where the abstraction reflects 'her' imagination, (*"A Pictorial Accompaniment in abstract forms"* / *"This film is a pioneer effort in a new art form— It is a modern artist's impression of what goes on in the mind while listening to music."*), that proposes a realist understanding of the abstraction *as* subjective imaginings, the opening in *Fantasia* makes the same connection. Oskar Fischinger, briefly employed at Disney to work on *Fantasia*, also included a similar title card in his MGM animation *An Optical Poem* (1938). The shift from abstraction (as such) in the 1920s to a subjective realism minimized the challenges this type of imagery poses to naturalistic realism common to live action cinema.

Abstract art, because of its visible differences from realist depictions (and its tendency to be seen as a foreign language), was problematic in the United States, as its long history of rejection there demonstrates: this is the audience that responded with ridicule and intense hostility when confronted by Marcel Duchamp's *Nude Descending a Staircase, No. 2* during its exhibition in the *1913 International Exhibition of Modern Art* (a.k.a. "The Armory Show") in New York. However, such hostility was not limited to the United States in the 1930s: abstract animation had been abandoned in Europe by almost all of its early innovators by 1934,[8] the same year Mary Ellen Bute released her first film, *Rhythm in Light*; her second film blends the abstract forms of rings and spheres of the first with more representational material, creating a work that is defamiliarized, abstracting, but not beyond the scope of realism. This limitation reflects the constraints that realist cinema imposes on abstract motion pictures in the 1930s and '40s.

The popular American rejection of abstract art is related to what philosopher Kurt Rosinger identified in 1938 as the tendency to see art as an 'instrumental factor of communication,' a belief that he argues leads to misapprehensions of the nature of art itself, as well as demands that are inappropriate to make for art, resulting it a common mistake about *what* is being encountered. The tendency validate realism while at the same time claiming that abstract art is "meaningless" originates with this misunderstanding:

> It is commonly believed that whatever else an object of art may be, it is essentially a vehicle constructed by its creator to carry a communication to its observers. So deeply embedded is this conviction that it is generally assumed that to understand a work of art is to perceive a communication in it. [. . .] The understanding of a work of art involves, for most men, not so much the enjoyment of its tones or colors or rhythmic movements and a comprehension and reaction to its underlying form, as it does an attempt to discover a hidden conceptual significance. [. . .] This erroneous belief in the importance of communication to art has greatly inhibited the pleasure of many people in their contemplation of art.[9]

Rosinger's comments reflect the understanding of Modernist art that was current when *Fantasia* was produced. His discussion offers a similar account of aesthetic experience to what Deems Taylor suggests: an experience focused on the *formal* features of the work as of primary importance to its evaluation as art. This is specifically a theory that emerged in the twentieth century as a way to address the innovations and challenges posed by the new abstract art of this time when confronting realism. That it also provides the answer to the 'problem' in comprehension—a shift from abstraction to realism—indicates both the commonality of the 'misperception' he describes, and the ways that audiences tended to misunderstand abstraction generally (formalist theory is primarily concerned with abstract art). The focus on 'communication' he describes means that when this communication–function is absent, the accusation that the work is 'meaningless' is logical, if incorrect. The difficult presented by this type of art is not one that can be easily answered through an appeal to the experience of tones or colors or which rhythmic movement can readily resolve. It is an issue linked to the conception of the depiction itself as *non–realist;* 'realism' shifts in these films to accommodate a wider range of visual forms. The verbal framing of how to interpret these shots—which play as long takes—moves them to the realm of the realist image.

Unlike representational art that is apparently 'grounded' by its visual contents—the resemblance to the everyday visible world providing an immediate, direct "meaning," for example, a painting by Paul Cézanne "containing" a depiction of 'an orange' or 'a nude'—abstraction appears to lack such constraints since it is not limited to the reproduction of readily recognizable forms from the everyday, visible world. It is *how* this initial encounter develops that distinguishes abstraction and representation precisely because abstraction does not enable these same instantaneous recognitions: the depicted "content" of representational art allows its audience to confuse this initial perception of subject matter with other types of interpretation, doubling its meaning as both representation and symbol. In contrast, understanding an abstract work depends instead on a fluency that is culturally derived, and is not present at this initial level of interpretation, an observation implicit in Rosinger's discussion. This difference demonstrates abstraction's dependence on *established* expertise—an abstract painting, such as a blue monochrome by Yves Klein, may not "contain" anything.

The audience's past expertise and familiarity with abstraction is therefore necessarily more prominent in its interpretation. This 'ungrounded' nature is literally the 'subject matter' of *Fantasia's* opening sequence via the background's resemblance to "cloud forms, or great landscapes, or vague shadows or geometrical objects floating in space"—many of the animated kinetic forms are not just audibly synchronized with particular instruments, they resemble them. These forms on screen retain visible links to their sources 'grounding' the abstracted content of the animation in a realist animation that looks prosaic and decorative compared to the abstract films produced by Walther Ruttmann and other avant–garde film makers twenty years earlier, but *is* radically abstract when contrasted with the other sections of *Fantasia* itself, or any of the Disney studio's other productions (before or after).

Realism is reflected in the other decisions about what and how to present the music in *Fantasia.* The use of recognized and already accepted music in all these films, coupled with their opening explanations, served to help make their abstract imagery more familiar and comprehensible; yet this usage did not address the 'ungrounded' character of the imagery itself emerging from its divergence from (animated) realism. The synchronization of sound and image apparent in the climactic moment of the *Toccata and Fugue in D Minor* sequence resolves the 'ungrounded' nature of the abstract form by linking it perceptually with music, but unlike the rest of this sequence, it does not employ realist–inspired forms abstracted from the actual form of the instruments. This shot was identified by Warner Brothers animator/director Chuck Jones in 1946 as one of two examples in *Fantasia* where sound and image became:

> the nearly perfect wedding of music and graphics
> which occurs when the visual and auditory impacts
> are simultaneous and almost equal. Both examples are
> from the picture *Fantasia*; both are bits. One consumed
> about four seconds in the *Toccata and Fugue* sequence.
> It pictured simply a ponderous, rocklike, coffin like
> mass that waddled into a murky background
> accompanied by a series of deep bass notes. I should
> not say "accompanied," because this Thing was the
> music: to my mind there was no separation; the fusion
> of the auditory and the visual was perfect.[10]

This single cartoon shot of an "abstract form" appears twelve minutes into the opening sequence, literally as the climax of the music. It is both atypical for this sequence, and conforms to the standards of cartoon realism employed in Disney's other films. By functioning as a direct linkage of music to abstract form, it gives that form a visible, tangible character that is to normative. Its different character from the rest of the opening sequence, returns the animation to those expectations common to naturalistic live action. This assertion of standard realism counters the rest of the 'abstraction' in *Fantasia,* which can be readily linked to the "musicians," as with the bow on a violin representing the violin's notes; others reveal a direct link between the instrument and its audible performance, as with the flute's notes and the briefly appearing flute+star forms. The subjective dimensions of this 'pseudo–realism' link what appears on screen to the music/ instruments directly—they are directly synchronized, appearing at precisely the same time. Thus, within the limited context of *Fantasia,* the *Thing* appears very abstract, almost *irrational* in its lack of any direct, clear connection to the orchestral imagery or the cloud forms that dominate this opening. (Even though, as William Moritz has noted, this shot is an 'out–take' from Disney's first feature, *Snow White and the Seven Dwarfs* (1937),[11] paradoxically it becomes the most abstract moment in an otherwise semi–abstract animation.) Taylor's introduction provides interpretive prompts for this movement between recognized, familiar forms (the musicians, the images of the flutes), pseudo–realism (the lines and other animations based on parts of the instruments, such as the bows), and the actually abstract forms (circles, stars, and other shapes that imply, but do not depict, instruments) by transforming all these visual elements into variations on a realist mode presenting an "essential truth" distinct from "mere appearances."

The *Thing* Jones identifies appears as a cartoon character: its morphology is familiar; even as a highly abstract shape within the sequence, it is at the same moment a familiar, realist *depiction.* The wobbling motions 'walk' with the music, shifting from corner to corner in sync with each descending note, the musical progression matched by the *Thing* descending in space, growing smaller as it moves into the background surrounded by swirling dark clouds. The most realist image simultaneously acts as an abstraction within the sequence. This interpretation of the

sequence as positioned between realism and abstraction reflects the demands made *by* realism as the dominant type of cinematic production, even in cartoons. The "darkness" of the music (low bass notes) is matched by the darkness of the shot, a connection dramatically emphasized by the immediate return of 'naturalism' in the next shot where "light beams" pierce the darkness from the top of the frame, extending down the center of the image in yellows and whites that contrast sharply with the dominant blues, purples and cyans of the *Thing* and its background.

This shot clarifies the role of realism constraining "abstract" art: the immanent encounter with abstraction becomes familiar, already understood—*realist,* part of the established naturalism::stylization dynamic—resembling the "superficial appearance of visible reality." The synchronization of music to these images, as this shot from *Fantasia* shows, alters the realism of live action photography fundamentally: the image does *not* "contain" an immediate, direct meaning as *representational art* might—it shows a *Thing,* but not *anything* in particular. Yet it does have an immediately recognizable, comprehensible *implied* content: it is the visual embodiment of the music (or sound), a possibility immediately manifesting for the audience. The formal structures of music synchronized with this climactic animation enable the matching of action to sound—via the *synchronization* described by Jones' comment, thus creating the meaning he ascribes to this *Thing,* transforming it into a realist depiction of an abstract concept, comparable to the other realist transformations throughout both opening sequence and other scenarios shown in *Fantasia.* These visuals *become* the form of the music in an understanding of relationships that are not dependent on any past experience with either abstraction or the music. This connection of sound to image is dependent on the conjunction of discrete audio–visual elements that would otherwise be independent of one another: in linking abstract form, dark environment and descending bass notes in this fashion, the shot creates the strong impression Jones notes about this *Thing*—that it is not merely an abstract form, but the literal form assumed by the music being played, not just an accompaniment or visual counterpoint as with the rest of the sequence.

Linking already–known music to abstract images organizes those visuals into a recognizable form they might otherwise appear to lack—because these recognitions are autonomous, typically

proceeding without conscious direction or engagement[12]—they imply a naturalness that then renders the connection of sound and image equally natural and seemingly inevitable. Synchronization is thus an essential factor in this process of making abstraction become realism. Music, as in the *Toccata and Fugue in D Minor* in *Fantasia*, "grounds" this abstracting tendency through the musical composition, resolving ambiguities in an affective realist naturalism of the sound–image link: the motion and shape of the *Thing* puts this recognition in motion. The "walking" gives it mass—each step falls on a note, a realist connection that makes the design and animation choices in advance of the work itself. Its apparent abstraction is a result of the doubling it presents, not just as an animated form in motion, but also as a *characterization* of the music itself.

However, while the *Thing* has definite shape, and suggests a massive, rigid object, it remains independent of the other abstractions. Where the other shapes are designed to appear as versions of the orchestra, this form does not: as Jones observes, the *Thing* seems to be not just a form in motion, but becomes *the music* itself—the shape becomes *"synaesthetic"* not just synchronized. The connections of sound and image in this climactic shot are three-fold: (*a*) its shifting motion that matches specific notes' beginning and duration; (*b*) its decreasing size as it moves across the screen, suggesting a descent not just on screen, but into the background; (*c*) an increase in darkened areas in this background against which the form moves, shifting from *yellow–purple* to *red–purple* as the highlighted space shrinks around it. Each of these three audio–visual connections follows the same tone sequence, synchronized so that at every note, the form moves, becoming smaller as the background darkens. These changes coalesce, arriving at full black as the final note in this musical phrase sounds. This cartoon character demonstrates how abstract forms assume an entirely different character with the addition of sound—the realism that ensues is of a different order than that of photography, but in their illustrative connection to the music abstraction becomes its embodiment. This apparent correlation of image and sound produces a synaesthetic effect transforming abstraction into a *subjective* realism. Visual abstraction linked to music enables the audience to interpret those visuals as a translation of the music into the concrete, visual realm of the image: abstraction thus *illustrates* the sounds, resolving some of

the otherwise 'inherent' difficulties that accompany abstraction through recourse to the realist dynamic of naturalism::stylization operative in commercial motion pictures. It is the coincidence of form and meaning in this work that Chuck Jones notes when he states that "this Thing was the music," a linkage dependent on the audible soundtrack no less than the apparent motion of this shape—the duality apparent in the *Thing* as being both abstract image and re–presentation of the music.

REFERENCES

1 Williams, C. *Realism and the Cinema: A Reader* (London: Routledge, 1980) p. 11.

2 Rushton, R. *The Reality of Film: Theories of Filmic Reality* (Manchester: University of Manchester Press, 2011) pp. 10–19.

3 Williams, C. *Realism and the Cinema: A Reader* (London: Routledge, 1980) p. 36.

4 Rushton, R. *The Reality of Film: Theories of Filmic Reality* (Manchester: University of Manchester Press, 2011) pp. 44–47.

5 Rushton, R. *The Reality of Film: Theories of Filmic Reality* (Manchester: University of Manchester Press, 2011) pp. 10–19.

6 Rushton, R. *The Reality of Film: Theories of Filmic Reality* (Manchester: University of Manchester Press, 2011) p. 53.

7 Eco, U. "Interpreting Serials," *The Limits of Interpretation*, (Bloomington: Indiana University, 1994), pp. 83–100.

8 Jordaan, LJ. "Fischinger's Symphony in Blau," *FilmLiga*, November 15, 1935, pp. 34–35.

9 Rosinger, K. "What Shall We Look for in Art?" *The Journal of Philosophy*, vol. 34, no. 12 (June 10, 1937) p. 309.

10 Jones, C. "Music and the Animated Cartoon" *Hollywood Quarterly*, Vol. 1, No. 4 (July, 1946), p. 365.

11 Moritz, W. *Optical Poetry: The Life and Work of Oskar Fischinger*, (Eastleigh: John Libbey, 2004) p. 87.

12 Bogdan, C. *The Semiotics of Visual Languages* (New York: Columbia University Press, 2002), pp. 9–22.

published in

Synchronization and Title Sequences:
Audio–Visual Semiosis in Motion Graphics

Routledge Studies in Media Theory and Practice

Routledge, 2017

THE IDEOLOGY OF VISUAL MUSIC

Historians and theorists of "visual music" treat its foundations with using pre–existing music (either the score or a recording) to create and synchronize the visual composition as a given; a brief digression into this history is thus warranted. The formal arrangement, timing, and design of sound::image, what art criticism and history term *synaesthesia*[1] is preplanned; borrowed from psychology, this term is the technical description for the simultaneous linkage of two otherwise distinct senses (such as hearing and sight) into a singular "cross–modal sensory experience." Before World War II, the historical avant–garde was closely engaged with issues of synaesthesia, both as an abstract reference and as a literal *material* to explore through new technologies of sound recording, such as the optical soundtrack.[2] The history of the abstract or "absolute" film's technical–aesthetic development during the two decades prior to the general embrace of synchronous sound recording by the film industry in 1927[3] transfers between avant–garde experiments in painting that were explicitly synaesthetic to motion pictures[4] are common.

The range of artists impacted by "visual music" cuts across the boundaries between movements, media, and decades of time to reveal a consistent interplay of abstract from, synaesthesia, and synchronization.[5] The visual music film uses synaesthesia to produce *statements* of *illustrative synchronization* that mask their cultural/ideological meanings as physical phenomena comparable in their immediacy of recognizable link to 'lip–sync.' Considering this heritage of "visual music" illuminates the complexity and aesthetics of synaesthetic form in title sequences—in the twin formal approaches of *illustrative* and *counterpoint synchronization*—as well as its acknowledges its ideological dimensions.

While visual music has informed a variety of aesthetic proposals, these approaches are historically limited in scope and application to particular types of musical composition and only to visual imagery evoking a synaesthetic experience (i. e. a phenomenal encounter that has the character of synaesthesia). The network of relationships between abstraction, synaesthesia, and visual music reveal more than just a set of congruencies—the histories of abstraction on film and in avant–garde art are more than simply parallel evolutions—visual music, abstract painting and motion graphics intersect, overlap and often share artists. This idea of a visual art that has the same emotional and aesthetic independence as music plays a central role in the early development of abstract painting and informs the entire history of abstract film; the desire to create kinetic abstract/synaesthetic visuals is apparent in its interdisciplinary scope. The *synaesthetic* functions metaphorically as a descriptor for the organization and development of visual works that follow the prerogative and formal structures of musical form—a reflection of how the musical develops as a cultural phenomenon, itself detached and free–floating, independent of the visual—however, the issue is not about *voice, sound* or even *music* but about its *synchronization*: the *statement* created through the relationship of sound (which may and often does include music) to visual materials is a simultaneous alignment of immanent sensory encounters and ideological content.

The movement between making art engaged with synaesthesia and creating films was common: at the start of the 1910s, the Futurists Bruno Corra and Arnolda Ginna began as painters, abandoned painting to make abstract films, then abandoned film to build a color organ.[6] During these same years, abstract painter/theorist Vassily Kandinsky experimented with visual music in his play, *Der Gelbe Klang*,[7] and his theories about color, art and spirituality in *Concerning the Spiritual in Art* are specifically synaesthetic.[8] The first abstract animations were all variously innovations, inventions, and experiments with producing a kinetic analogue to then–recent developments in avant–garde painting[9]; motion pictures was the only technology suited for these experiments in form and meaning.[10] The aesthetic and formal linking of sound::image correspondence requires a technologically–produced art such as motion pictures. The earliest attempts to create an abstract art of color focused on light alone,

without imagery; however, these experiments with "color music" lead to a general conclusion by the end of the nineteenth century that an art of light is not just an amorphous play of color, but must include form as well—"visual music." The role of Theosophy in this development of synaesthetic visuals in painting and the abstract/absolute film is a well documented history.[11] These movements between different media reveal how synaesthesia and visual music converged at the start of the twentieth century.[12] The influence of Theosophy on early abstraction, particularly the imagery of Anne Besant and Charles Leadbetter's book *Thought Forms* first published in 1901,[13] that assigned mystical and esoteric meaning to the "synaesthetic form constants" psychologist Heinrich Klüver would document in the 1930s[14] is a common thread between these experiments and innovations. Understanding synaesthetic arrangements of sound::image as presenting spiritual states of consciousness is the common heritage of visual music shared by later abstract filmmakers.[15]

The invention of motion pictures in the 1890s enabled the creation of abstract films precisely because the various technologies invented to modulate and compose light itself were clumsy and imprecise compared to the projected imagery of film. The surviving abstract films made in Germany in the early 1920s reveal the Theosophical influence. Abstract animations[16] by Walther Ruttmann[17] and Oskar Fischinger[18] both employ the same 'language' of abstract forms, while the work of Viking Eggeling[19] and Hans Richter[20] (whose *Universelle Sprache* employed the same synaesthetic forms as found in Kandinsky's paintings, and was explained using explicitly musical terms[21]) drew their forms and approaches directly from painterly abstraction.[22] The visual shapes appearing in all these visual music films/art works recreate those described by Besant and Leadbetter's text[23]—the works of Len Lye, Norman McLaren, and Mary Ellen Bute are exceptions to this tendency to employ imagery from Theosophy in their motion pictures.

The history of abstraction, spirituality, and a musical analogy for visual art begins in Romanticism and Symbolism. The transformation of earlier "color music" into the abstract films made by Walther Ruttmann, Viking Eggeling, Hans Richter and Oskar Fischinger, as well as American Mary Ellen Bute, realize synaesthesia as an immanent phenomenon, either through a direct analogy to music or by creating a counterpoint

demonstrating "visuals comparable to music" that reiterates Michel Foucault's recognition of the dominance of vision as an arbiter of knowledge that demands the "true nature" of the world become visible. The first abstract animations produced in the 1910s and 1920s all belong to this same ideological revelation; their meaning comes from their foundations in visual music.

The shift from the invocation of a phenomenal encounter to one constructed from ideological belief can be subtle: the links between *direct synchronization* and realism are constants, even when the connections are as simple as 'lip–sync' or the alignment of verbalized and written language. This transformation, an equally direct and automatic linkage as naturalistic synchronization, returns the audible to the realm of signs, assigning particular meaning otherwise absent *outside* the motion picture. *Illustrative synchronization* is complementary to the realist approach of *naturalistic synchronization* that creates an appearance of the everyday phenomenal world, but in place of re–producing the everyday experiential/phenomenal encounter with that world, what illustrative synchronization produces is a "more true" depiction.

o

The centrality of vision in this history of abstraction–as–synaesthesia reveals Michel Foucault's identification of *sight* as an integral ordering of the world, as the primary vehicle for knowledge of that world, a history of ideological reification that includes both visual music and *direct synchronization* generally. The apparent immediacy of connection presented in perception—synchronization is always an invocation of realism—conclusively brings cultural beliefs into these constructions: ideology becomes an immanent presentation, illustrated "empirically" by synchronizing sound::image in the typical naturalism::stylization dynamic of realist movies. Considering these dynamics makes the role of visual music readily apparent: the abstract visual *is* the sound, in the same way that seeing a plucked string is; they are both a visible *equivalent* to the audible note through their relationship/demonstration of the concept "synaesthesia."

Foucault's "gaze" identifies how this ordering emerges. It describes the visualization process as more than simply a demonstration: the assertion of knowledge through vision is an

ordering of the world that implicitly demands specifically *visual* proof, provided through the motion picture:

> The breadth of the experiment seems to be identified with the domain of the careful gaze, and of an empirical vigilance receptive only to the evidence of visible contents. The eye becomes the depositary and source of clarity; it has the power to bring a truth to light that it receives only to the extent that it has brought it to light; as it opens, the eye first opens the truth: [. . .] light, anterior to every gaze, was the element of ideality—the unassignable place of origin where things were adequate to their essence—and the form by which things reached it through the geometry of bodies; according to them, the act of seeing, having attained perfection, was absorbed back into the unbending, unending figure of light.[24]

The realism of the presentation becomes the demonstration of its reality; this integral link between sound::image affirms the ideo–cultural appearance of order. This emphasis on 'light'—nothing more or less than the enlightenment on view—is an absolute dominion of visualized knowledge. The synaesthetic serves this order through the translation of non–visual into visual—in the link of sound::image into the *statement*. Synchronous sound and its demonstrative organization of audio–visual phenomena as an apparently *neutral* phenomenal encounter masks the cultural construction Foucault describes. The dominance of vision as the ideological organization of the world finds an immediate ally in the motion picture's orchestration of sound::image in the *statement*.

Visual music reifies ideo–cultural beliefs about the unseen "true nature of reality" in an equally realist approach to sound::image::text synchronization—both (*direct* variants) *naturalistic* and *illustrative* synchronization—make their link of sound to image immanent, a product of an instantly apparent *statement* of direct linkage. This proximate association of audio–visual elements renders their distinction—*naturalistic* or *illustrative*—a discernment of what specifically seem to be subtle shifts in articulation. The directness of both these connections makes the ideo–cultural dimensions of *illustrative* synchronization seem "natural" and "inevitable," rendering its ideological content precisely beyond challenge, a simple demonstration of a "truth" that cannot be perceived. For *visual*

music compositions, the consistency of the synchronization creates meaning by being a visionary demonstration of associations between visual forms and audible sounds ("synaesthetic" form).[25] In the process, hearing becomes secondary to seeing, affirming the visual through its synchronization; the *statement* thus created informs the audience about the nature and meaning of their encounter: the sounds heard become the sounds *of* whatever is being shown on–screen, a superficially autonomous relationship that is precisely arranged to copy the mimetic naturalism of 'lip–sync.'

By recognizing ideology as an instrumental force demonstrated through the morphologies of *naturalistic, illustrative* and *counterpoint synchronization,* it becomes clear how these *statements* serve to validate cultural belief through their demonstration–presentation as "natural" phenomena: in the simultaneous, immanent encounter that connects the abstract forms shown with the sound they "make" affirms an ideo–cultural belief that *"Sound and Light are Similar,"* an ancient concept articulated by Renaissance author Athanasius Kircher as the direct equivalence of color and sound / music that continues through the nineteenth century with concerns about synaesthesia.[26] This claim, common to mediaeval European thought, assumes literal form in Kircher's explanation of the relationship between sound and color.[27] Kircher's ideas have proved remarkably durable—in spite of centuries of scientific evidence and demonstration of their falsity, they persist, a testament to the dynamic of fantasy::reality, since even well–known fallacies continue to inform cultural production.[28]

The morphologies of synchronization are distinguished by the frequency of the 'sync–points' used to create the synchronization of sound::image, directly producing for the viewer an apparent, immediate, and spontaneous connection. The *meaning* of these links between **note–color/forms** in visual music are produced by how synchronization re–animates Kircher's proposal through its immanent presentation. The synchronization of **note–color/form** creates a natural, perceptual correlation that also renders the cultural idea Kircher articulates as being an equally natural, inevitable event. The *statement* thus produced is one where the autonomous, natural perception renders the additional, culturally–originating relationship of **note–color/form** seem equally inevitable. This association is effected by the *statement,* (the self–contained nature of synchronization as empirical

SYNCHRONIZATION OF SOUND::IMAGE

demonstration), employing the phenomenological encounter to mask its lexical construction. This entanglement makes meaning invisible; an assertion of the linked relations of ideological and "natural" phenomenon in the specific formal structure on view. Once the audience interprets this simultaneous presentation as being "*synchronized,*" the transformation of artifice into natural fact—Rushton's "forms of life" approach to realism—necessarily follow how the an illustration of the language–vision–hearing hierarchy imposes order onto our perceptions.

The naturalism offered by synchronization hides the cultural and ideological dimensions of the artifice imposed by this correspondence (its stylization). While the natural connection of **note–color/form** is recognizable from everyday experiences with objects making noise, (as well as experiences with live musical performance), the visual music presentation of colored forms is foreign, even alien to these common experiences for most audiences. The unification of 'objective' and 'subjective' conceptions of "true reality" through *visual music*[29] evokes the presentation of an "unseen truth" (subjective) through the phenomenal encounter (objective), which motion pictures render via *synaesthetic form* and the spirituality ascribed to it as a presentation of "inner visions." This externalization of interior 'sight' answers to the necessity for visualization described by Foucault's gaze. The need for a specifically visual proof makes the synchronized construction and its formal link to the synaesthetic "form constants" of hallucinations[30] inevitable. The empirical rendering demonstrates antithetical realisms: the "reality of the mind" ("subjective") through the "mere appearances" of the phenomenal encounter ("objective"). For both Moritz and Wees,[31] the *statement* serves to seemingly reconcile these opposed

realisms an immanent meaning connected to metaphysical claims (the Theosophical heritage) about synaesthetic abstraction revealing "hidden truth" in the visual music film,[32] a product of the historical meanings attached to synaesthesia.

Synaesthesia is commonly understood to present an elemental 'purity' superior to the 'fallen' state of our typically discrete sense perceptions—it was understood as a recovery of primal experiences, thus a more "accurate" depiction of reality. [33] Its "purity" comes from the *failure* to be separate and independent—originating in cultural claims of recovering a lost, primal state of innocence. The initial meaning of "abstraction" as *the* mode of "unfettered exploration of the world" originates in synaesthetic visions understood as unbiased encounters with a normally invisible *actuality*—a revelation of a deeper, unseen "truth." Synchronization makes these unseen, hidden relationships an immanent feature of their direct presentation on–screen.

The regime of signification created by synchronization as a *statement* formalizes the connection of disparate sensory encounters that can be separated from each other only in a very relative way because they are two sides of a single assemblage. As Foucault suggests, this relationship is enunciation; in becoming a particular *statement,* the result constructs the reality it demonstrates—*it becomes tautology*—an immanent presentation whose arrangement provides the proof for its own construction, in being arranged it justifies the associations and linkages used for its arrangement. The initial moment of encounter renders the beliefs that organize it as being beyond question, as *fact*. However, this facticity is an illusion—ideology informs all claims of "truthful" depiction, an invisible structuring that makes visual music a form that always has a partisan, documentary dimension—arranging sound::image relationships to produce synchronization always aligns with 'reality effects' of realist presentations; thus, the construction of visual music always has a "documentary" character, a depiction of unseen realities. To challenge them is to put the entire nature of the 'document' itself in question. There is no need to consider Groucho Marx's comment, "Who are you going to believe, me or your lying eyes?,"[34] as an opposition of two distinct positions—there is no long any distinction between "true reality" and "perception"—the *statement* produced by visual music and realized in the synchronization that defines the form reifies ideology, making the unseen *visible*.

REFERENCES

1 Galeyev, B. "Open Letter on Synaesthesia" *Leonardo*, vol. 34, no. 4, 2001, pp. 362–363.

2 Donguy, J. "Machine Head: Raoul Hausmann and the Optophone" *Leonardo* vol. 34, no. 3, 2001, pp. 217–220.

3 Betancourt, M. *The History of Motion Graphics: From Avant–Garde to Industry in the United States* (Rockville: Wildside Press, 2013).

4 There are multiple sources for this history. See Tuchman, M. *The Spiritual in Art: Abstract Painting 1890–1985* (New York: Abbeville Press, 1985) or Brougher, K. *Visual Music: Synaesthesia in Art and Music Since 1900* (New York: Thames & Hudson, 2005).

5 Tuchman, M. ed. *The Spiritual in Art: Abstract Painting 1890–1985* (Los Angeles: LACMA, 1985).

6 Corra, B. "Abstract Cinema——Chromatic Music" *Futurist Manifestos* ed. Umbro Apollonio, trans. Robert Brain (Boston: MFA Publications, 1970) pp. 66–69.

7 Originally published in *Der Blaue Reiter*, 1912. Held in The Thomas de Hartman Papers, Irving S. Gilmore Music Library, Yale University, Series II. A. 1, folders 22/192, 22/193, 22/195.

8 Kandinsky, V. *Concerning the Spiritual in Art* (New York: Dover, 1977).

9 Lawder, S. *The Cubist Cinema* (New York: Anthology Film Archives, 1980).

10 Moritz, W. "Visual Music and Film–as–an–Art Before 1950" *On the Edge of America: California Modernist Art, 1900–1950* Paul J. Karlstrom, ed. (Berkeley: University of California Press, 1996), p. 224.

11 See page 109.

12 Kemp, M. *The Science of Art: Optical Themes in Western Art from Brunelleschi to Seurat* (New Haven: Yale, 1992).

13 Besant, A. and C. W. Leadbeater. *Thought–Forms* (Wheaton: Quest, 1925).

14 Klüver, H. *Mescal and Mechanisms of Hallucination* (Chicago: University of Chicago Press, 1966).

15 Wees, W. *Light Moving in Time: Studies in the Visual Aesthetics of Avant–Garde Film* (Berkeley: University of California Press, 1992) pp. 137–146.

16 Norden, M. F. "The Avant–Garde Cinema of the 1920s: Connections to Futurism, Precisionism and Suprematism" *Leonardo*, vol. 17, no. 2, p. 112. See also Patrick de Haas, "Cinema: The Manipulation of Materials." *Dada–Constructivism*, exhibition catalog, Annely Juda Fine Art, (London: December 1984) np.

17 Ruttmann, W. "Painting with the Medium of Light" *The German Avant–Garde Film of the 1920s*, ed. Angelika Leitner and Uwe Nitschke (Munich: Goethe Institute, 1989) p. 104. See also Bock, Hans–Michael and Tim Bergfelder, eds. *The Concise Cinegraph: The Encyclopaedia of German Cinema*, (Berghahn Books, 2009) pp. 405–406.

18 Moritz, W. *Optical Poetry: The Life and Work of Oscar Fischinger* (Eastleigh: John Libbey Publishing, 2004).

19 Werner, G. and Bengt Edlund. *Viking Eggeling Diagonalsymfonin: Spjutspets I Återvändsgränd*, (Lund: Novapress, 1997). See also Gösta Werner, "Spearhead in a Blind Alley: Viking Eggeling's *Diagonal Symphony*." *Nordic Explorations: Film Before 1930*, (Sydney: John Libbey & Co, 1999) pp. 232–235.

20 Richter, H. "My Experience with Movement in Painting and in Film" *The Nature and Art of Motion*, ed. Gyorgy Kepes (New York: George Braziller, 1965), p. 144. See also Cleve Gray (Ed.), *Hans Richter by Hans Richter* (New York: Holt, Rinehart and Winston, 1971), p. 85.

21 Richter, H. "Demonstration of the Universal Language" *Hans Richter: Activism, Modernism and the Avant–Garde*, ed. Stephen C. Foster, (Cambridge: MIT Press, 1998) p. 208.

22 Le Grice, M. *Abstract Film and Beyond* (Cambridge: MIT Press, 1981) pp. 19–31. See also Schobert, W. *The German Avant–Garde Film of the 1920s*, (Munich: Deutsches Filmmuseum, 1989).

23 Alderton , Z. "Colour, Shape, and Music: The Presence of Thought Forms in Abstract Art" *Literature & Aesthetics* vol. 21, no. 1 (June 2011) pp. 236–258.

24 Foucault, M. *The Birth of the Clinic* (New York: Routledge, 1976) p. xiii.

25 Galeyev, B. "Open Letter on Synaesthesia" *Leonardo*, vol. 34, no. 4, 2001, pp. 362–363.

26 Franssen, M. "The Ocular Harpsichord of Louis–Bertrand Castel: The science and aesthetics of an eighteenth–century *cause celebre*" *Tractrix: Yearbook for the History of Science, Medicine, Technology and Mathematics 3*, 1991, pp. 19–22.

27 Kircher, A. *Musurgia Universalis*, facsimile edition (New York: George Olms Verlag, 1970) p. 240.

28 Dann, K. *Bright Colors Falsely Seen* (New Haven: Yale, 1998).

29 Wees, W. *Light Moving in Time: Studies in the Visual Aesthetics of Avant–Garde Film* (Berkeley: University of California Press, 1992) p. 130.

30 See page 109.

31 Dann, K. *Bright Colors Falsely Seen* (New Haven: Yale, 1998) pp. 94–119.

32 Some of these spiritual claims were codified in religious terms by theosophists Annie Besant and C. W. Leadbeater in *Thought–Forms* (Wheaton: Quest, 1925).

33 Dann, K. *Bright Colors Falsely Seen* (New Haven: Yale, 1998) pp. 94–95.

34 This comment was relayed by Richard Pryor in his performance *Live on the Sunset Strip* (1982).

CPSIA information can be obtained
at www.ICGtesting.com
Printed in the USA
LVHW010124081218
599701LV00001B/14/P